a g u i d e t o

PHOTOGRAPHING

THE ART OF NATURE

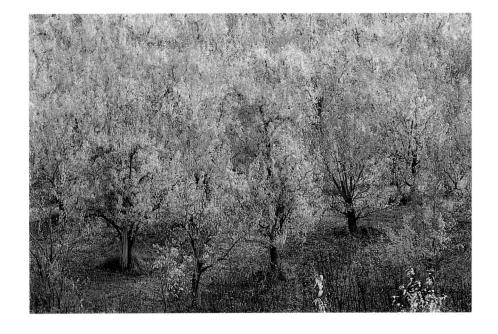

Bruce W. Heinemann

PRIOR PUBLISHING · SEATTLE

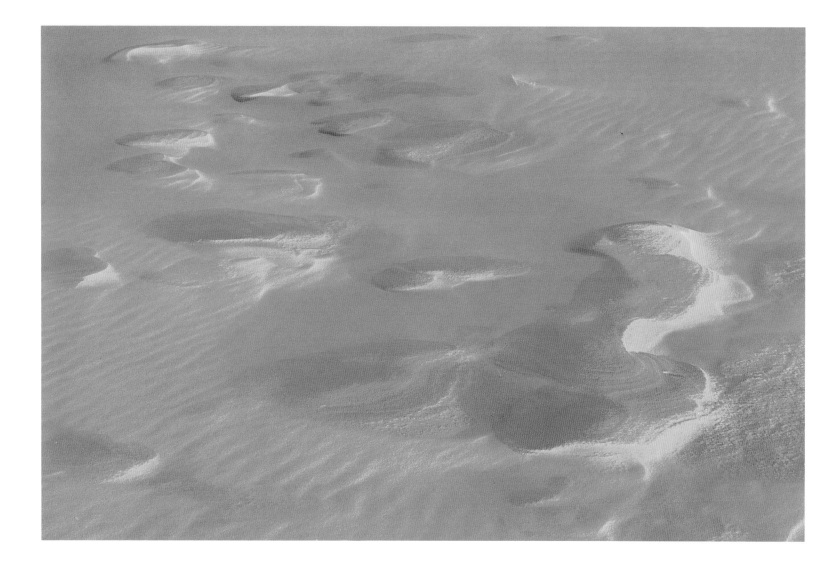

TABLE OF CONTENTS

PHOTOGRAPHING

THE ART OF NATURE

"It's time to go home!" I implored my two year old son. I continued walking along the road toward the house, wondering whether I would still have time to cook dinner, practice my trumpet, and exercise before the night settled in. The absence of small footsteps scattering gravel behind me prompted me to turn around. Squatting by a small puddle, peering at the mosaic of rocks beneath the water, he had found yet another reason to delay the inevitable trip back home. Rolling my eyes and losing my patience, I approached him, hand extended, to lead him from further distraction. Picking up a rock from the bottom of the puddle, he examined it briefly before letting it fall into the water, sending a splash over his face and all his clothes. Looking up at me, his eyes brightened as he giggled with delight. As it so often does, his disarming innocence held me captive, leaving me unable to do anything but smile.

Before I could take another step, I realized that as a photographer who encourages people to slow down and appreciate the beauty and magic of the world around us, I too had been caught in the tornado of routine, schedules, responsibilities, and deadlines. In but an instant, my son had unwittingly reminded me that the profound and beautiful in our lives can literally be at our feet, if we would but take the time to see it.

What had become the ordinary to me was an encounter of utter magic and delight to him. The feel of cool water enveloping his hand as he lifted up the speckled rock before his eyes, rolling the hard roundness in his fingers. Released from his grasp, the rock seemed to fall not by gravity, but to move down through space by the will of his mind. Exploding the surface of the puddle, the rock instantaneously transformed, becoming a flying sculpture of silver, scattering itself into disappearance.

Picking up my son and heading home once again, I thought about how the interpretation of our sensory experiences so strongly influences our response to the world. Though my son and I saw the same thing, we experienced it very differently. As author Tim McNulty observes, "What is it that makes the familiar and day-to-day world become suddenly charged with beauty? And what process in each of us turns our vision away from that mystery to focus instead on the tasks at hand, purposeful, productive, and numb?"

Why is it that from our experience and our analytical and linear education, as adults we seem to recognize everything, yet are so capable of seeing very little? Sometimes I think the real joy of living isn't about becoming more experienced, mature, or accomplished at what we do, it's really about recapturing the wonder and delight of living that we left behind in our childhood. The great painter Picasso mused that it took him fifteen years to learn to be a good technical artist, but it had taken him a lifetime to learn to draw like a child.

I think that good photography and art in general are characterized by creativity, imagination, and an intuitive sense of the subject. It is the conception and expression of content and ideas in a way that is unique to that artist. Picasso's sentiments speak to the creative purity and impulse of

the free and uninhibited spirit that we all possess. Learning to express ourselves and the nature of our experiences requires that we engage the world with an open mind and heart, and with the unrestrained curiosity of a child.

There has been considerable discussion is recent decades about photography as an art form. Photography possesses a number of unique properties that set it apart from other visual mediums. It can record subject matter with exact precision, in an instant or over a period of time, and photography works with visual materials that already exist. If a camera is capable of simply recording the precise details of an event or a scene, what then imbues an image with artistic quality and content?

The concept of art can mean many things to different people, but for my purposes I consider art as simply the expression of the human experience. Therefore, in the broadest sense, images that convey or express ideas, relationships, emotions, or experiences possess the fundamental characteristics of artistic content.

Much attention has also been focused in the last few decades on the use of equipment and technique in the creation of the photographic image. While these are part of the process of making good photographs, they are not the essence of that process. Consequently, I am not a proponent of the "step 1, step 2, step 3" technical approach to photography. I realize that this approach seems more structured and definitive, and therefore appealing to some people. The importance of technique in photography or any other art form is undeniable and, in fact, technique is vital to artistic expression. Nevertheless, it is a great challenge to help the student of photography understand that the question "why do I take this picture" is considerably more important than "how do I take this picture." When we understand what attracts us to our subject, what it expresses or how we respond to it, the technical considerations for creating that image will fall into place. Like all artistic mediums, equipment and technique are tools or extensions of the creative process that give actual form

or substance to artistic expression. The fundamental essence of photography remains the enduring expression of our experience, and that is something that requires more of us than simply following rules and formulas.

Since the recent publication of my first photographic book, The Art of Nature: Reflections on the Grand Design, I have received a very positive response from photographers and painters who share my interest in landscape photography. Consequently, I have written this book for those who would like to explore and develop their artistic potential in the realm of landscape photography.

This book is not intended to be a complete guide to all areas and applications of nature photography. There are many books that serve that end. In presenting this material, I have focused on those aspects that I feel are most crucial to good landscape photography: the phenomenon of light; the experience of seeing; a concept I call the art of being, learning to be a part of the landscape instead of a visitor to it; the concept of visual design; the

expressive potential of color; the application of technique for greater visual expression; and the conscious process of learning. I will use the term landscape photography frequently. It is really the same as nature photography and I use it in the broadest sense.

The three chapters in the book are followed by a gallery style presentation of images that are intended to demonstrate the concepts in the preceding chapter. At the end of the gallery images, I describe how the images were created using the concepts in the chapter, the time of day and season of the year the image was taken, and how the exposure was calculated.

I have endeavored to keep the ideas and concepts in this book simple and straightforward in an effort to help you improve the quality and results of your photographic experience. Too much theory and conceptualization runs the risk of confusion rather than enlightenment. The development of your skills as a photographer lies mostly in the doing, the creating, and most importantly, in the

self-teaching. You will find that your artistic abilities will emerge quite naturally when you are fully engaged in the creative process. I hope, however, that you will return to this book from time to time as, from a broadened perspective of more practice and experience, these ideas and concepts may make more sense and therefore find greater application in your photography.

We find ourselves in a time when our very existence and that of other species truly hangs in the balance. While this book is not explicitly about environmental protection, I believe that to effectively photograph subject matter, in this case natural landscapes, we must explore our relationship to it or in some way express how we feel about it. Clearly, the power and communicative potential of photography, like other visual mediums, lies in the expression of the relationship between the artist and subject. As more and more of the natural landscape around the world is degraded or lost to development, each image of nature that we take becomes an act of preserva-

tion. By sharing our images of the landscape with everyone who would look at them, we have the power to help direct the course of human relationship to the planet we share.

The underlying premise of my work as a photographer, and consequently of this book, is that the beauty and wonder of nature is not remote; it is close at hand and all about us. I offer this book as a demonstration of that notion, for, with the exception of the two aerial photographs, every image in this book was either photographed standing on or alongside a road, or a very short walk from my van.

Reflecting on my son's exploration along the road home, I realize that every drop of water, every speckled rock, hold the secrets, the beauty, and the mystery of life as we know it. To slow down, crouch in silence, and witness the miracle of the ordinary in a way that had escaped us before, with the curiosity of a child, is truly the joy of Photographing The Art of Nature.

ESSENTIAL LIGHT

Standing on the lake shore, I must have spent more than an hour observing and photographing a single stream of sunlight drift in and out of the low-hanging clouds, spilling across the still water a thin sheet of gold. Enchanted and mesmerized by the constant movement of the light, I began to see it not as scientifically describable waves of radiation, but more as a whimsical spirit amusing itself on an early summer afternoon. How appropriate it is to think of light as being alive, because light is life. Sunlight is the radiant energy that gives life to our planet.

The phenomenon of light is one of the most revealing elements of life. It is the prime condition for most species' activities. It presents to the eyes the endless cycles of the hours and the seasons. It is one of the most vivid and spectacular experiences of the senses. But it can become so familiar that it is largely unnoticed and unappreciated in the blur of our daily routine. As Rudolph Arnheim so insightfully observed, "It remains for the artist and the occasional poetical moods of the common man to preserve the access to the wisdom that can be gained from the contemplation of light".

When I first think about light and the photographic image, I imagine the quality of light: indirect or direct, with frontlighting, sidelighting, or backlighting. However, when I contemplate the most essential nature of light, I think more about the infinite variations and sensations of light that cannot be adequately described, only experienced. So much of what constitutes the process of becoming a good landscape photographer is not what can be learned through the written word, but simply what is experienced and intuitively understood. In my experience, the following concepts are essential aspects of working with light in creating the photographic image.

THE FUNDAMENTAL NATURE OF LIGHT

Light creates color and form (textures, shapes, lines, and, perspective, by the contrast of tones). The elements of form are influenced by the quality of light, which may be direct or indirect, representing the softness or harshness of its character. These concepts are explained in the next sections.

The Quality of Light

Direct light *comes from the unobstructed light of the sun. It emphasizes contrast and, relative to its direction, can increase or reduce texture and depth. Direct light affects form through frontlighting, backlighting, sidelighting, and reflected light.*

Frontlighting *exists when light strikes the subject nearest the photographer. It can be spectacular, particularly when it produces strong contrasts. It may also eliminate shadows and reduce perspective.*

Sidelighting *exists when the light source comes in from one side, casting shadows across the image. This lighting is usually dramatic because the shadows establish high contrast. Sidelighting also emphasizes textures.*

Backlighting *exists when you are facing the light source and it is illuminating the back of your subject matter. This light condition creates sharp and extreme contrast. It defines shapes and increases the sense of depth by causing shadows to reach toward you.*

Reflected light *allows you to photograph your subject matter with the qualities of indirect light, as the direct light of the situation is reflected from surfaces in the area around the subject.*

Indirect light *exists when the light source is obscured and the light is diffused before it reaches the subject. For example, a cloudy day typically produces indirect light. Indirect light reduces contrast because tonal gradations are more even and less abrupt. Textures, lines, and shapes may also be less distinct.*

EVALUATING THE QUALITY OF LIGHT

Working effectively with light requires an understanding of how direct and indirect light interact with the landscape. Light is not just illumination of the subject matter; it is also an important component of visual design and composition.

The first consideration before creating an image should be a determination of the light. Since we cannot change the light (the use of flash is excluded here) we must work with the light that is present. The major error photographers commit regarding light is that they photograph subject matter in a way that is inappropriate relative to nature of the available light. I think this most often occurs in direct sunlight. A bright, sunny day seems like a great opportunity to go outside and take pictures. However, in direct light colors tend to wash out, and because tonal contrast is so strong details that the eye perceived in the shadows may not show up very well or are completely

lost in the picture. The results are often a bewildered disappointment. Somehow the visual excitement of the scene as you saw it is lost or diminished in the photograph.

These experiences not only are part of the process of learning to work with light, but also are lessons in understanding how your film responds to and records light. Learning to understand the extent and limitations of your film's tonal range is crucial to selecting suitable subject matter. If you are working with direct light, choose subject matter that is best expressed by the photographic features of direct light: strong contrasts, lines, textures, reflected light, the appearance of depth, and a dramatic quality.

It is equally important to understand the visual possibilities with indirect lighting. Because indirect lighting reduces contrast, it more clearly defines and illuminates tonal variation. Colors are more saturated and, at the same time, the subtleties and the variations of hues are more apparent.

Although images created with direct light tend to be more dramatic, images created with indirect light possess a magical quality of their own. The softness of this light gives the impression that it is not moving from object to object, but appears as an inherent property of the objects themselves. Subject matter seems to radiate a luminescence of its own. Because of these qualities of indirect light, a photographer can work with subject matter in indirect light with varying degrees of subtlety as a refinement of expression.

The Transient Nature of Light

The most fundamental character of light is its transient nature. The location and direction of light changes progressively during the hours of the day and the days of the season as the earth moves through its endless cycles. For a landscape photographer, developing an acute awareness of the quality and nature of the ambient light is essential to the process of creating good, expressive images.

Developing this awareness requires that we actively engage our vision in a moment-to-moment attentiveness to light, acquiring a refined sense of the subtle changes that evolve before our eyes. The use of light in photography is often the reason that an image either works or just misses. Knowing how the light illuminating the scene will render the subject matter on film, learned through practice and experience, is the key to consistently creating good images.

THE ELEMENTS OF WEATHER OR ATMOSPHERIC CONDITIONS

Low clouds, mist, fog, rain and snow are not properties of light, but they can interact with light in a way that may noticeably affect the illumination of the landscape. When photographing in conditions such as these, the basic properties of light still apply. The presence of any of these elements in a scene creates light conditions unique to that moment, which can often produce very expressive and dramatic images. In my experience, these are the most gratifying simply because they are unique to a moment in place and time.

The weather is in a constant state of change, thus influencing the transient nature of light. Working effectively with light in changing weather conditions is a matter of experience and intuition, that is, predicting and sensing how the changing light will illuminate the landscape. For example, will the fog lift, exposing more of the landscape or will it move in and shroud everything? Are the clouds going to part and allow direct sunlight to strike the landscape? If so, what will be the effect of direct sunlight on this landscape that I am now considering in the indirect light? If the sun comes out, should I reposition myself to photograph this scene?

My experiences working under these conditions are my most challenging, yet enjoyable and

productive, photographing experiences. The biggest challenge of these conditions is obvious; they usually involve inclement weather. For that reason, many photographers stay home when the weather is deemed less than perfect and tend to venture out only on sunny days. A photographer's dedication and desire is truly the determining factor here. There is so much opportunity for creating very fine landscape images when the weather is not perfect. These conditions will require more desire and effort on your part, but your efforts will seldom go unrewarded.

Learning to work with light is an aspect of landscape photography that is largely beyond communication through rules, formulas or concepts. It is, of course, important to understand and grasp the fundamental properties of light discussed here. In the explanatory text that follows the gallery section, I have provided numerous examples of each of the specific properties of light as they relate to landscape photography, and demonstrate how I worked with them to create that particular image. Working effectively with light in landscape photography is an art in itself and, as such, transcends the lengthy use of terms and descriptions. The art of working with light begins by surrendering one's attention to a lifelong study of the magical and infinite nature of light. Combined with the creative and purposeful application of photographic technique, the photographer may bring the photographic image to the highest levels of artistic expression.

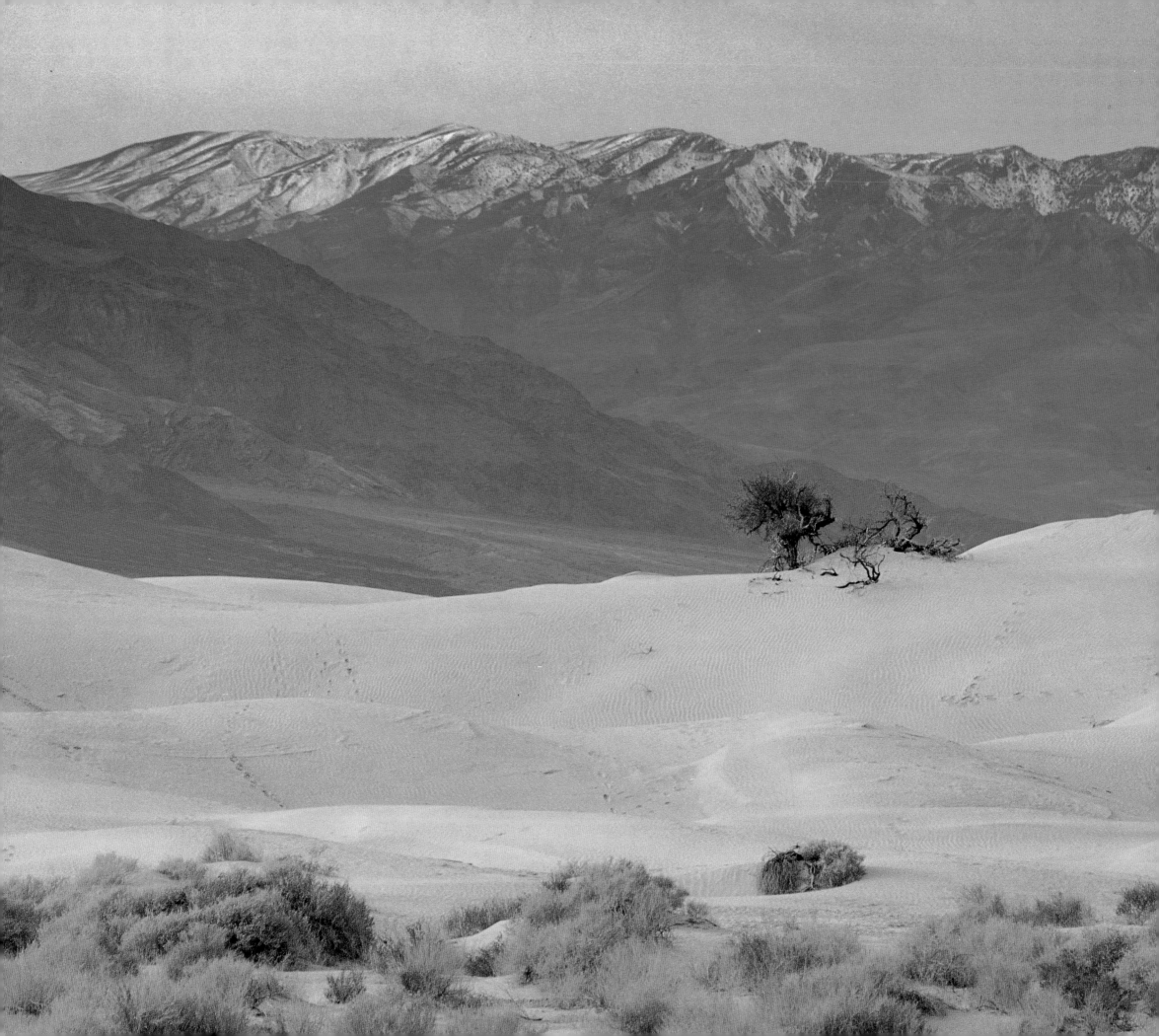

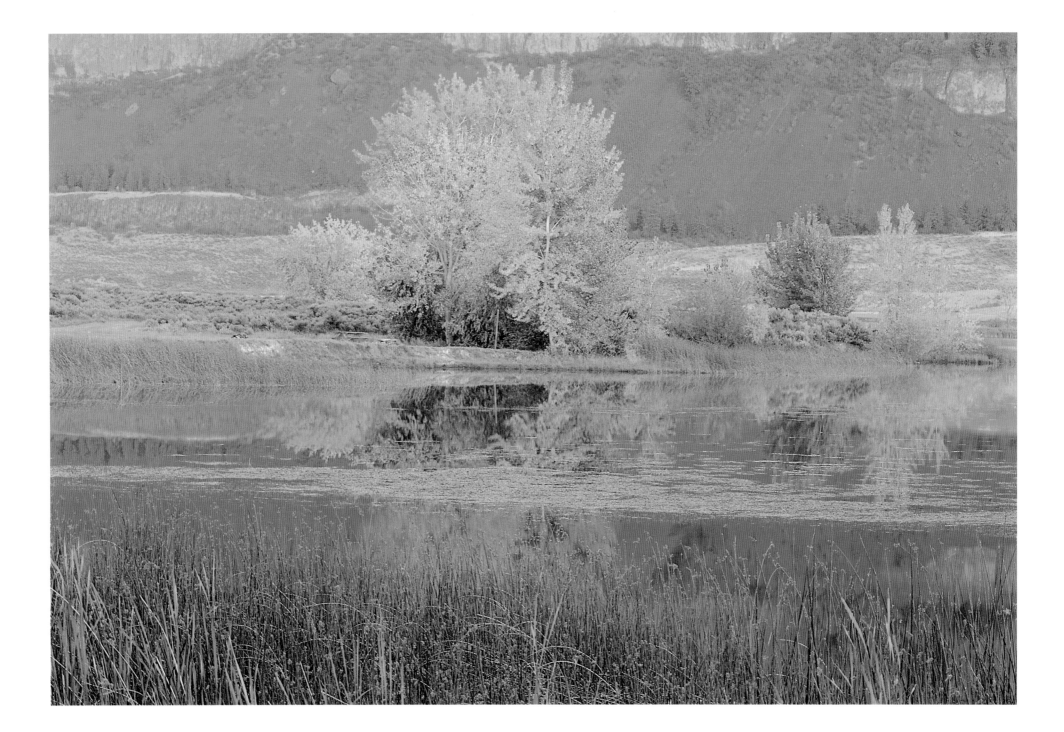

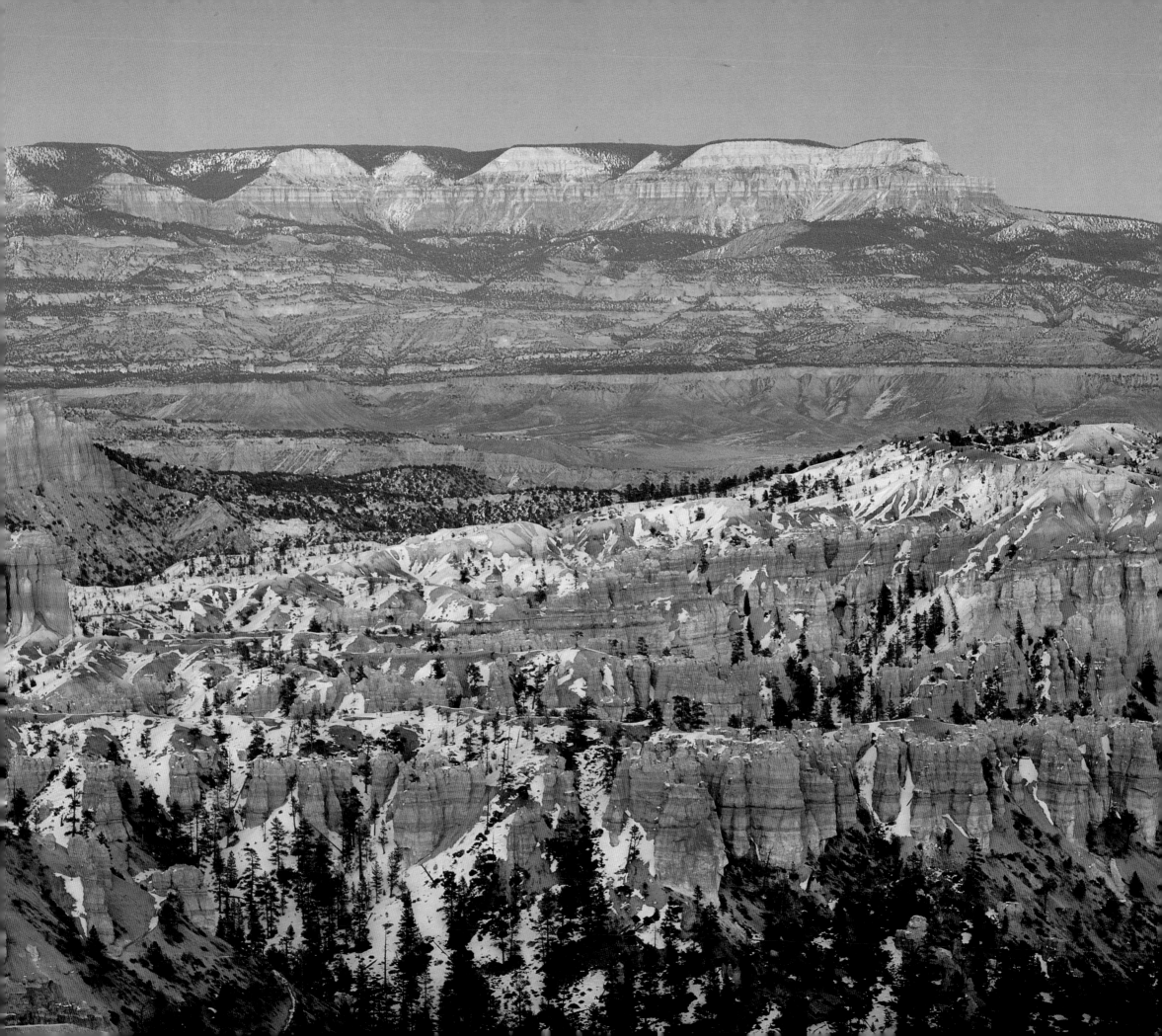

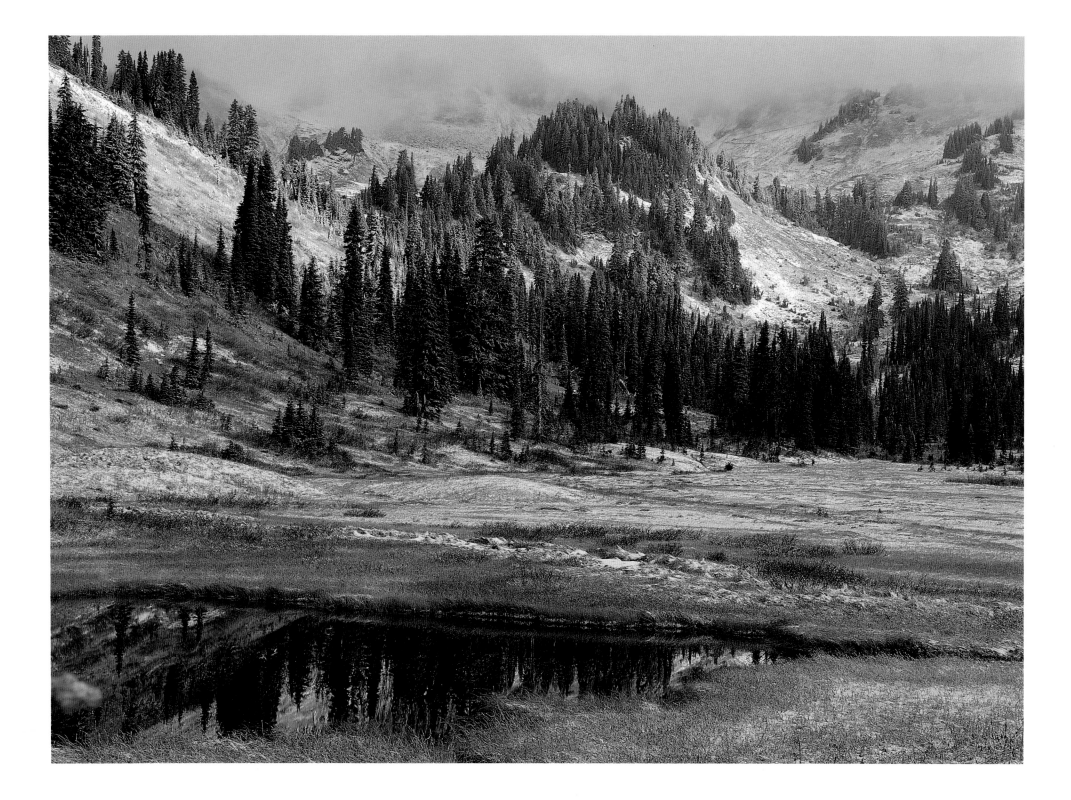

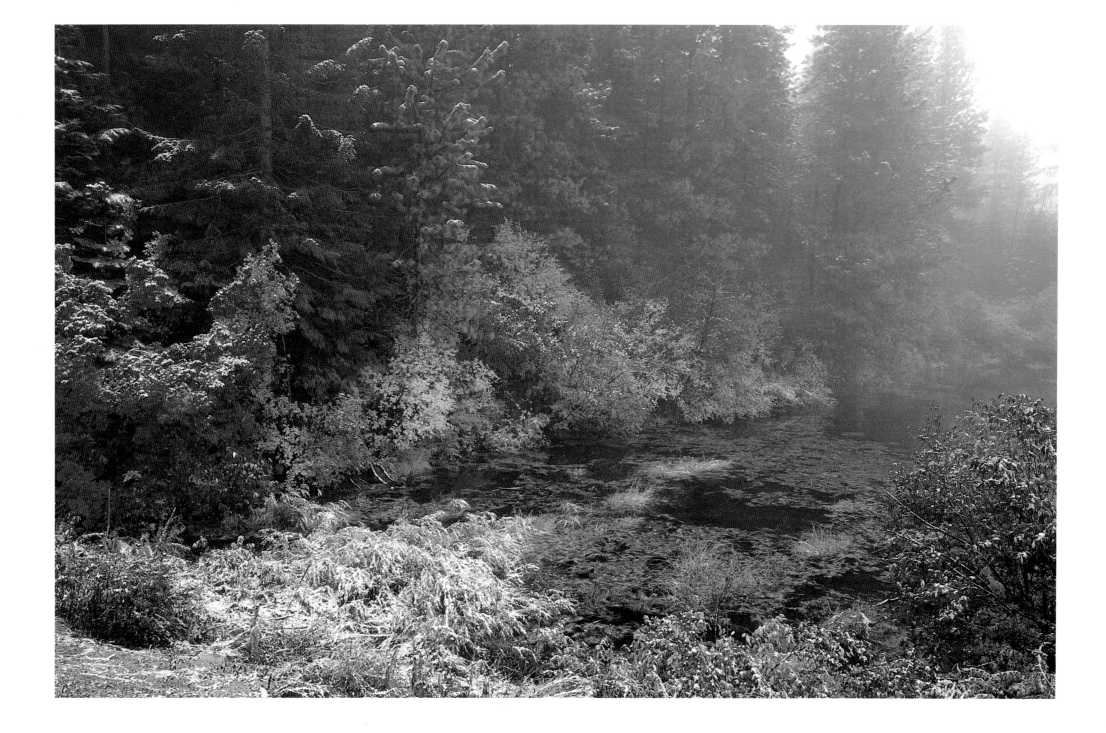

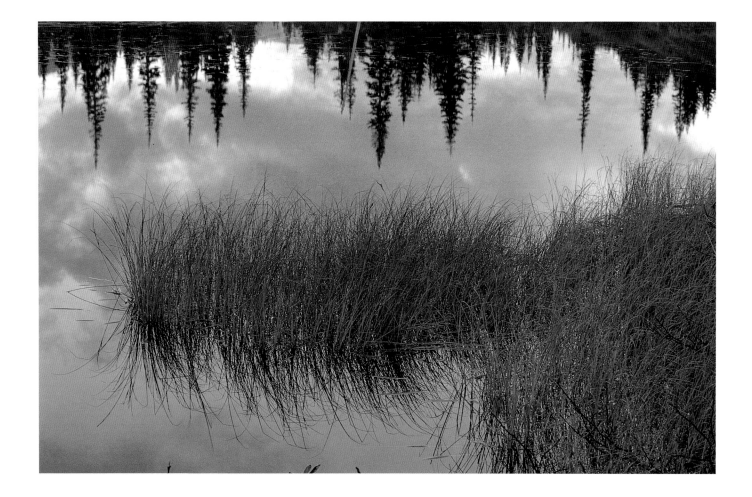

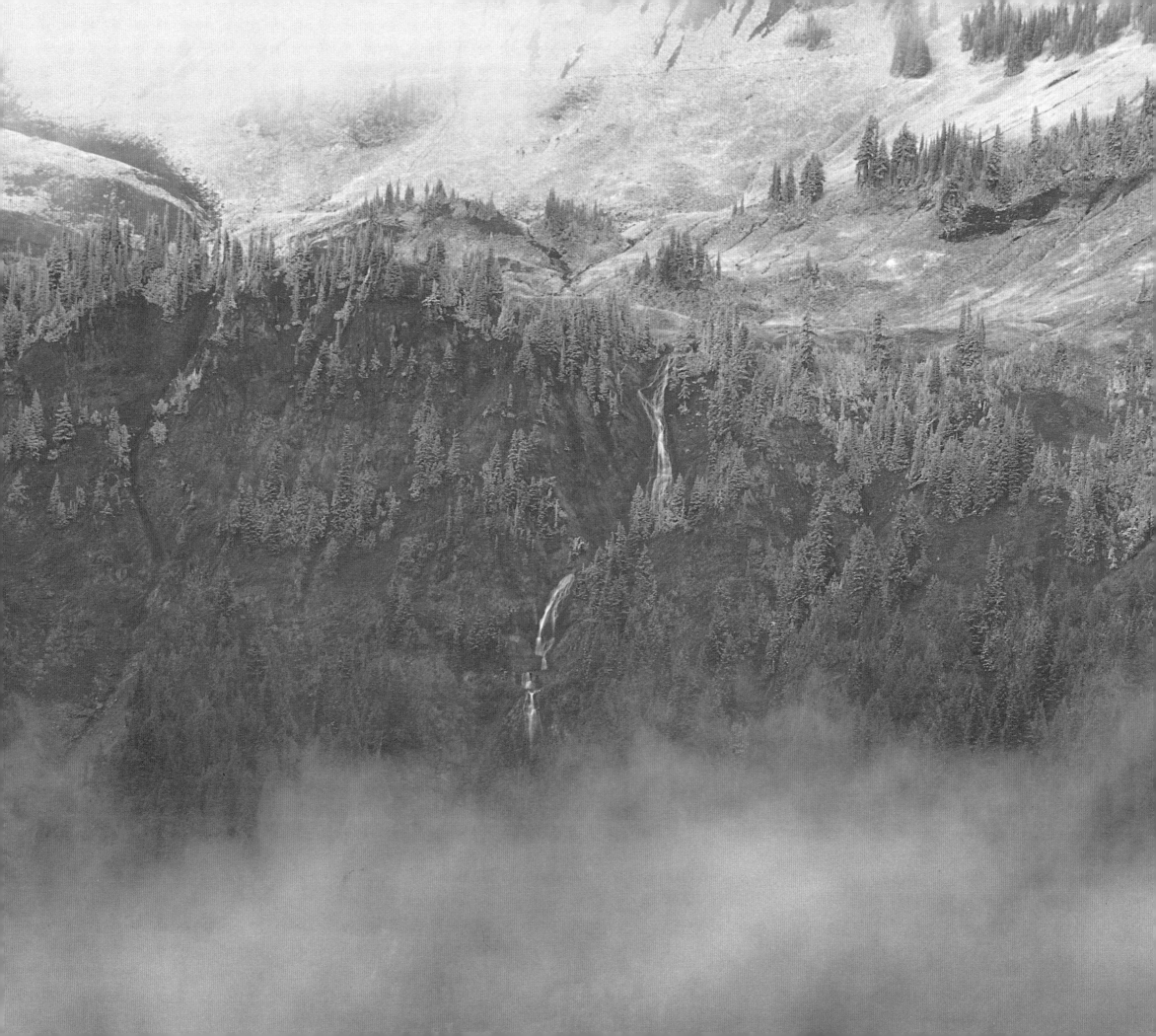

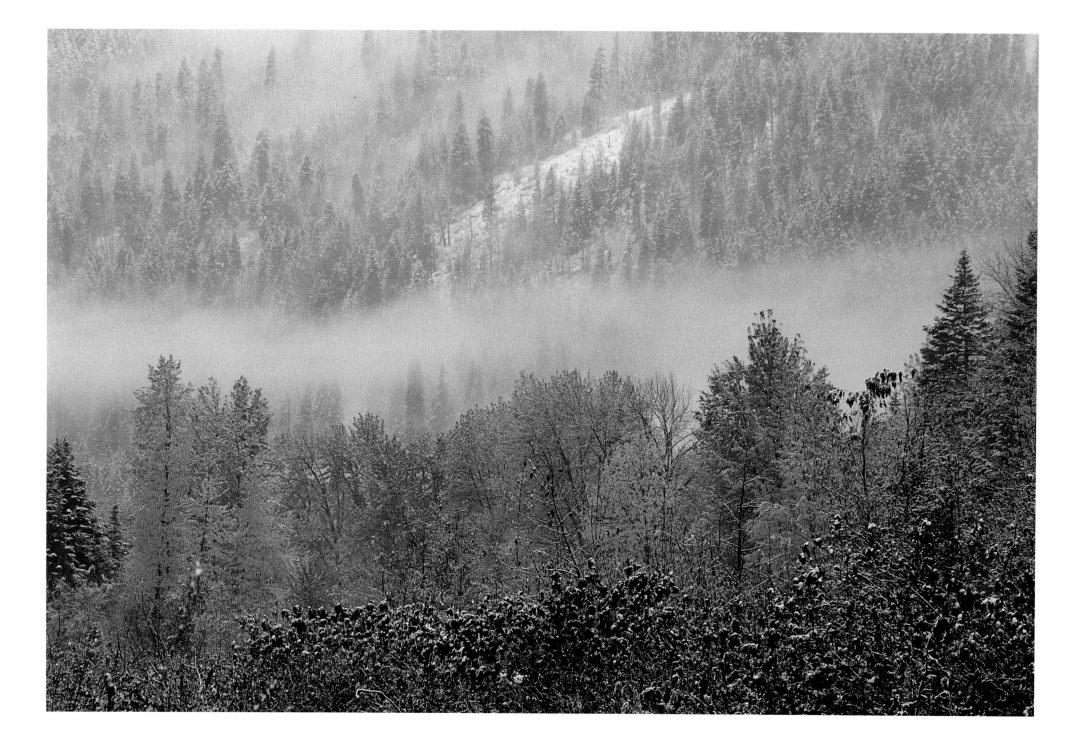

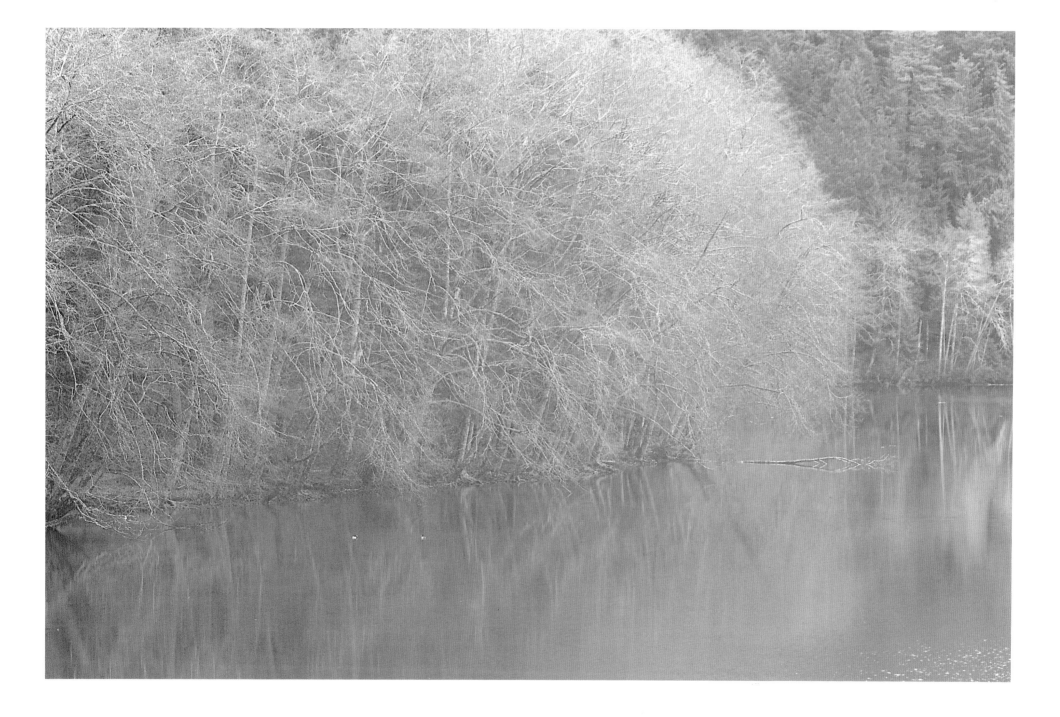

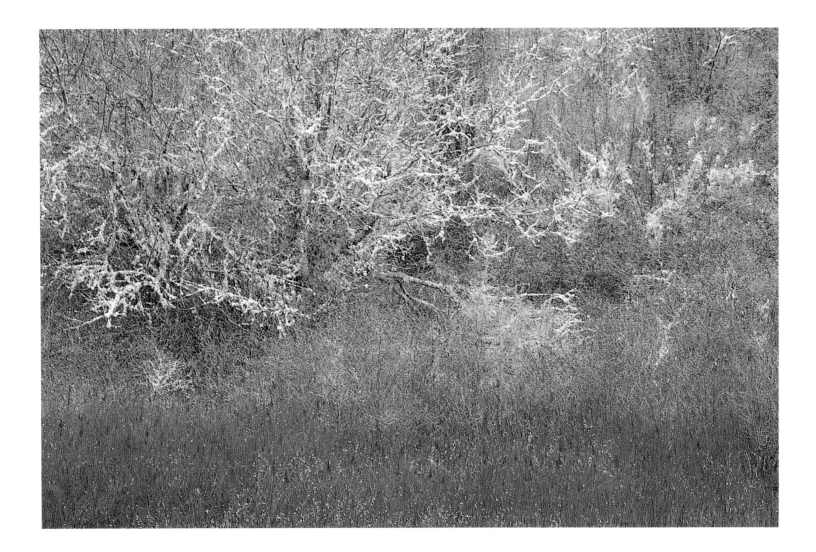

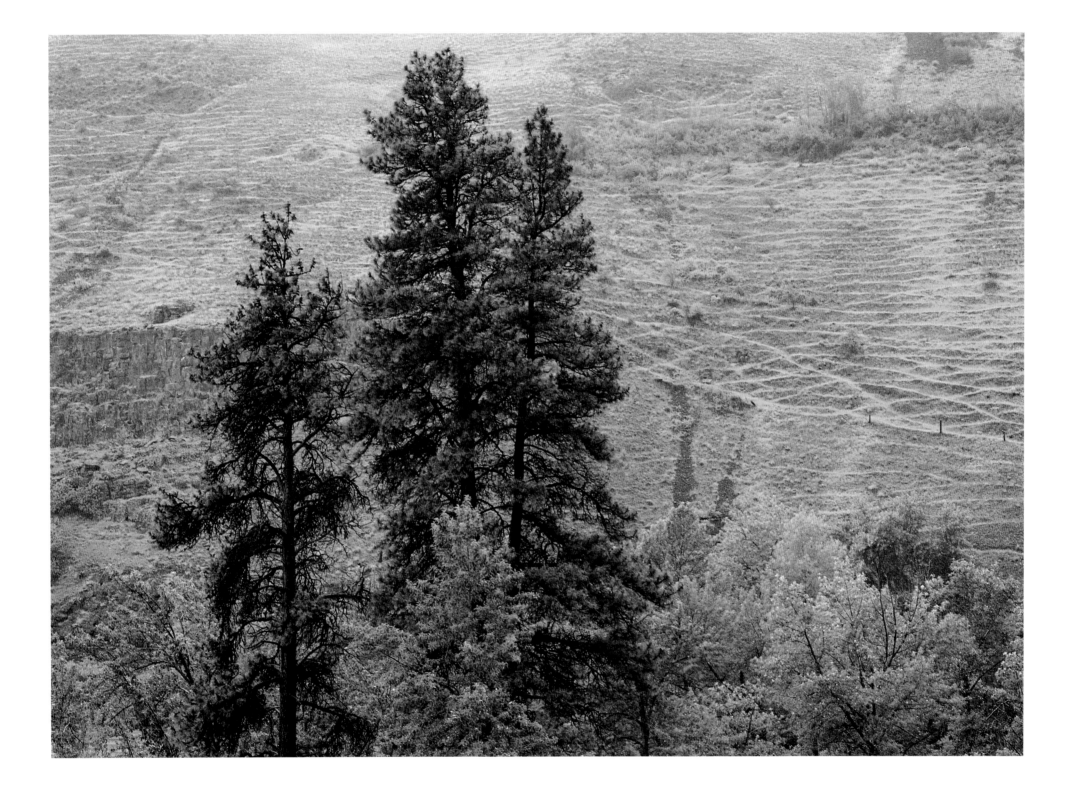

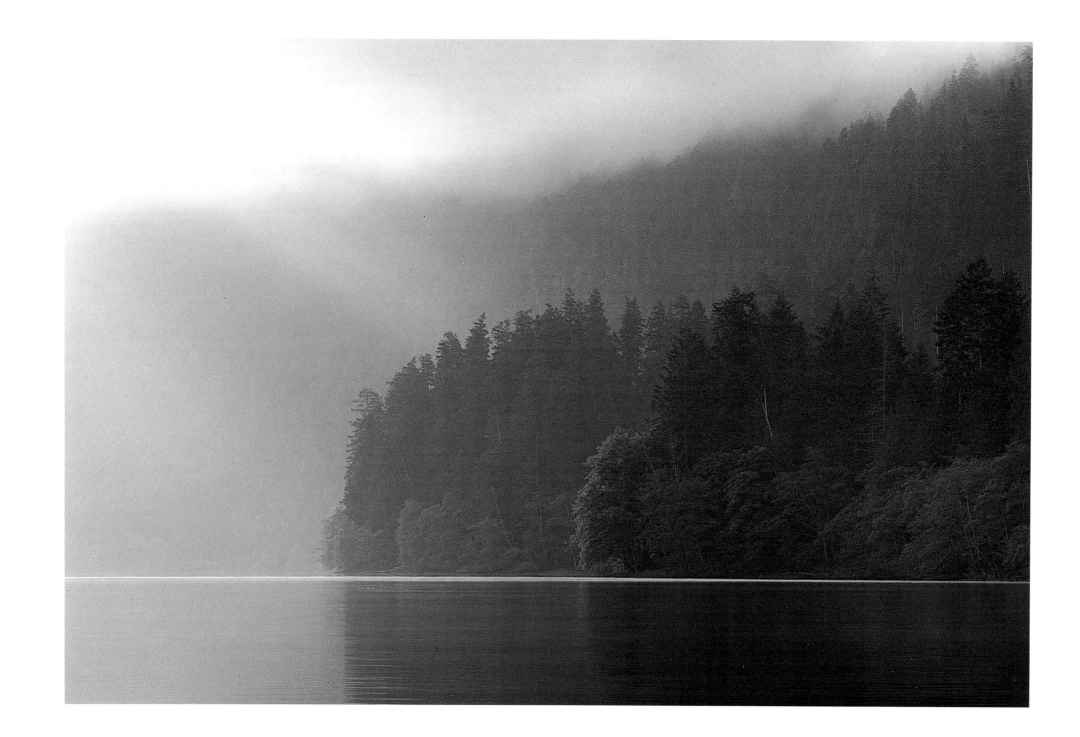

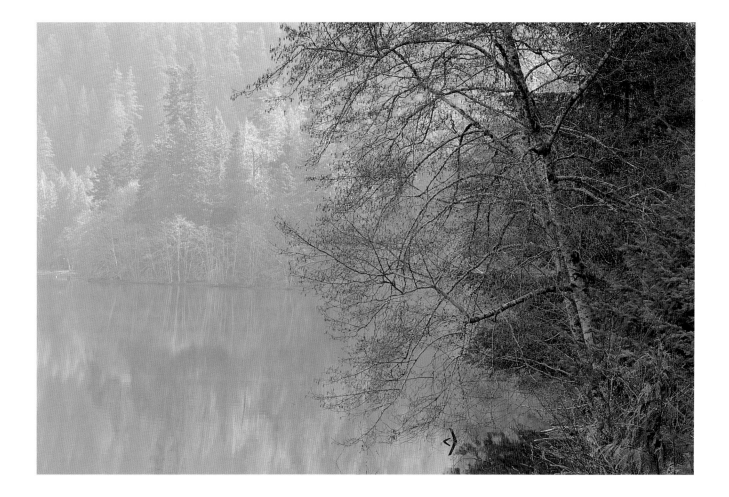

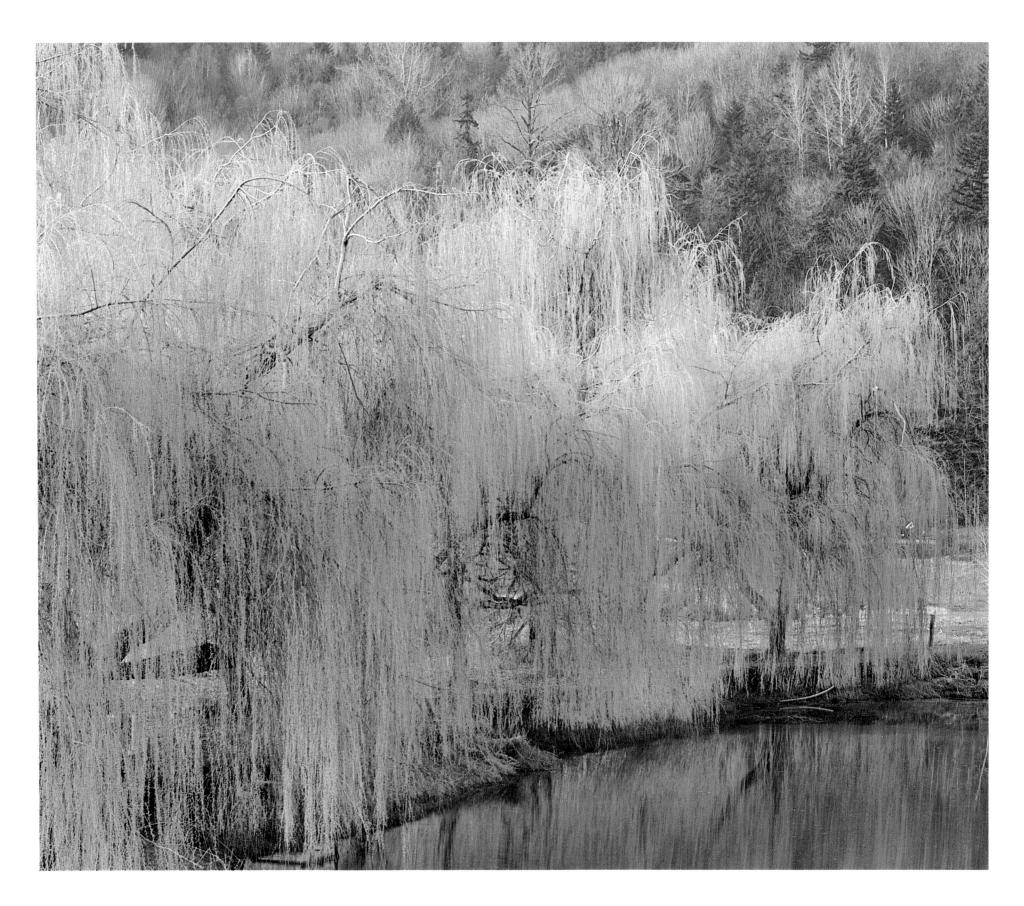

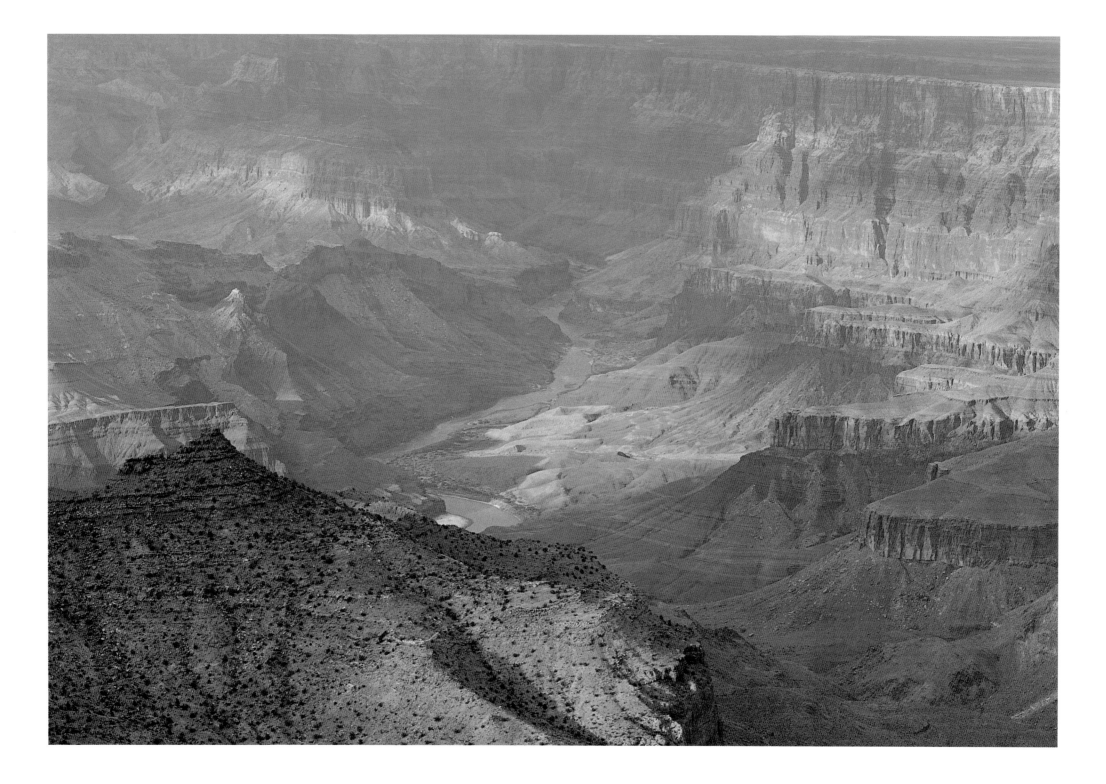

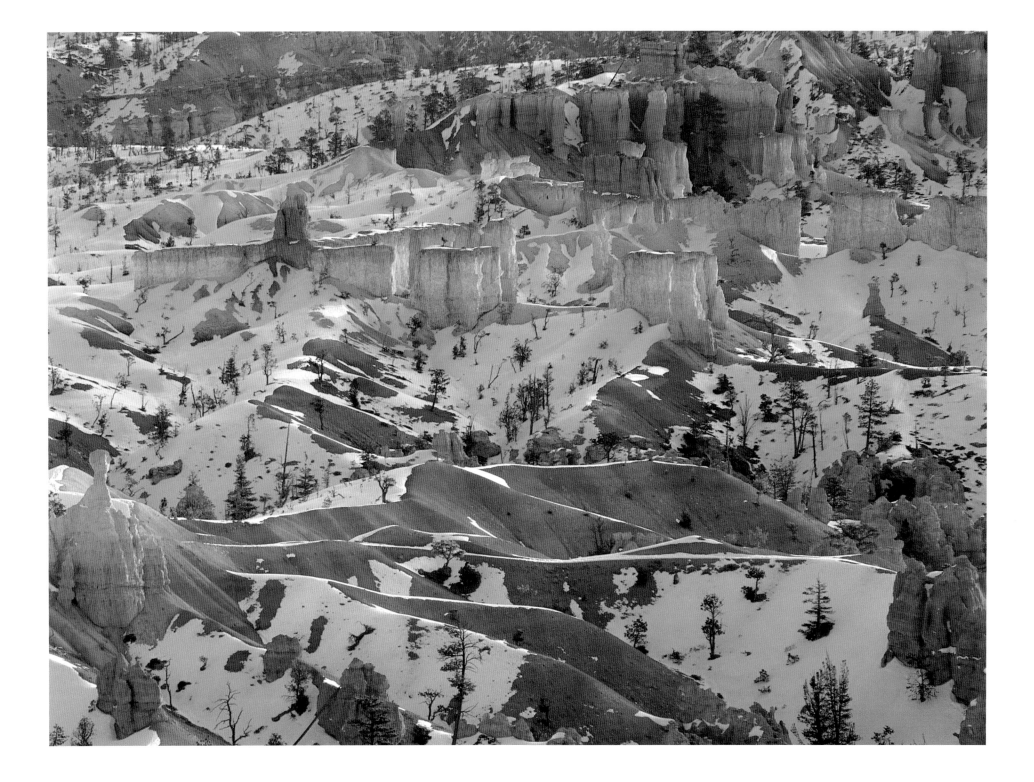

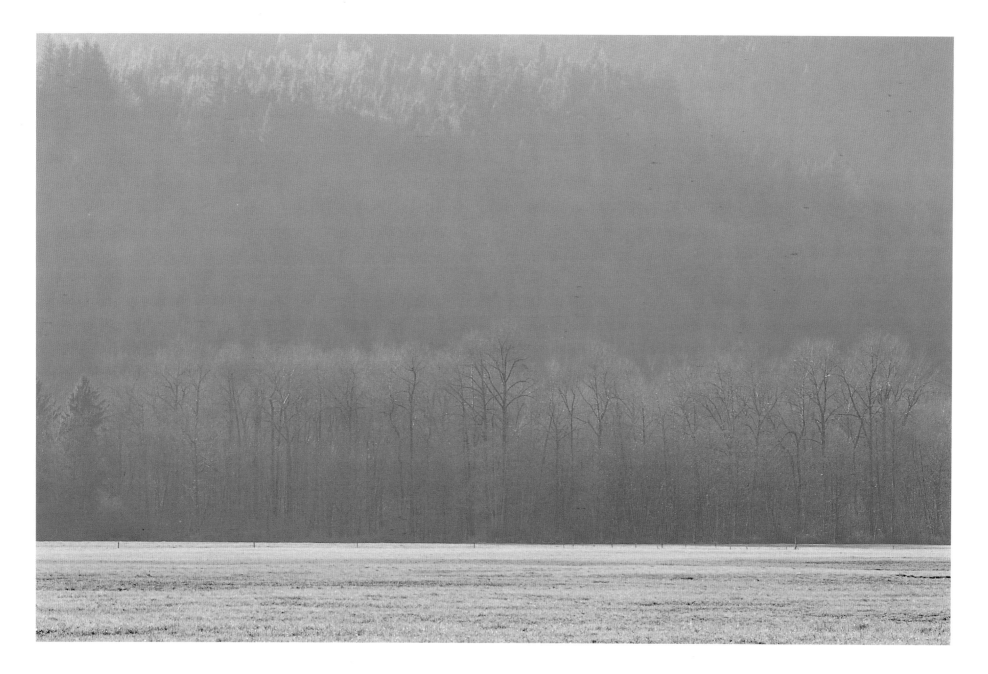

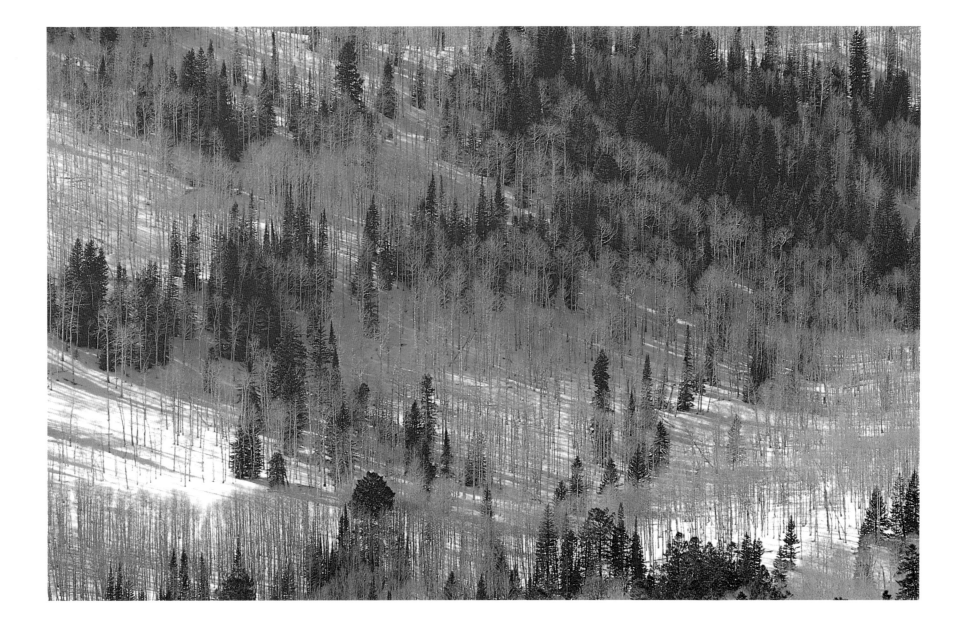

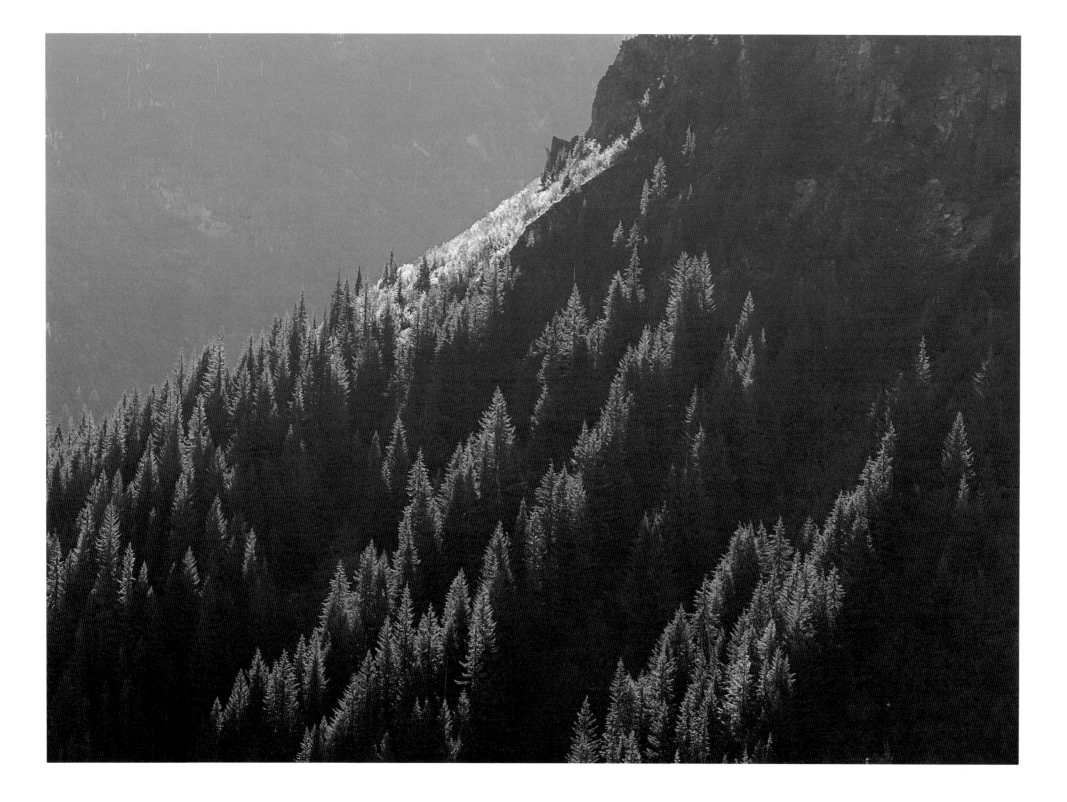

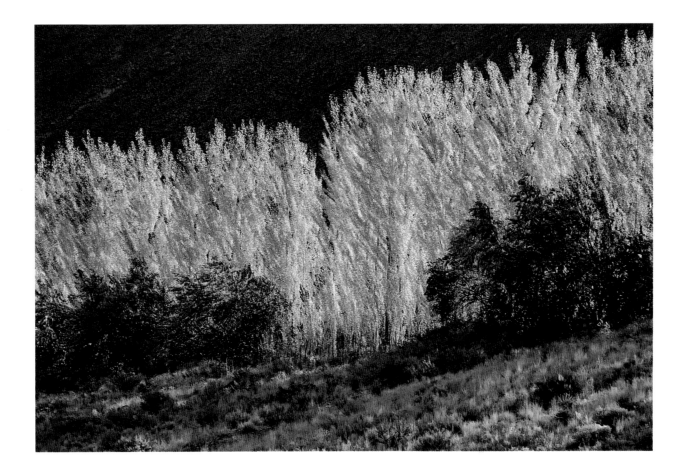

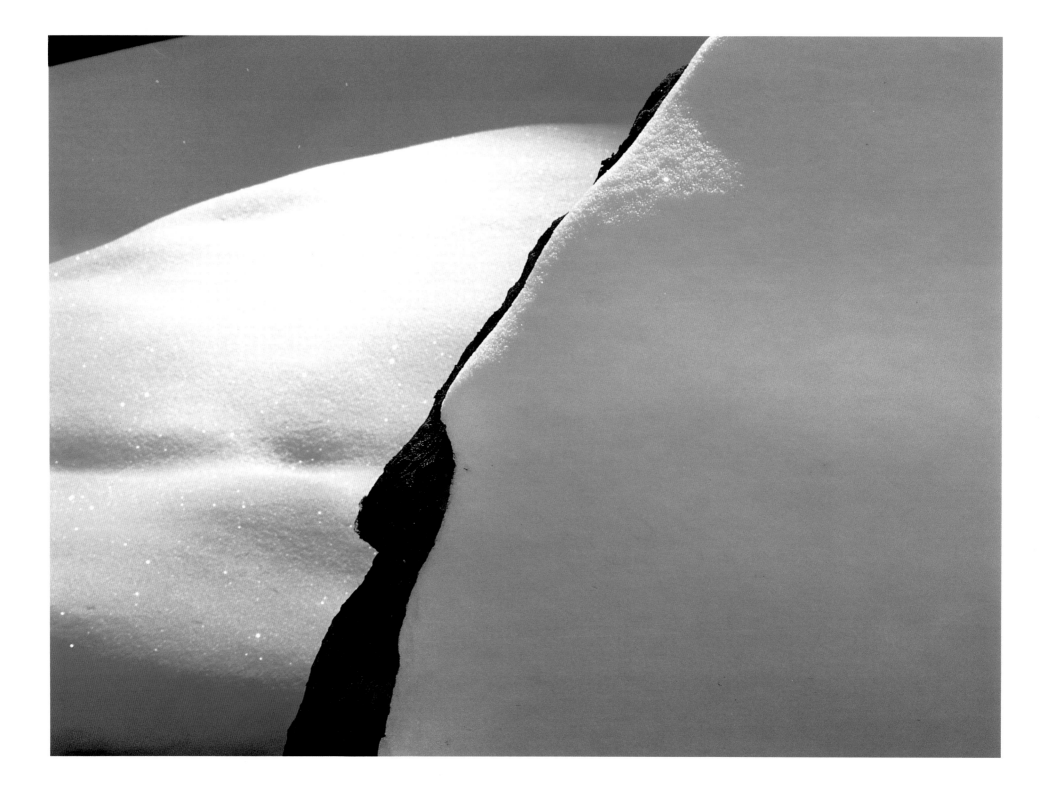

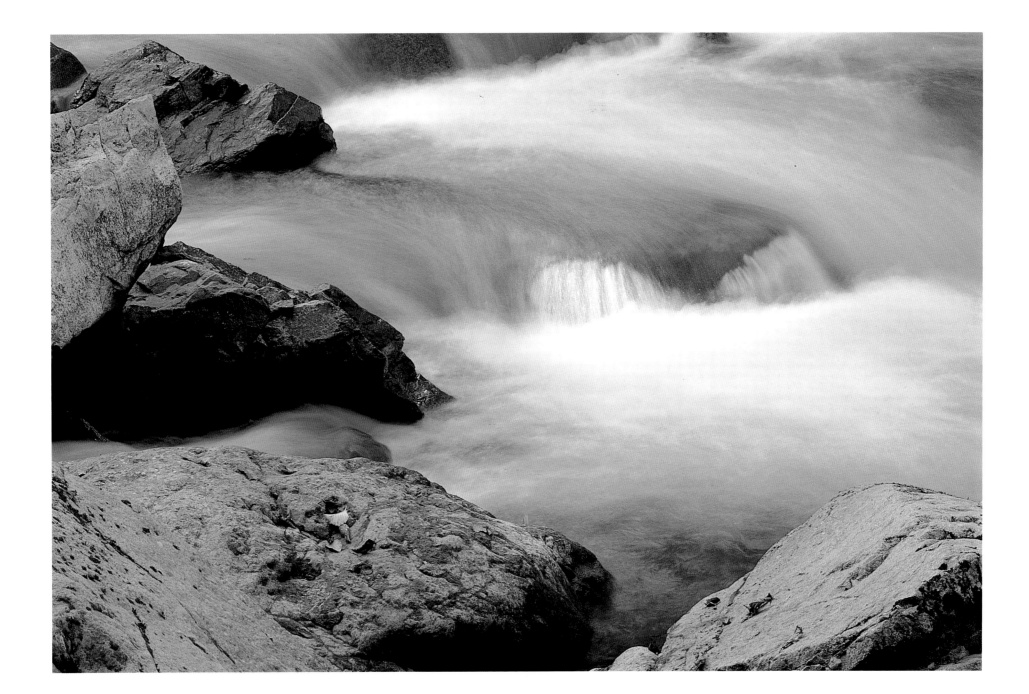

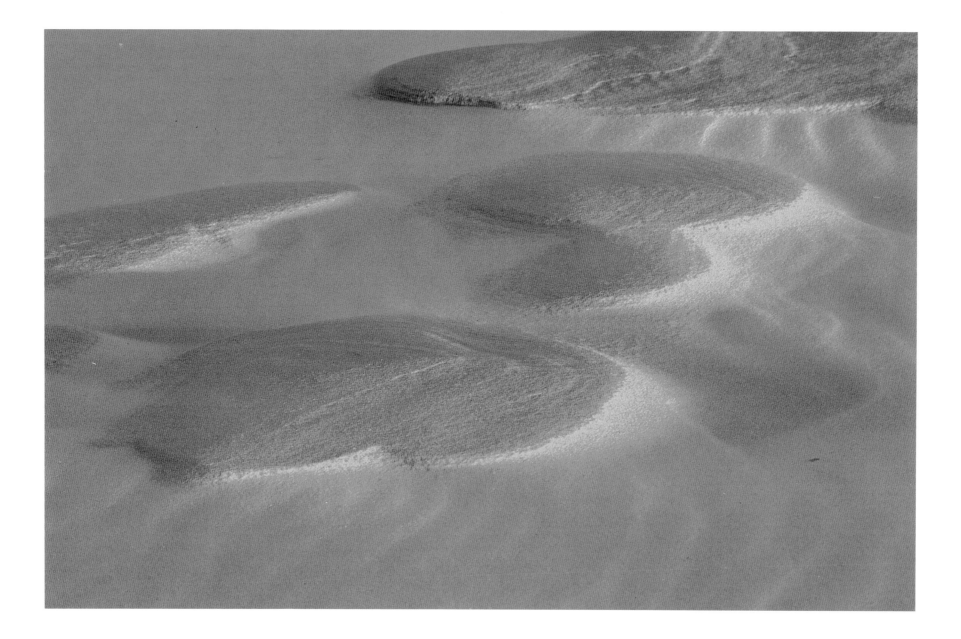

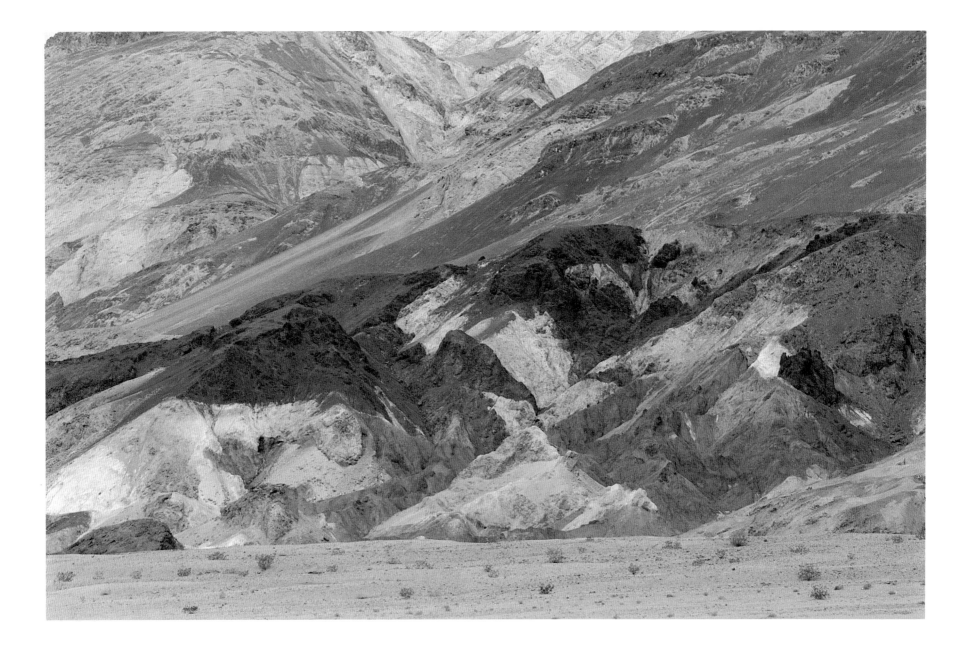

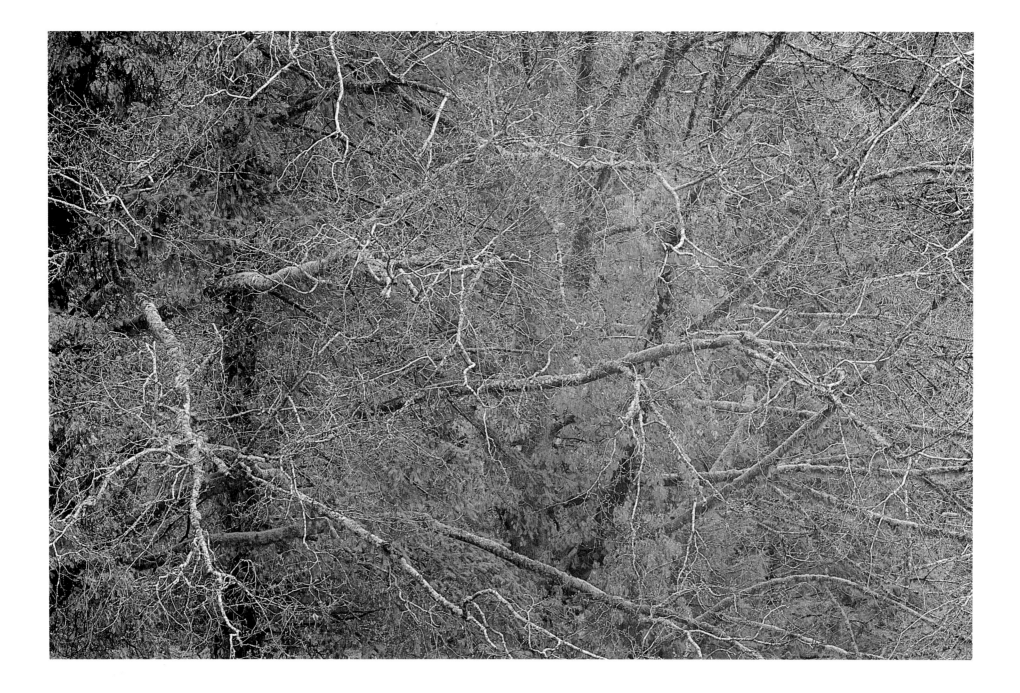

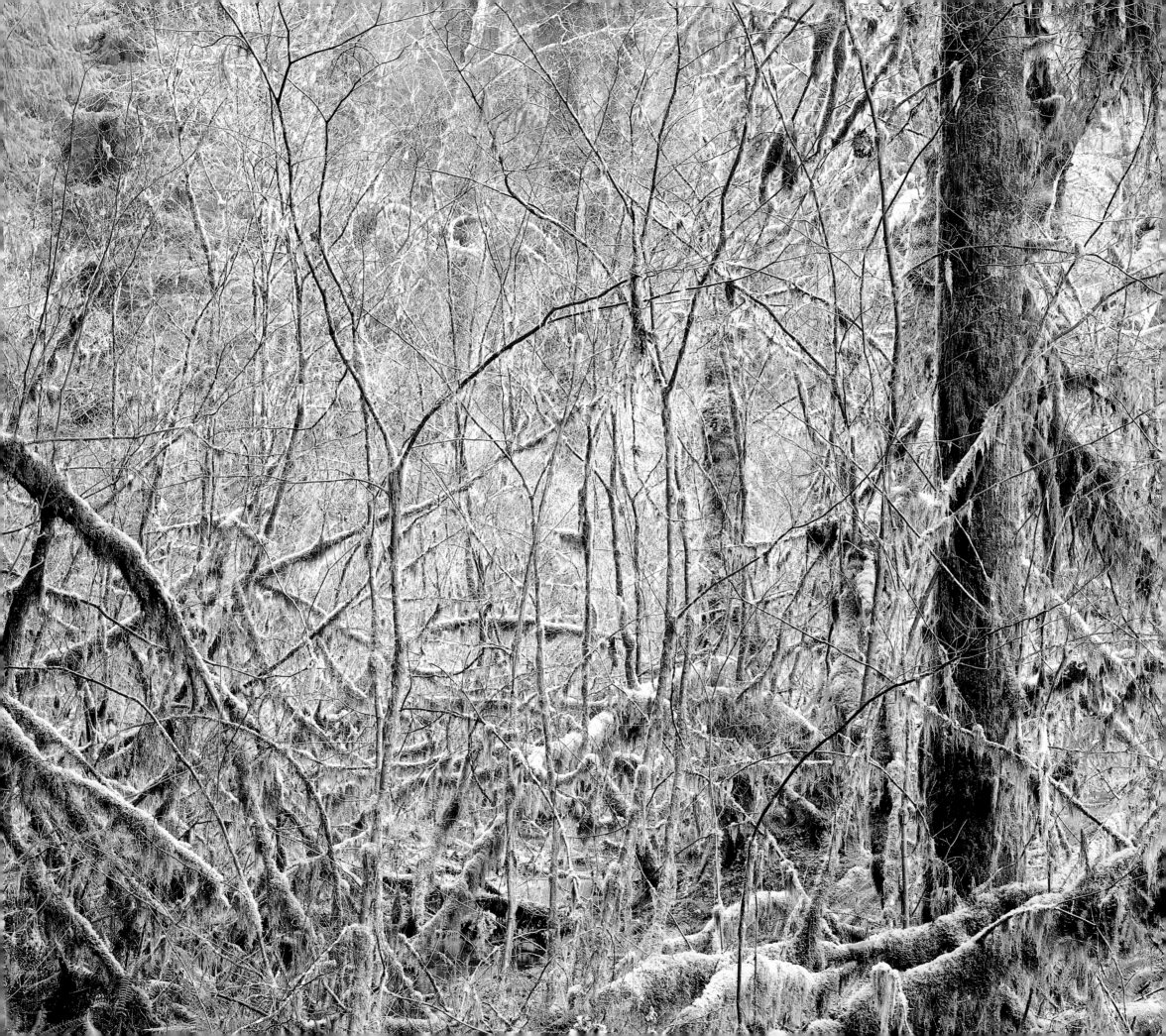

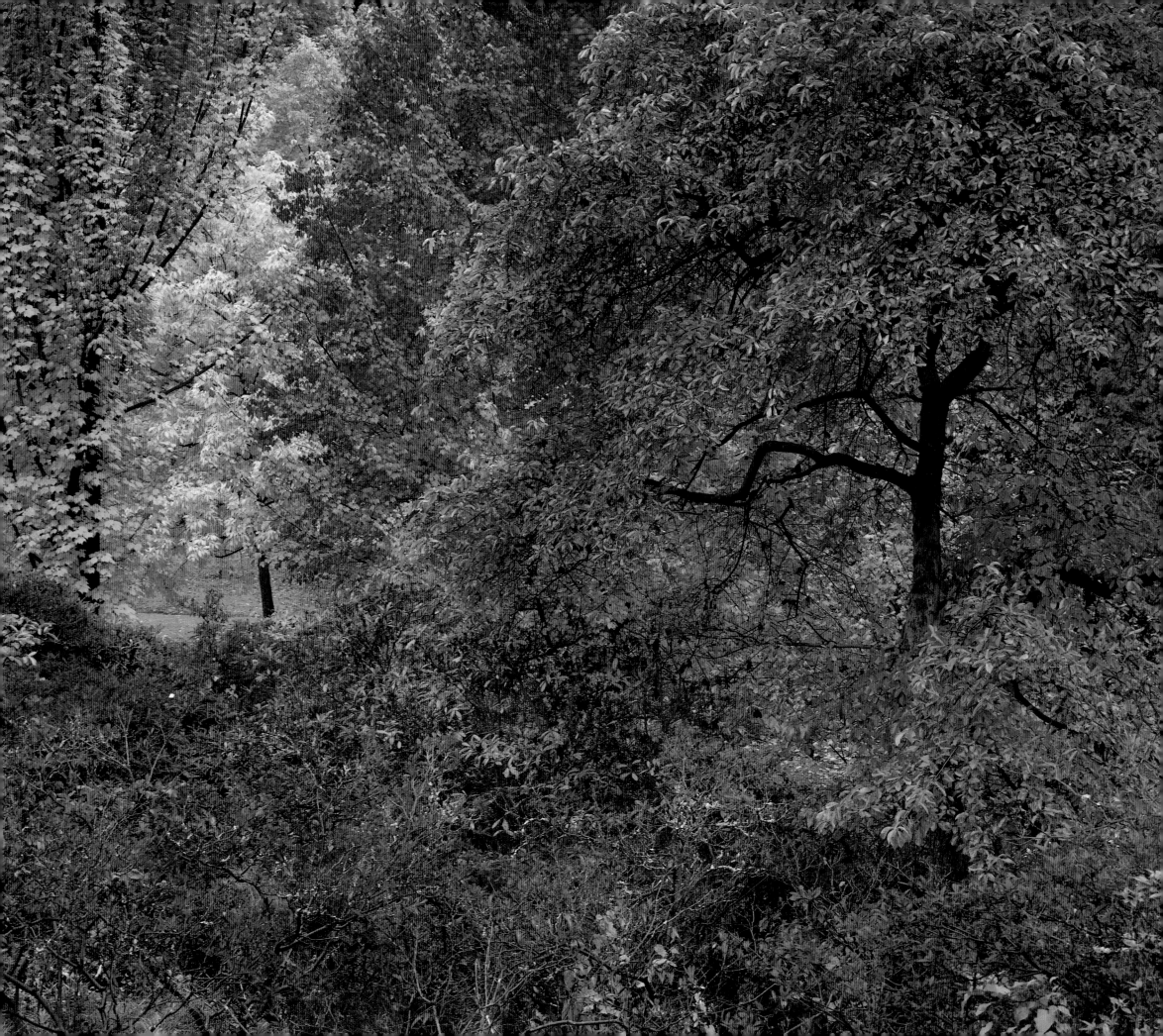

Page 1 LATE FALL AFTERNOON, CASHMERE, WA.

As I was setting up to photograph this, I observed how a few passing clouds would temporarily block the direct light, and in the process change the appearance of the scene. With the sun obscured, the shiny reflectivity of the leaves was reduced, increasing the richness and saturation of the colors. For that reason, I choose to shoot with the indirect light. Also, because the scene was shot in shadow, the uv rays of the sun appear on film as blue and purple, adding another element of color. 80-200mm zoom lens. F/8, 125th sec. (general metering) K25

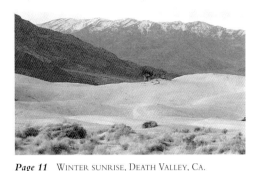

Page 11 WINTER SUNRISE, DEATH VALLEY, CA.

I shot this just before the sun appeared on the mountaintops. At this point, the light is still indirect and the landscape is receiving the pink and mauve colors reflected from the sky. Knowing that time exposures of more than a second tend to shift the film towards magenta, I stopped down to f/22 for a two second exposure (metered from sand). This did not add color, it simply offset the normal loss of color that occurs in the transfer from reality to film. 80-200mm zoom lens. Velvia

Page 12 AUTUMN SUNSET, BANKS LAKE, WA.

I intentionally chose to be at this location at sunset to see how the magenta cast of the sun would play upon the brown and gold colors of this semi-arid landscape. The sun is slightly to my right, behind me, and everything in the scene is evenly lit. The result was a pleasing combination of earth tones set off against the emerging fall colors and a stroke of blue from the sky captured by the tips of the reeds in the water. 80-200mm zoom lens, f/16, 1/8th sec. (general metering) Velvia

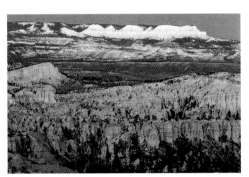

Page 13 WINTER SUNSET, BRYCE CANYON, UT.

I shot this frontlit image with the setting sun almost directly behind me. As it got closer to the rear horizon, the colors in the scene, particularly in the distance, became increasingly intense. At sunset, I often look to the eastern horizon to see what the sun is doing to the landscape as it is likely to be more stunning than the sunset itself. Pentax 67, 200mm lens, f/16, 1 sec. (metered from near cliffs) Velvia

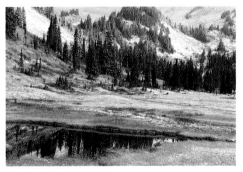

Page 14 EARLY FALL MORNING, MT. RAINIER, WA.

I started shooting this scene in a complete foggy overcast. Observing the patterns of the sun briefly appearing on the distant hillsides as the fog began to lift, I repositioned myself to include the pond and meadow in the composition. Taking advantage of the transient nature of light comes from experience, intuition and sometimes luck. Pentax 6X7, 135mm lens, f/22, 1 sec. (metering on middle foreground) Velvia

Page 15 EARLY FALL MORNING, CASCADE MTS. WA.

Every fall I try to time a visit to the mountains during a snowshower. Not only can the light possess a mysterious or surreal quality, but a dusting of snow on the emerging autumn foliage can embroider a landscape with a delicate lace of white. I shot this image from the road as the snow that had fallen was melting quickly. 24mm lens, f/16, 1/2 sec. (general metering) Velvia

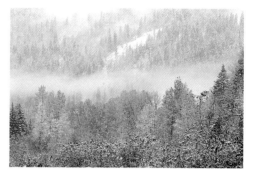

Page 16 AUTUMN EVENING, MT. RAINIER, WA.

This image and the next one were taken about ten minutes and a mile apart. A late afternoon autumn storm was breaking up and the light was changing moment by moment. Most of the mountain was still shrouded in clouds. These clouds in the distance were gathering some of the warm light from the setting sun and reflecting in this small lake, so I spent my remaining time photographing the light in the lake. 80-200mm zoom lens. f/11, 1/2 sec. (metering from grass) Velvia

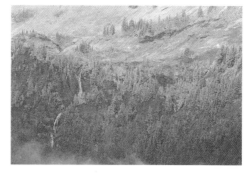

Page 17 FALL EVENING, MT. RAINIER, WA.

The storm clouds that had settled in the canyons were starting to lift, exposing portions of the mountainside. The light that sifted through the dense clouds created an erie, almost dreamlike mood. The waterfalls, cascading down the mountain seem to appear out of nowhere in the terrain, then drop and disappear into the clouds. As I continued to drive up around the side of the mountain, I found the lake and the sun setting in the clouds. 80-200mm zoom lens, f/11, 1/2 sec. (metering from dark hillside) Velvia

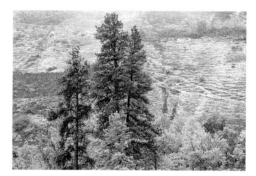

Page 18 FALL AFTERNOON, CASCADE MTS., WA.

I came upon this scene just after the snow had stopped falling and the clouds wrapped around the hills began thinning, forming pockets of mist. Even though it is later afternoon and the light is diminishing, the mist and snow seemed to reflect and sustain the light that was present. Here, the horizontal band of mist forms a soft visual counterbalance to the mostly vertical elements in the scene. 80-200mm zoom, f/16, 1 sec. (metered from colored trees) Velvia

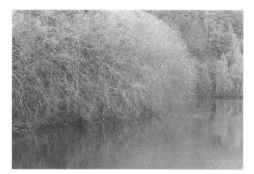

Page 19 EARLY SPRING MORNING, CRESCENT LAKE, WA.

I shot this standing next to a gas pump at a mini-mart. The light was very even, and the subtle colors in the trees and their interplay with the water intrigued me. However, it really came to life when I looked through the viewfinder, and the moisture in the lens from shooting in the rain the day before imparted a gentle softness that really brought out the subtle colors of the trees and gave them a delicate texture. 80-200mm zoom lens, f/16, 1/2 sec. (metering from trees) Velvia

Page 20 SPRING AFTERNOON, DUNGENESS, WA.

I spent almost an hour in a constant downpour photographing at this wetland area. The colors of the vegetation here were beautiful to begin with, however, as it so often does, the rain enlivened and saturated the colors even more. The falling rain, even though it is not apparent in the image, produced a softness of light that was complementary to th subject matter. It wasn't until the next morning at the lake that I discovered the unintended consequences of shooting in the rain. 80-200mm zoom lens, f/16, 1 sec. (general metering) Velvia

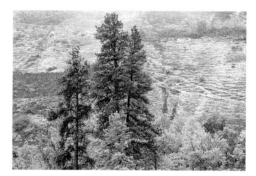

Page 21 SPRING AFTERNOON, ELLENSBURG, WA.

I also shot this standing in the rain, and once again, the moisture is boosting the saturation of the colors and softening the light. The vertical thrust of the pine trees provides an effective balance to horizontal patterns of trails etched by the wildlife and livestock as they traverse the steep hill. The pure desire to create good landscape images is often called upon when photographing in marginal weather, but the rewards are many. 80-200mm zoom lens, f/16, 1/2 sec. (general metering) Velvia

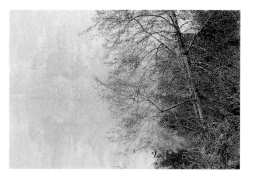

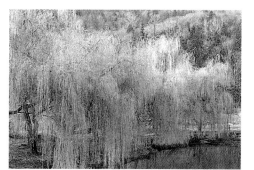

Page 22 LATE SUMMER AFTERNOON, CRESCENT LAKE, WA.

This is the scene of "the dancing spirit of light." It was one of those unique situations when the light is moving and changing noticeably every moment. Because there were areas of extreme light and dark in the composition, exposure was critical. I took my meter reading from the trees along the shoreline, as I wanted to keep some of the detail in those shadow areas. By doing so, it also slightly overexposed the sunlight and clouds, which effectively reinforces the spiritual nature of the theme. 80-200mm zoom lens, f/16, 1/8th sec. Velvia

Page 23 LATE SUMMER AFTERNOON, CRESCENT LAKE, WA.

I shot this image a short time after the previous one. The clouds had broken up, and the direct sun shone through a little bit of haze. I metered from the tree in the foreground as I wanted to retain the shadow detail, allowing the highlights in the direct sun to overexpose slightly. When I looked at the picture later, I noticed a little blue–purple cast in the sunlit areas due to the uv rays on the film. It was unanticipated but I liked the effect. 80-200mm zoom lens, f/16, 1/4th sec. Velvia

Page 24 EARLY SPRING SUNSET, DEMING, WA.

The dramatic sidelighting here is creating this image in several ways. First, the light and shadow in the willow have produced two distinct horizontal bands of hues, which are part of the visual design. Second, the sunlit hillside in the distance provides an abrupt color contrast, creating perspective, bringing the willows and reflecting pond forward in the image. Third, the expressive quality derives from the visual tension between all of the hues and the drooping movement in the willow branches. 80-200mm zoom lens, f/16, 1/4th sec. (metered from shaded branches) Velvia

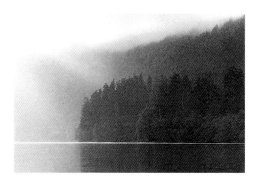

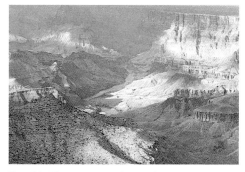

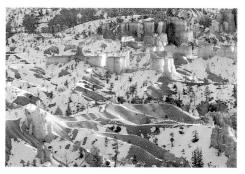

Page 25 EARLY SPRING, ELWA RIVER VALLEY, WA.

When working with light, it is especially important to consider all areas of the image before tripping the shutter. The most striking feature of this image is the expressive move-ments of the greens and yellows of the sidelit mossy branches. However, this is made possible by the blue background behind the trees created by the late afternoon shadows off in the dis-tance, providing the color contrast to set them off and give them prominence. 80-200mm zoom lens, f/16, 1/30th sec. (metered from treetrunks) Velvia

Page 26 WINTER SUNSET, GRAND CANYON, AZ.

I shot this picture as the setting sun was slanting through broken storm clouds passing over the canyon. As the sun would strike the walls in various places, the compositional opportunities would change as well. While I was waiting for the right light combination to appear, I went ahead and calcu-lated my exposure by doing an average metering of the sunny/shadowed cliff in the left foreground. Thinking ahead in transient light situations prepares you for that right moment. 80-200mm zoom lens, f/22, 1/4th sec. Velvia

Page 27 WINTER SUNRISE, BRYCE CANYON, UT.

I photographed the canyon here just after sunrise while the angle of the sun was low. Consequently, the strong back/sidelighting is only illuminating the spires and some of the exposed earth, leaving almost all of the snow-covered areas in shadow. As a result, once again, the sunlight is a compositional element in the image, forming a design of illuminated vertical and horizontal landscape features. 80-200mm zoom lens, f/16, 1/4th sec. (metered from sunlit brown soil) Velvia

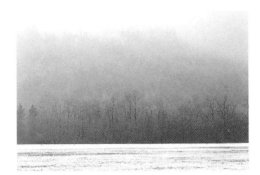

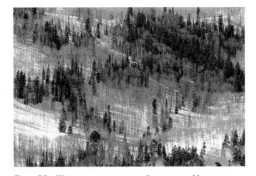

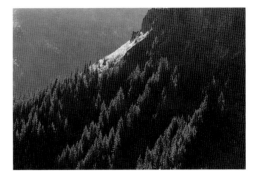

Page 28 EARLY SPRING, LATE AFTERNOON, ACME, WA.

This picture is almost exactly as it appeared to my eye. My concern when preparing to shoot was, will the film hold the subtle details in the shaded areas? Once again, exposure calculation was critical. I took an average of the values between the darkest band in the middle and the backlit trees below. This gave enough light in the dark band for some detail without overexposing and washing out all of the nice detail in the trees below. Unusual light exposure calculations are not difficult, they simply require thinking them through. 80-200mm zoom lens, f/16, 1/4th sec. Velvia

Page 29 WINTER AFTERNOON, SOUTHERN UTAH.

Driving through a mountain pass in Utah, I came upon this vista near the summit. The forms and shadows being created by the strong sidelighting were presenting a wealth of compositional opportunities. What I found most interesting was a type of soft texture in the scene produced by the visual difference between the evergreen and deciduous trees and the elongated shadows. 80-200mm lens, f/16, 1/30 sec. (general metering) Velvia

Page 30 MIDDAY, AUTUMN, STEVENS CANYON, WA.

The burst of brilliant autumn colors isolated amongst the conifers on the top of this hillside was what originally aroused my attention. Using an 80-200mm zoom lens, I zoomed in for a mid-distance shot which emphasized the contrast between the shapes and colors of the autumn foliage and the oblique rows of sidelit evergreens. I have exposed for the highlights so that the shadow detail will diminish, keeping the contrasts strong. F/16, 1/30th sec. Velvia

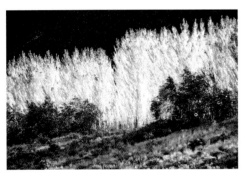

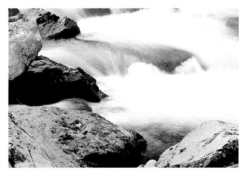

Page 31 AUTUMN MORNING, WENATCHEE, WA.

Driving through the farmlands of eastern Washington, I found this windbreak of poplars spectacularly lit up by the morning sun. Surging forward with the gusting wind, this row of backlit trees looked like a wall of flames leaping skyward. Using my 80-200mm zoom lens, I zoomed in tight to compose the image with the three design elements of the grasses, the trees, and the shadowed basalt cliffs in the background which I positioned behind the trees to create a strong contrast. F/16, 1/30 sec. (metered from trees) Velvia

Page 32 WINTER AFTERNOON, CASCADE MTS. WA.

The last bit of afternoon light was slicing down through the steep river canyon and reaching the snowbank along the river. What caught my eye was the warm patch of reflected light in the right half of the image. This small amount of light and color is what made this design work by balancing the areas of light and dark and the strong oblique line of the rock. I carefully metered on the area of reflected light for my exposure. 80-200mm zoom lens, f/8, 1/30th sec. Fuji 50

Page 33 SUMMER AFTERNOON, SAUK RIVER, WA.

Perhaps the most enduring excitement of landscape photography is the opportunity to encounter new and unusual light conditions. I photographed this part of the river for almost two hours, changing positions and subject matter frequently as the sun moved lower in the sky. By the time I took this picture, the sun had nearly disappeared, except for this one shaft of light that found its way through the trees and lit on the waterfall. The even light and absence of shadows help create the impression that the sparkling light emanated from the water. 80-200mm lens, f/16, 1/2 sec. (metered from foreground rocks) Velvia

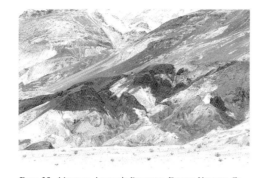

Page 34 WINTER SUNSET, CORAL PINK SAND DUNES, UT.
I arrived at this park just prior to sunset. Hurrying out through the dunes, I began looking for abstract patterns as the last rays of sunlight slanted across the wind swept sculptures in the sand. The unusually warm hues of this sand were accentuated by the golden light of the setting sun. The extreme low angle of the sun striking these elevations of sand highlighted their distinct forms and variety of textures. 80-200mm zoom lens, f/16, 1/15 sec. (general metering) Velvia

Page 35 MIDDAY, ARTIST'S PALETTE, DEATH VALLEY, CA.
When I entered the valley that Winter morning, the sky was clear and the sun was bright. By the time I got here, a high, thin layer of cirrus clouds was beginning to form. When I began to shoot, the sun was still fairly bright and creating shadows in the scene. I hoped that by waiting, the clouds would build up and diffuse the light. My patience was rewarded, as shortly all shadows disappeared and the impressive range of hues and tonal gradations became clearly visible. 80-200mm zoom lens, f/22, 1/4th sec. (general metering) Velvia

Page 36 MORNING, EARLY SPRING, CRESCENT LAKE, WA.
This image was also shot from a gas pump at a mini-mart previously mentioned. The heavy cloud cover has created a shadowless, even light. In this light situation, detail and color saturation are greatly enhanced. In fact, the overall design and composition of this image was possible only because the enormous detail in the scene is clearly visible. 80-200mm zoom lens, f/16, 1/2th sec. (general metering) Velvia

Page 37 MORNING, OLYMPIC RAINFOREST, WA.
This was shot on a heavily overcast, early spring, day. The richness and luminescence of the browns and greens, and the enormous detail visible in the scene derives almost entirely from the even, shadowless light. A photographer who shot this on a sunny day, expecting to see this detail and color, would be greatly disappointed. Developing a reliable sense of how various light conditions will render subject matter is fundamental to good photographic expression. Pentax 67, 135mm lens, f/32, 1 sec. (general metering) Velvia

Page 38 AUTUMN AFTERNOON. SEATTLE, WA.
This is another good example of how indirect light so effectively shows detail, tonal gradations, and saturates colors. My first inclination is to shoot fall colors on overcast days for the above reasons, however, if I end up working in direct sunlight, I often then turn my attention to the reflection of sunlit autumn colors in water. This tendency has evolved to become, in part, my style. How does light influence your style? Linhof Techna and Schneider 210mm lens, f/32, 1 sec. (general metering) Fuji 100

Page 44 & Cover AUTUMN AFTERNOON, CASCADE MTS., WA.
I photographed this design of autumn foilage alongside the road of a mountain pass. The overcast light is accentuating the rich colors and highlighting the great amount of detail in the trees and bushes. I used an 80-200mm zoom lens to select this design out of the larger scene and stopped down to f/16 to keep all of the forest in focus. There was nothing terribly complicated about getting this image, it was simply a matter of seeing the inherent design in this scene and cropping with the zoom lens a little. 1/4th second, general metering. Velvia

THE EXPERIENCE OF SEEING

I had been observing the downtown Seattle skyline from my car for a while when I decided to get out and look without the distortion of the windshield. It was an unspectacular grey day and there was nothing really visually interesting about the rows of brick, steel, and glass buildings. For some reason, however, I couldn't seem to stop looking at the skyline, when a very strange sensation came over me. It is difficult to describe, but in essence I began to perceive the spatial distance between myself and the buildings downtown as rapidly diminishing. In an instant, the buildings and I were no longer separate: we were one and the same. I remember thinking, as I was being held in this momentary reality, how ironic it was that, not being particularly fond of the downtown, I found myself connected to it in a most intimate and profound way.

The experience lasted about ten seconds, then faded and disappeared. I sat and thought about it for a while and ultimately decided that what I had experienced was not really mystic or religious in origin, it was simply a sudden and dramatic shift in cognitive perception. I am not sure why it happened, but it has been an important influence on my sense of awareness and visual perception of the landscape. I believe that our perceptions about the world arise from our experiences and attitudes. Our interpretation and expression of our experiences largely define who we are, particularly through our artistic work.

THE ART OF SEEING, THE ART OF BEING

Currently there is a movement of thought in visual art, championed by painter Fredrick Franck and photographer Freeman Patterson, among others, that is termed, the art of seeing. It is a way of perceiving, imagining, and creating that engages the total self. It is an approach to visual expression that emancipates the artist from common thinking and encourages a journey of self-discovery and a conscious contemplation of our evolving relationship to the subject . The concept of the art of seeing is a most fundamental aspect of landscape photography.

Recognizing the familiar things in our lives is important for our survival. But that process can also limit our ability to see because it can create a distant and passive relationship to everything that isn't of immediate concern. Breaking out of that mode of seeing and relating requires a sustained effort to expand our awareness and entertain new ideas and perceptions of the world around us. For the photographer, or any visual artist, I think it begins by looking at the world anew, with fresh eyes and the delight of a child.

The subject matter that attracts us, and the way in which we respond to and photograph it, says a great deal about us. Improving and refining our ability to encounter, select, and photograph the landscape with expression, results from a consistent effort to not just look, but to really see. Looking and observing are objective. To really see is to respond, interpret, and express, for this is the

process of artistic expression. Real seeing means encountering the landscape with our whole being, our complete, conscious, focused attention. It means forgetting about what new car we're getting, or what color to paint the house. It means being fully present and fully engaged with where we are and what we see.

From my experience there is another relevant notion that I call, the art of being , that is, being a part of the landscape instead of merely a visitor to it. It is closely related to seeing, but I think that it leads the photographer to ever deeper considerations of his relationship to the landscape. Being a part of the landscape means encountering it with your emotions and all of your physical and intuitive senses. By doing so, we not only see the process of life unfolding before us, but also we begin to realize more fully our place in the uninterrupted continuum of life.

In the most practical sense, the art of being means simply to be in tune, or in touch, with your environment. When we leave home and visit another city, for instance, it may be unfamiliar to us. We don't know the people, where the streets lead, what happens or when. But where we live we probably know those things. We have a feel for our town, or a sense of the pulse of our city.

Being in the landscape means we are feeling, listening, smelling, tasting, seeing and sensing the life and conditions around us. What do we feel while standing at the ocean shore, surrounded sights, smells, and sounds. How do we respond to these sensory experiences and what do they tell us about the landscape? For the photographer, quiet contemplation forms a keen awareness that translates into good, expressive images. A good example is found in the description of the image on page 99. A critical expressive element in this image is the windblown sway of the willow tree. My awareness of sudden gusting winds in the area induced me to wait until one came along, creating movement in the branches of the willow. You can probably recall examples like that from some of your experiences.

The art of being is also an understanding and anticipation, like knowing a friend. I have a favorite river in the North Cascades of Washington State that I return to throughout the seasons. From each succeeding experience on the river, I gain a greater sense of the visual flow of life there over time. I know the opal hued granite rocks breaking the stream of water at each bend. I know the falls and drops of the river as it surges past the mossy stumps of the old growth forest hugging its shore. I feel the mist rising along the soaring granite cliffs as the river carves its way through the canyon. But each encounter also brings the pleasure of seeing what I have not seen, for each day presents new light, a different flow of the water, and the uncovering of those things I missed before. Returning to the same location throughout the year can offer many photographic opportunities. It can also teach us much about the life and character of that landscape, and if we pay careful attention, it will be reflected in the expressive quality of our images.

You will have your own ideas, sensations, and experiences in relation with nature. How you perceive it or what you may call it is not important. Becoming more aware of that relationship not only helps improve your images of the landscape, but also increases the chance that your images will be a reflection of you. It is from this process of realization that creativity and expression emerge, and all other considerations in photography follow.

EXPRESSION, VISUAL DESIGN, AND THE ART OF SEEING

The expressive qualities of an image derive from the photographer's ability to abstract, to select parts from the whole. The process of abstraction is seeing the basic form of a scene and recognizing the elements that comprise it. Good visual design can be developed by learning how to abstract from subject matter the important visual components of line, color, texture, pattern, and form. While the art of seeing involves the recognition and identification of things we see, such as a pine tree, ripples on water, or the petal of a flower, it is, more importantly, the ability to see their textures, lines, forms, patterns, and colors, not only as things in themselves, but also as the basic elements of visual design and composition. Expression is the primary content of vision and the photographer uses these elements contained in the subject matter to convey that expression.

These are the components of visual design or composition, but the energy that gives life to expression is visual tension. Expression is based on tension. It could be said that all physical objects possess tension and we perceive the tension between them when we look at an image. The relative size and placement of lines, forms, textures, patterns and colors interact to create visual tension. The photographer must use the balancing properties of order and stability to effectively control and direct the expressive forces of tension.

We can control tension by the way we organize and balance objects, forms, textures, lines, patterns and colors in the image. Tension may not only be conveyed through visual design, but also through thematic content such as rising and falling, approach and withdrawal, weakness and strength, harmony and discord, etc., as it is part of our lives and occurs in the events of nature.

Lines and color (which will be discussed in the next chapter) have great expressive power and are very important in visual design. Lines have position (horizontal, vertical, and oblique), length, and direction (they can move our eyes and attention through the picture space). The careful use of lines can bring both movement and simplicity to compositions. Few lines in an image can make it simple, and many lines are expressive when they work in unity. Horizontal lines imply stability and a sense of calm. Vertical lines can convey strength or rigidity. Oblique lines are perhaps most expressive because they bring movement and activity to a composition. Curved lines are not as strong as

straight lines but are important to visual design because they can slow the viewer down by leading them more indirectly through the picture space. Images with great detail or subtlety benefit from the presence of curved lines because they induce the viewer to go slower, increasing the likelihood that these elements will be seen and appreciated.

When beginning to compose an image we are usually faced with the consideration of where to place the main subject of focus, also known as the center of interest. A helpful concept for this is called the rule of thirds. Simply put, if you divide the image space into thirds both horizontally and vertically, you have an area divided into nine boxes. By placing the center of interest on or near the intersecting lines you have moved it away from the static center of the image space. These locations allow you to work with the elements of visual design to create tension and movement in the composition. This is not a fast rule, but a useful place from which start.

In landscape photography, because the photographer is presented with visual elements that already exist, he works with two kinds of design: the design he observes and the design he creates by abstraction and selection. When we find subject matter and begin to engage in the process of creating the image, we must first consider what the subject matter expresses (theme, subject, emotion, etc.). Then we must determine how that expression was achieved by means of the colors, lines, forms, patterns, and textures inherent in it. Finally, we must understand how we respond to it. Perhaps the quiet, placid lake expresses tranquillity and restfulness by its subdued colors and the long horizontal lines of the far shore and the undulating bands of stratus clouds reflected in the water. When we have answered these questions we can proceed to use and organize the elements of visual design to clearly express the subject and how we feel about it. The photographer's challenge is the creative and appropriate use of visual design such that the subject and theme are clearly and effectively expressed. The subject matter we choose and the way in which we express it through visual design and techniques we employ (time exposures, telephoto lenses, extension tubes, etc.) is also an expression of ourselves. When our images begin to portray a consistent and discernible mode of expression, we have developed our own unique photographic style.

I believe that the best way to learn and develop as a photographer is through practice and experience. The ideas and concepts discussed here may not be fully realized until you begin to see them appear in your photographic images. At that point, understanding and applying them in a conscious way begins the real process of developing and refining your creative and photographic abilities. The concepts and application of visual design are vital to clear and effective photographic expression. With practice, visual design can become a natural and integrated part of your seeing.

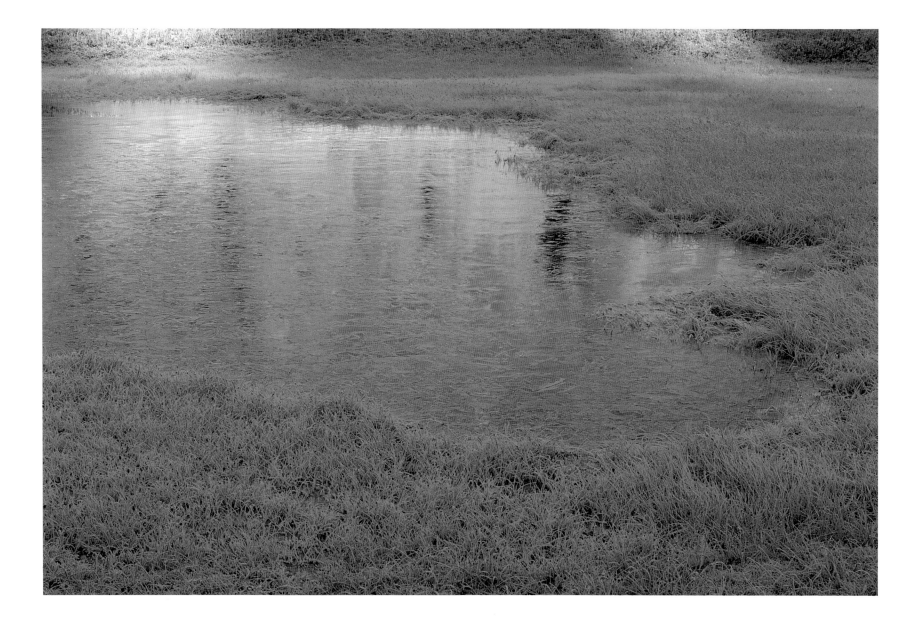

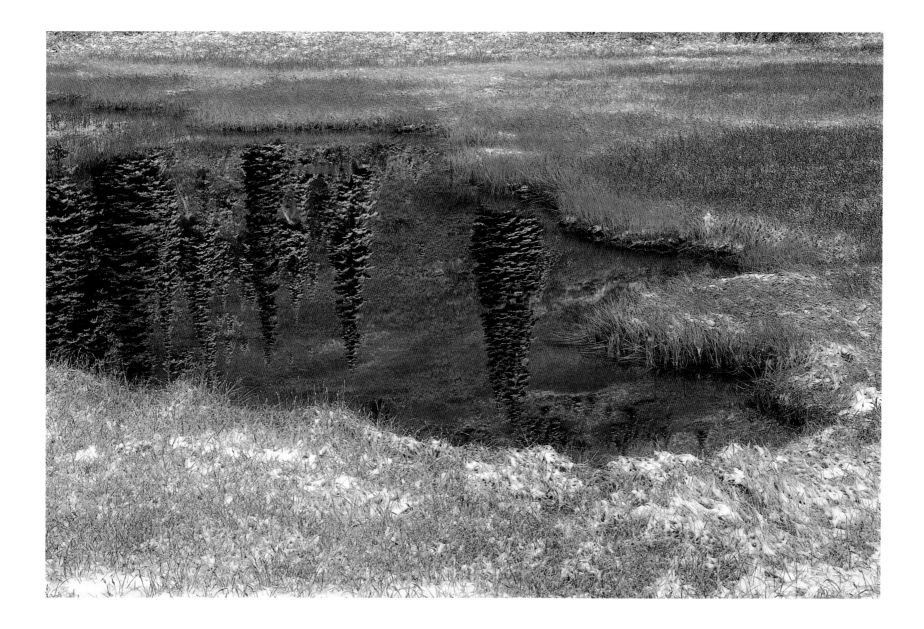

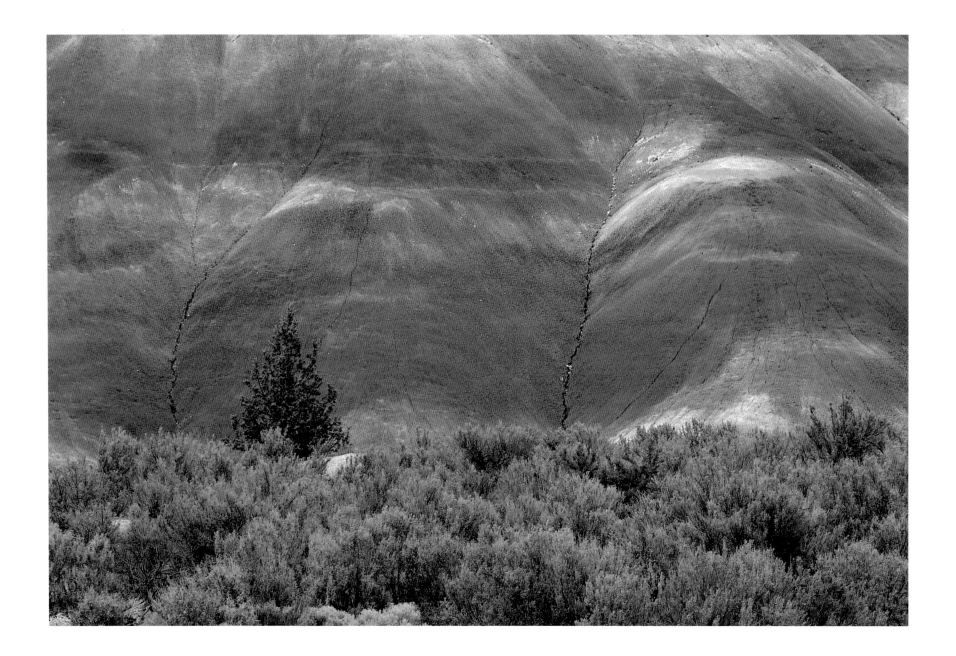

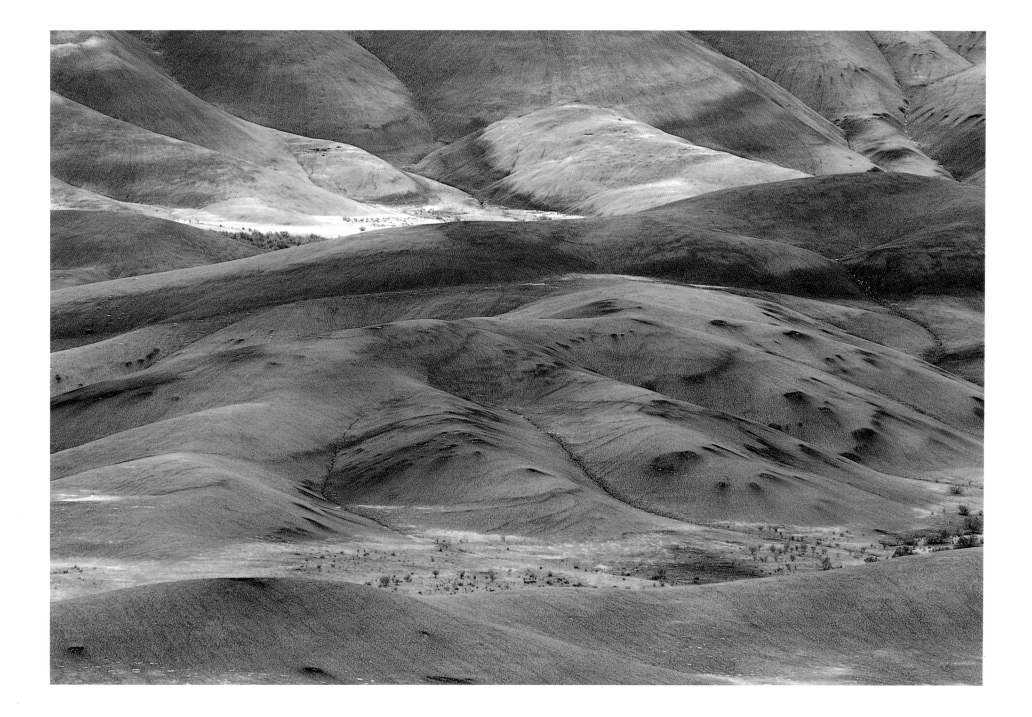

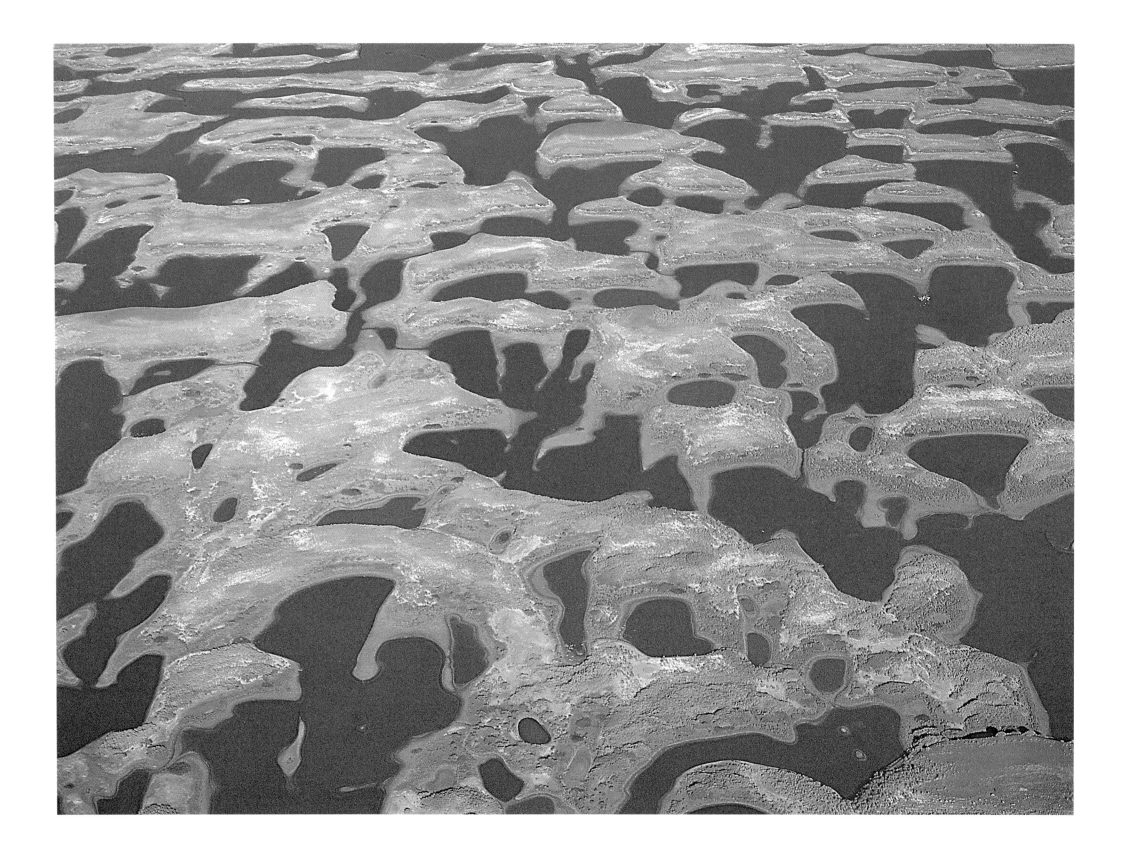

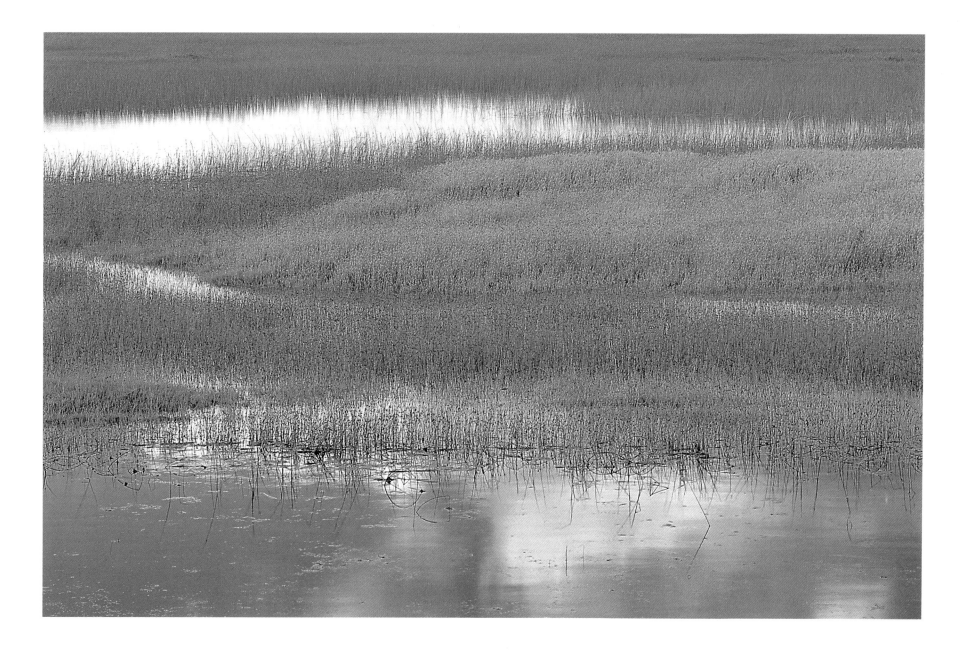

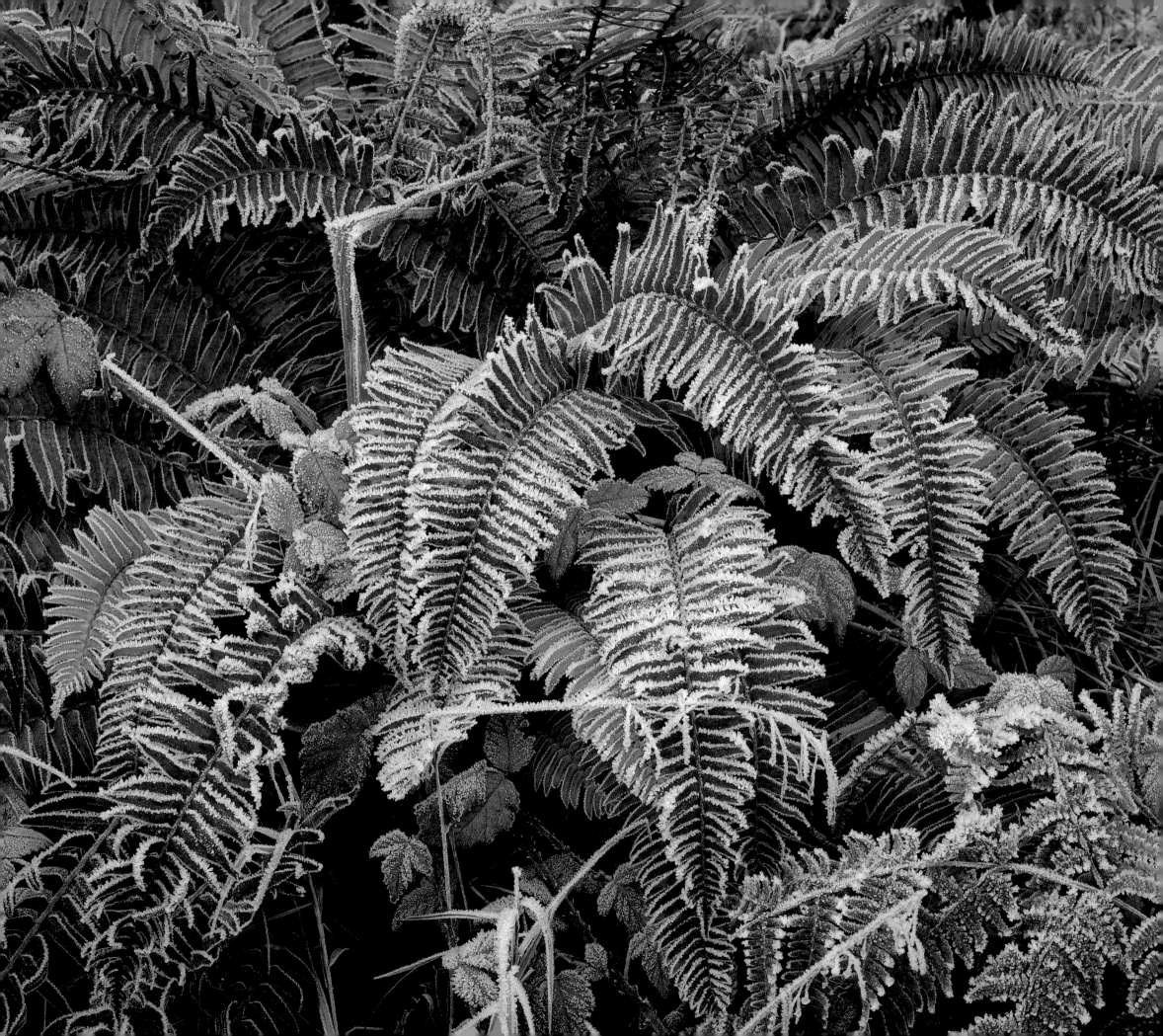

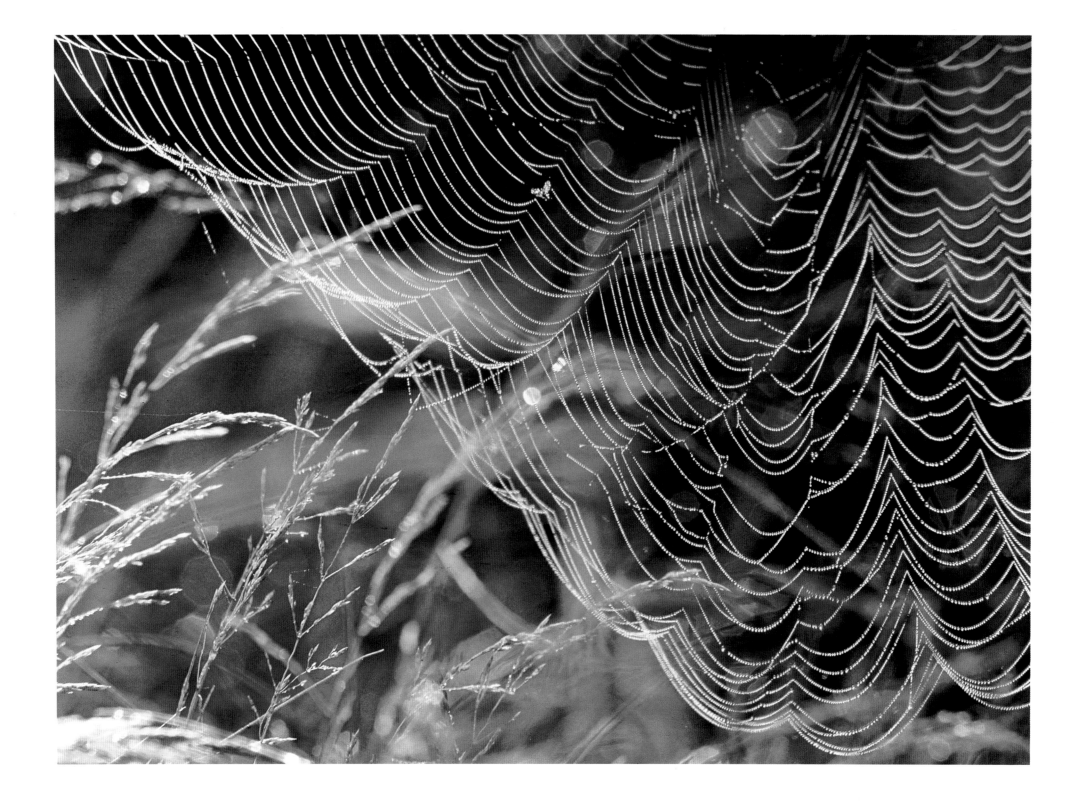

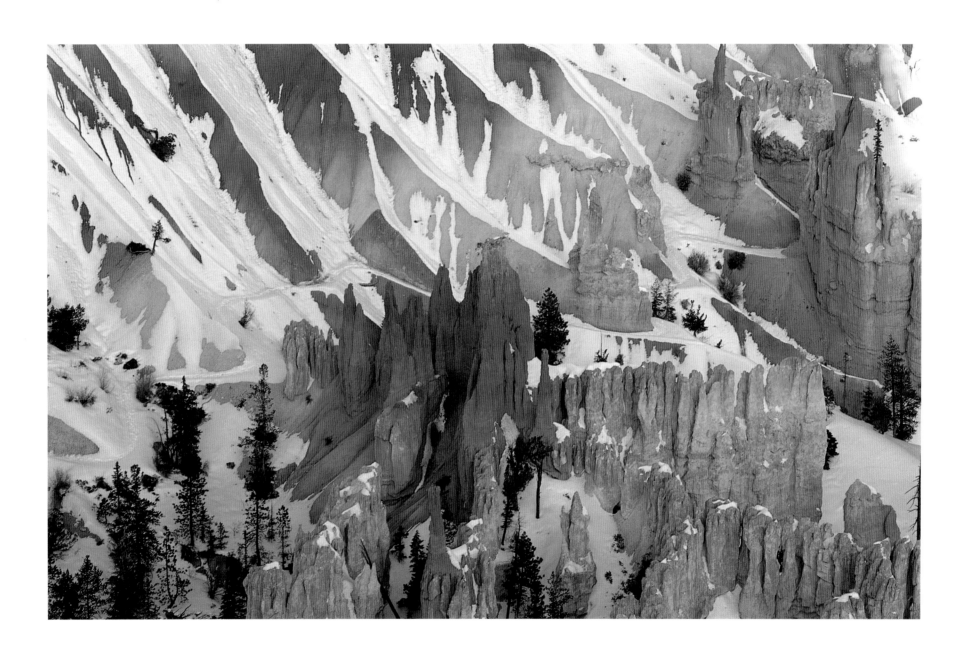

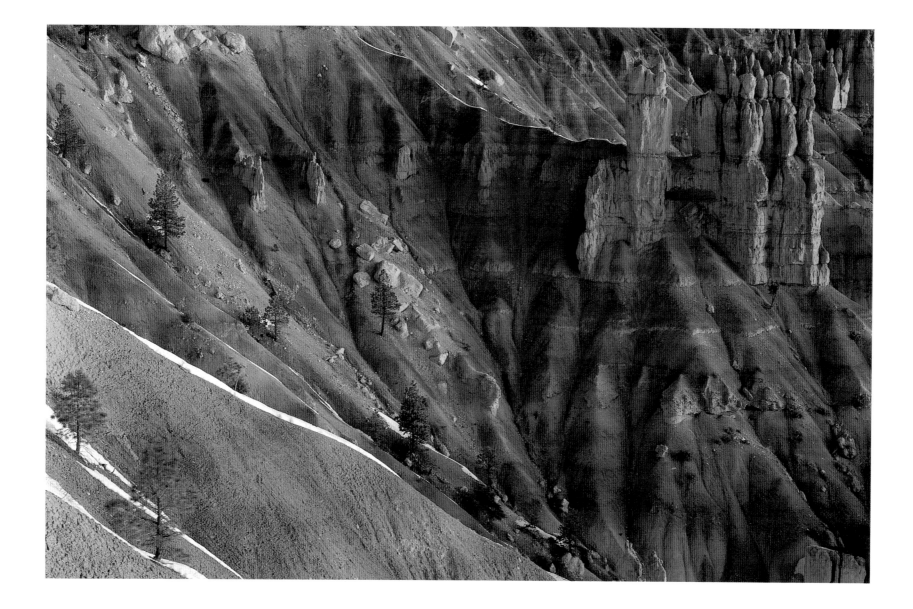

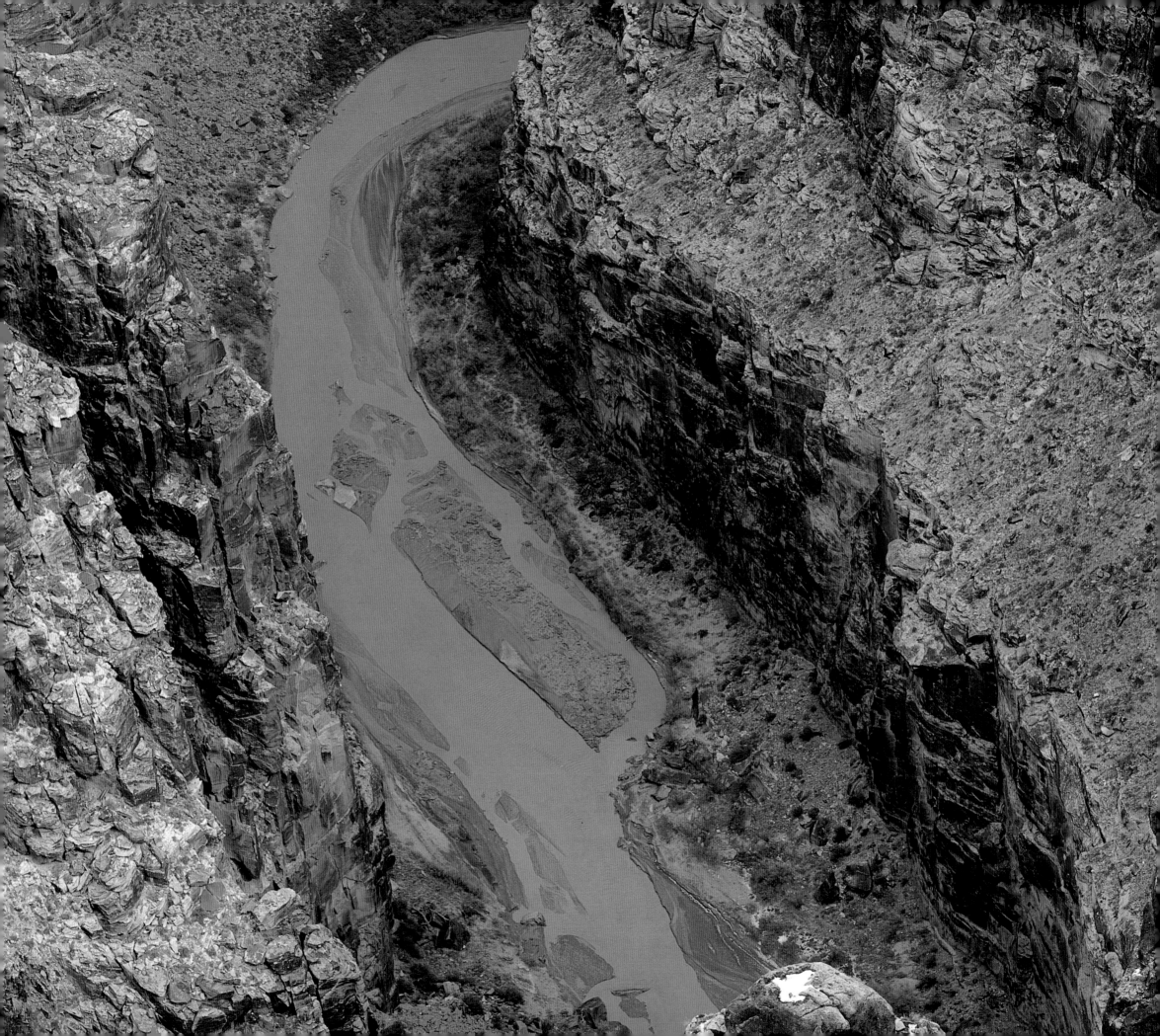

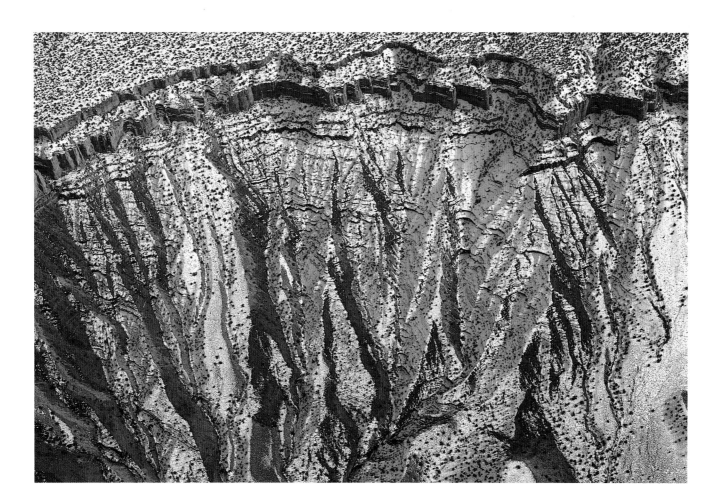

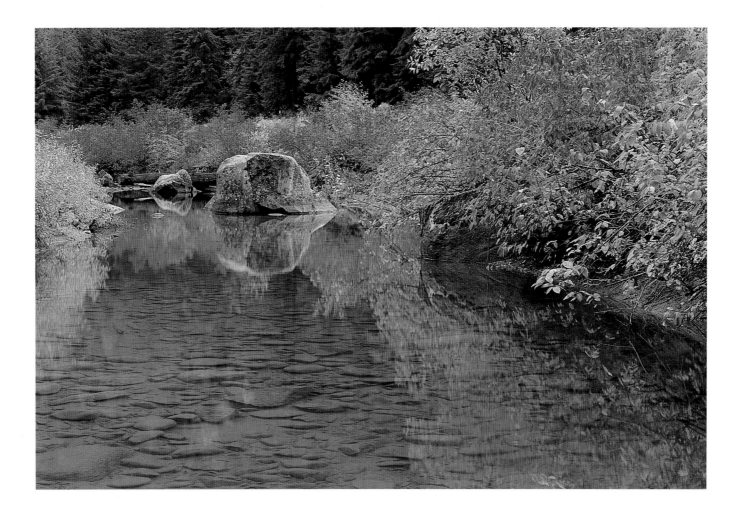

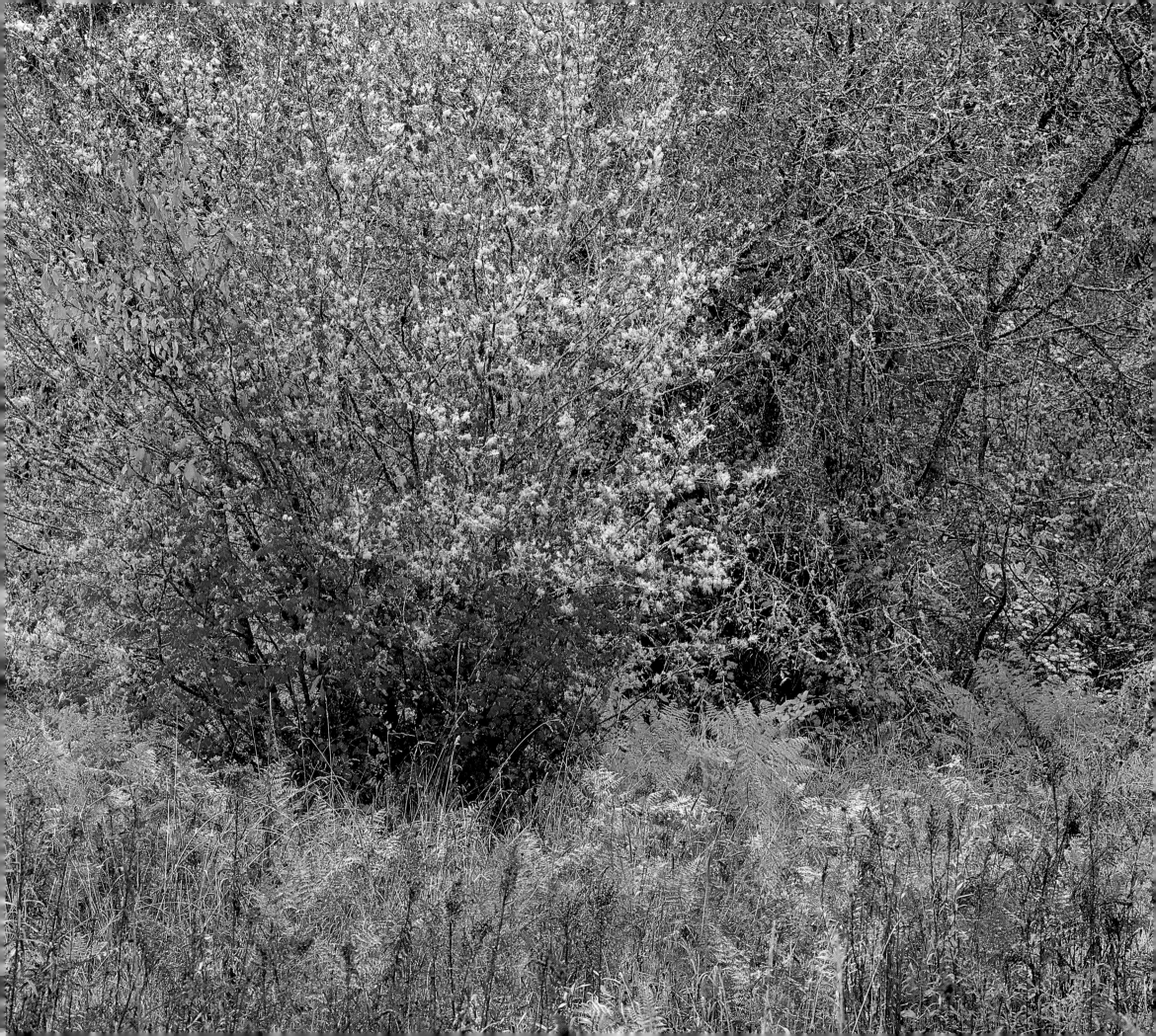

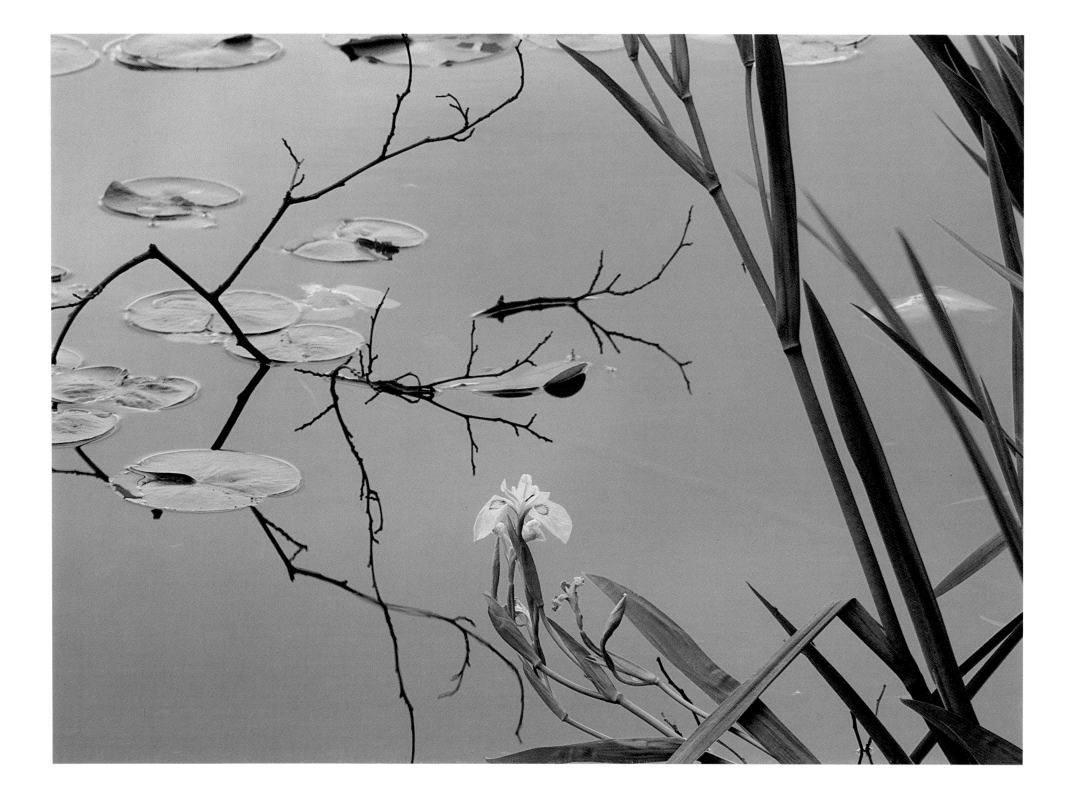

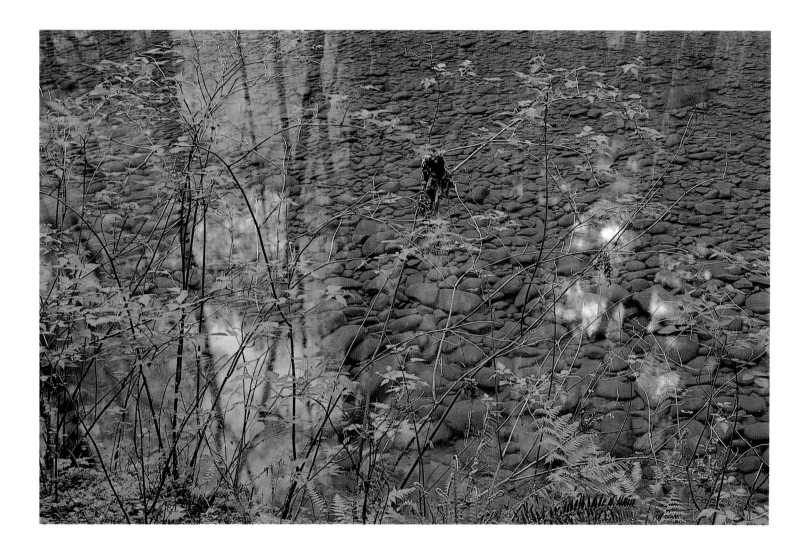

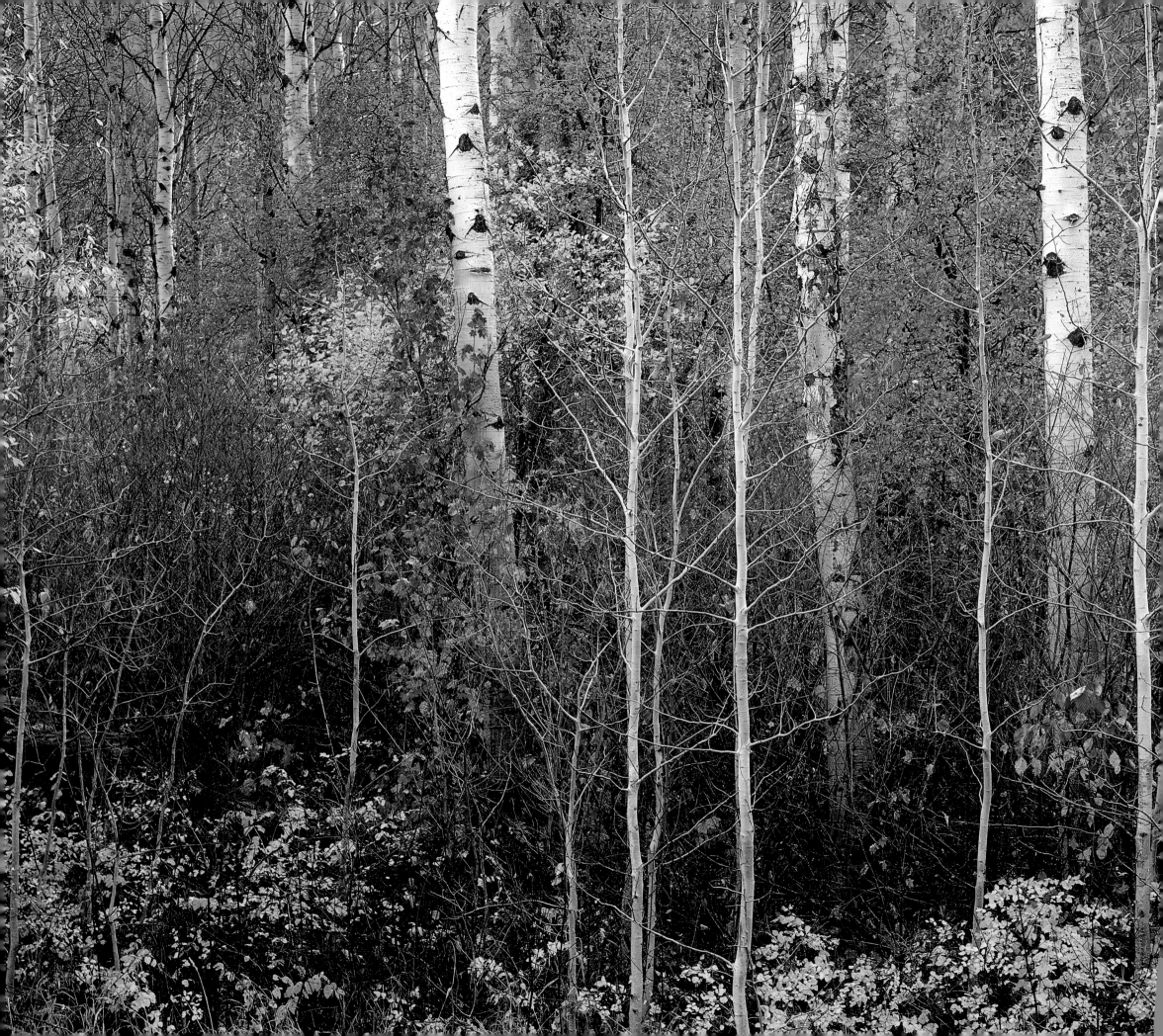

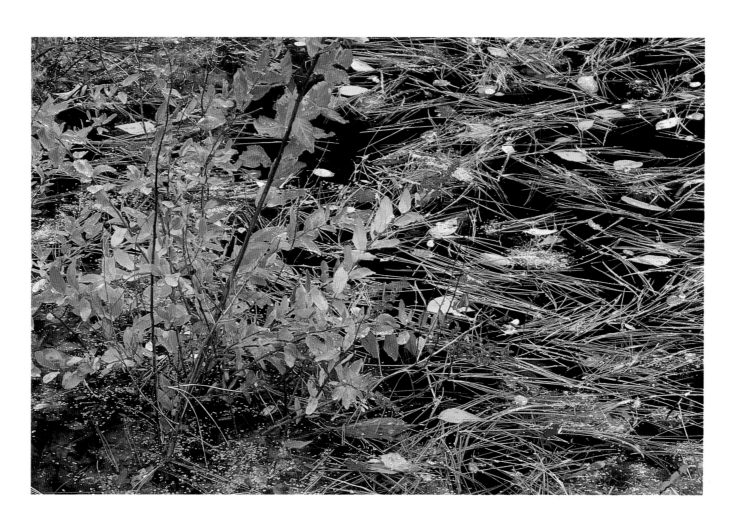

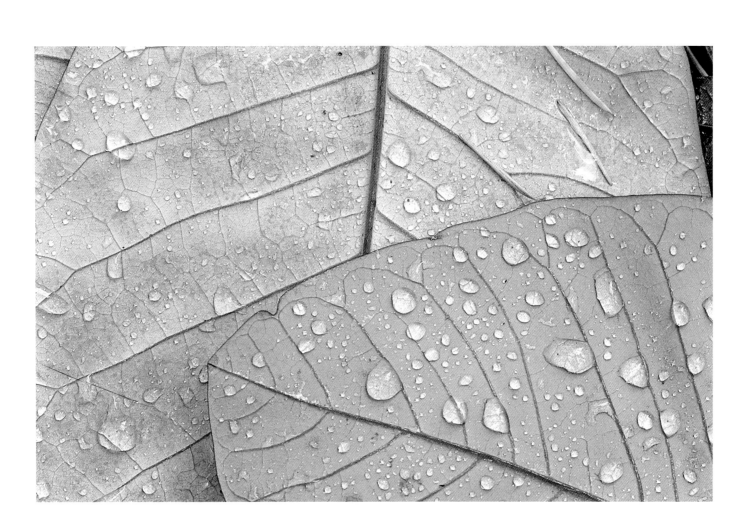

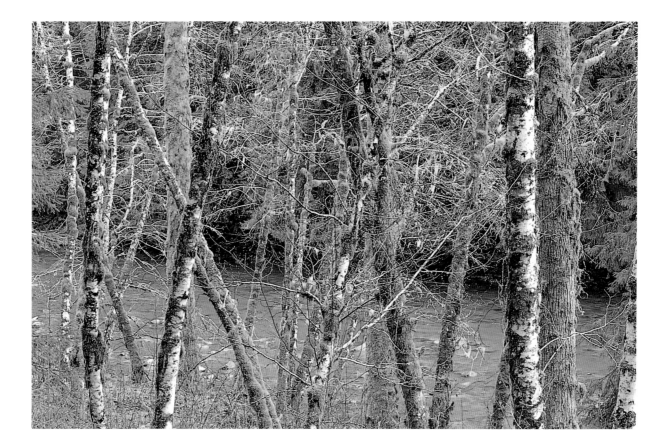

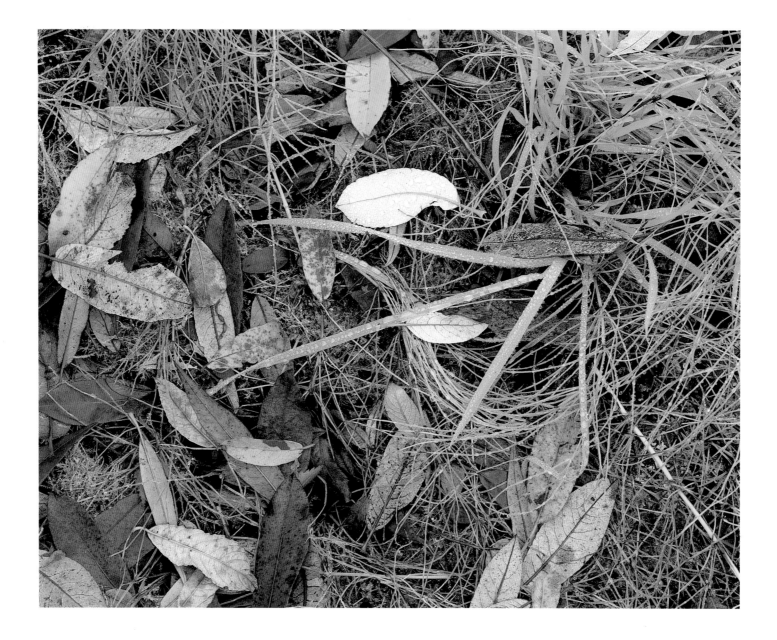

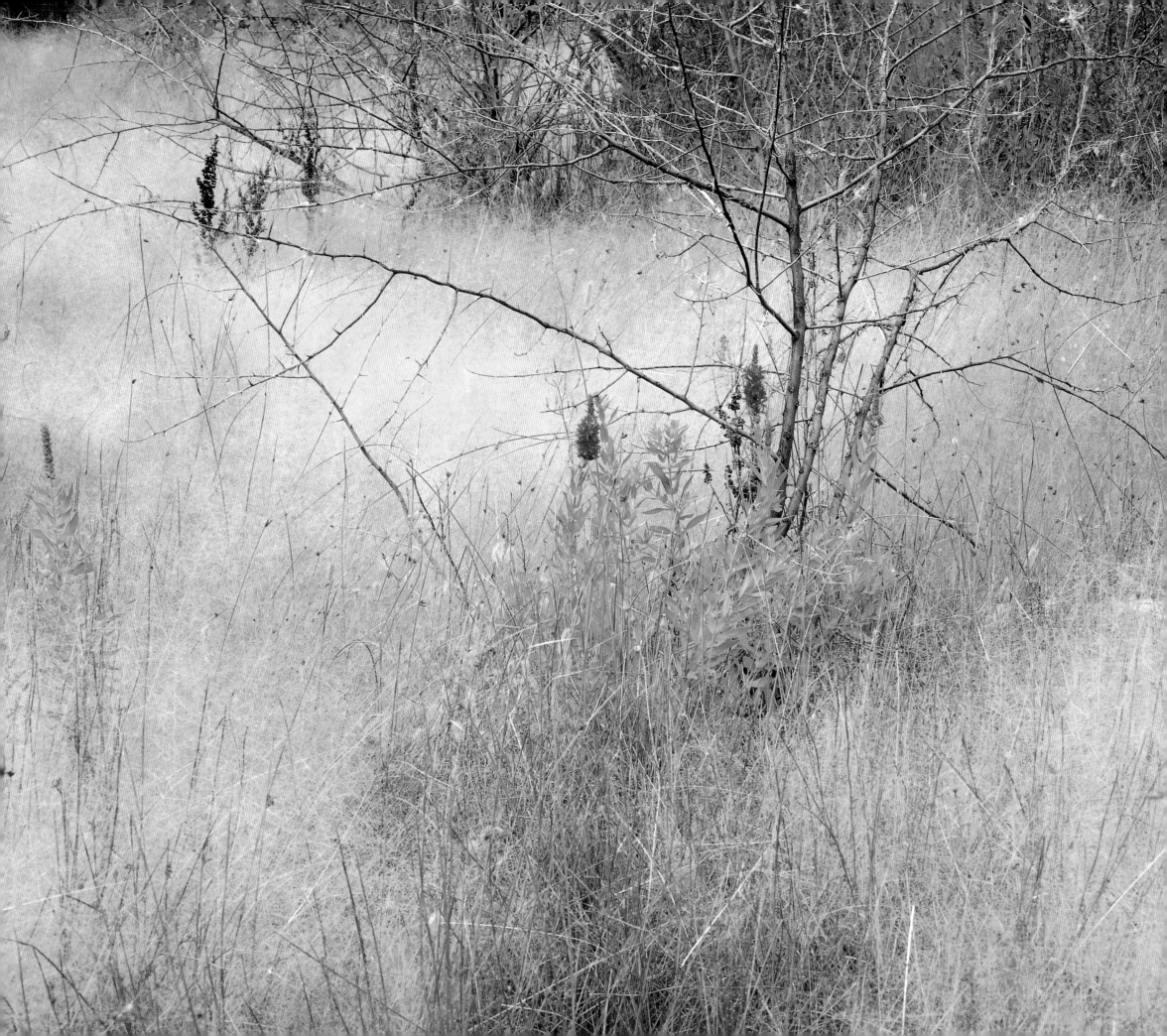

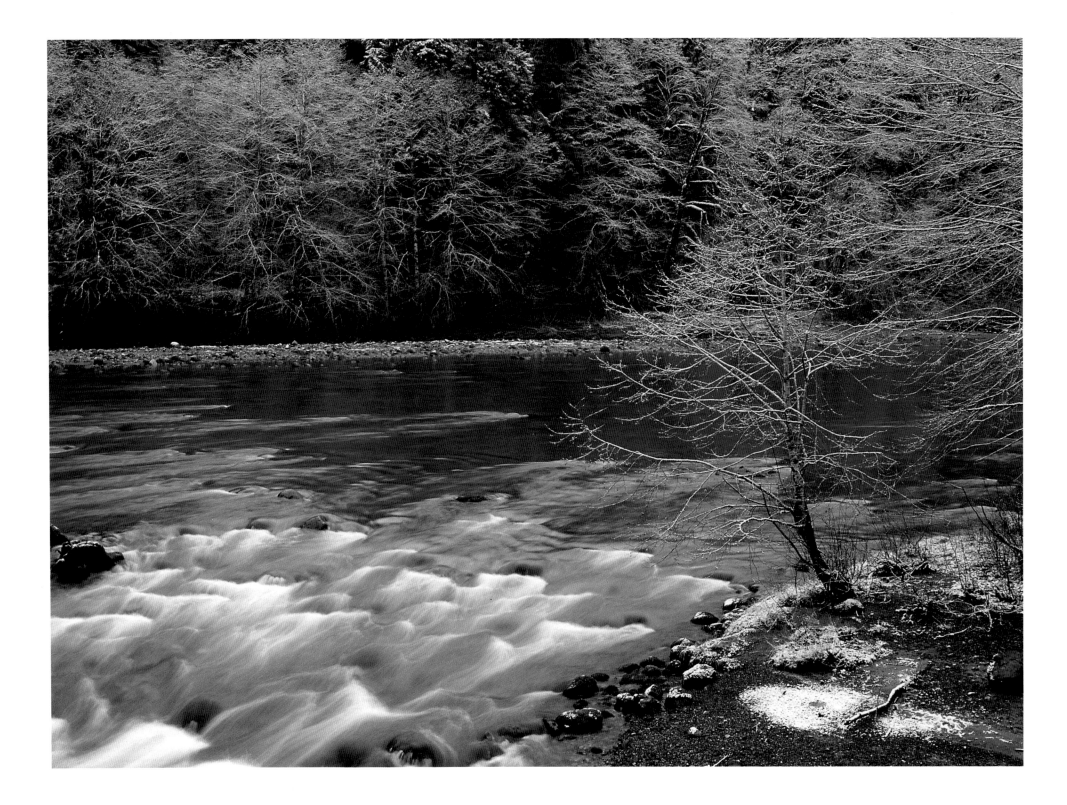

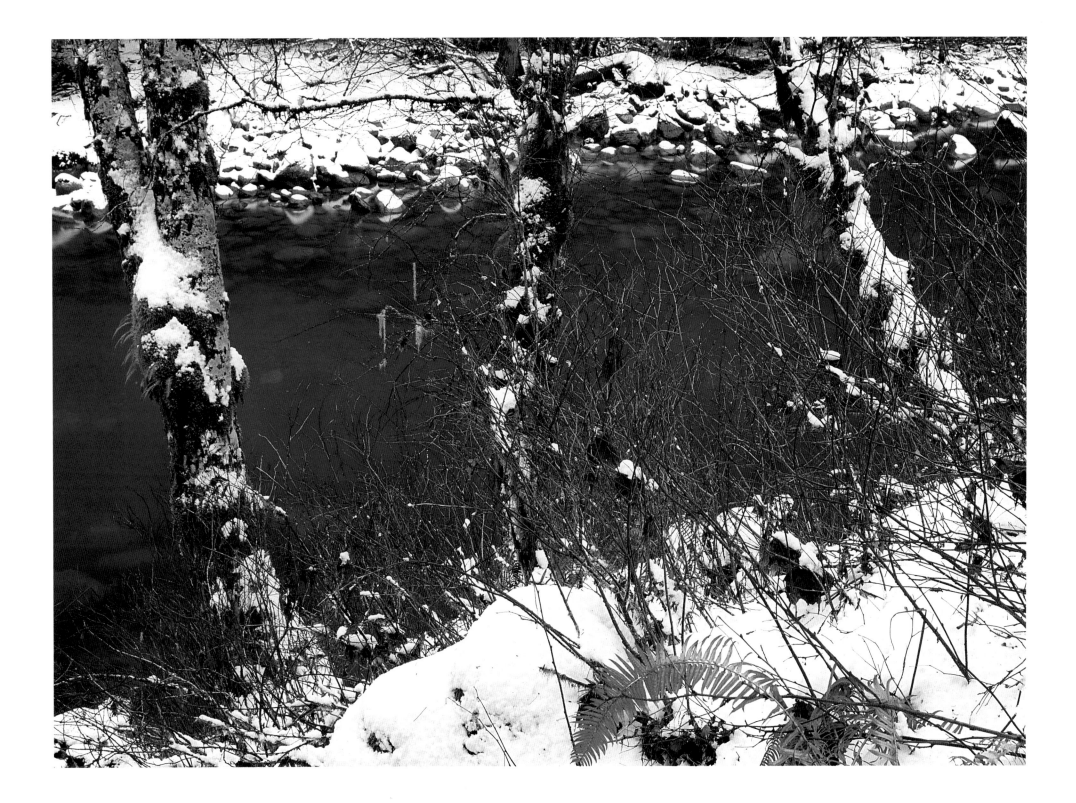

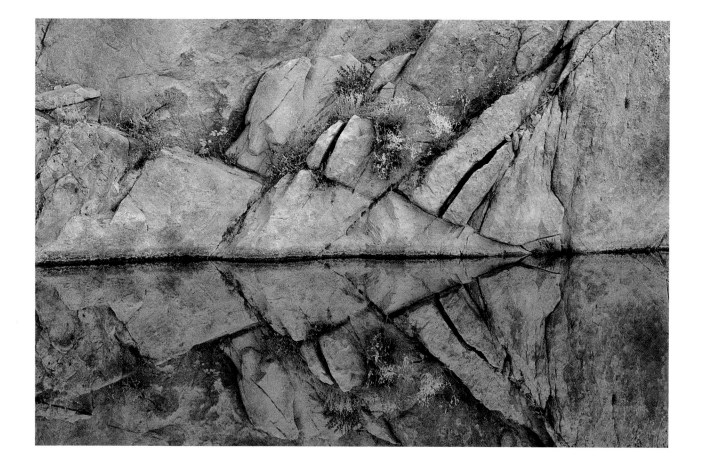

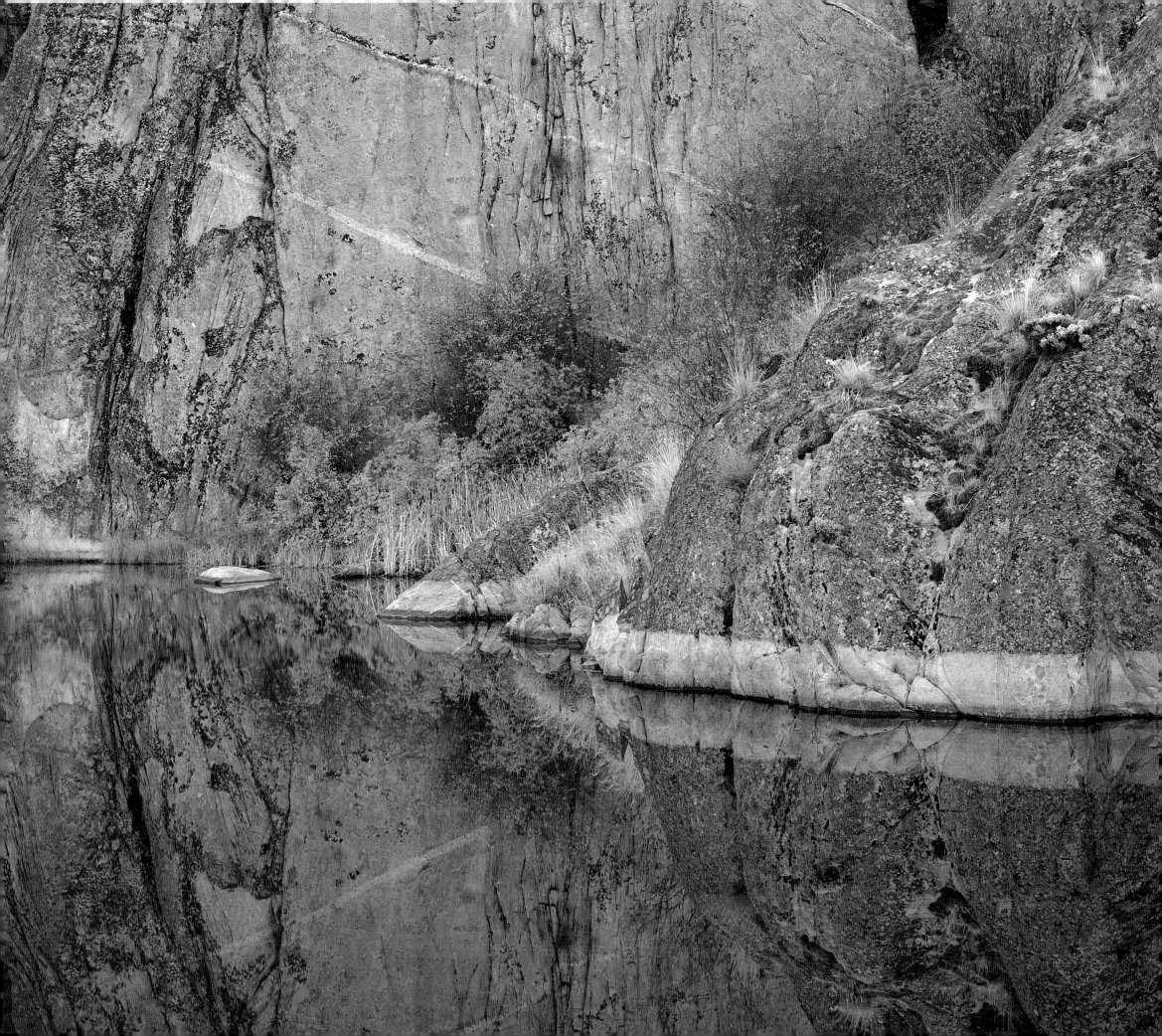

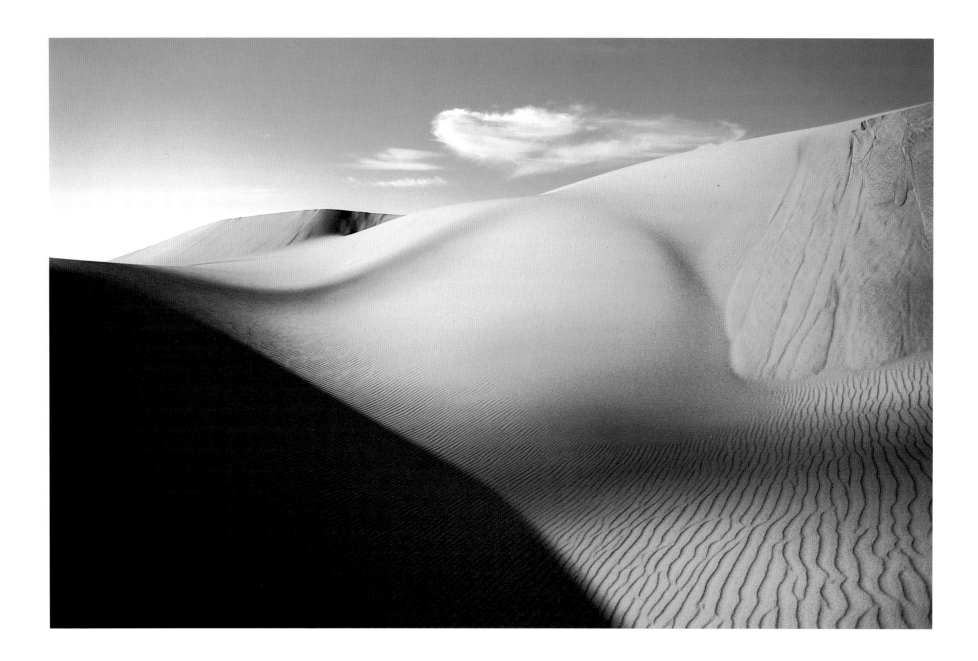

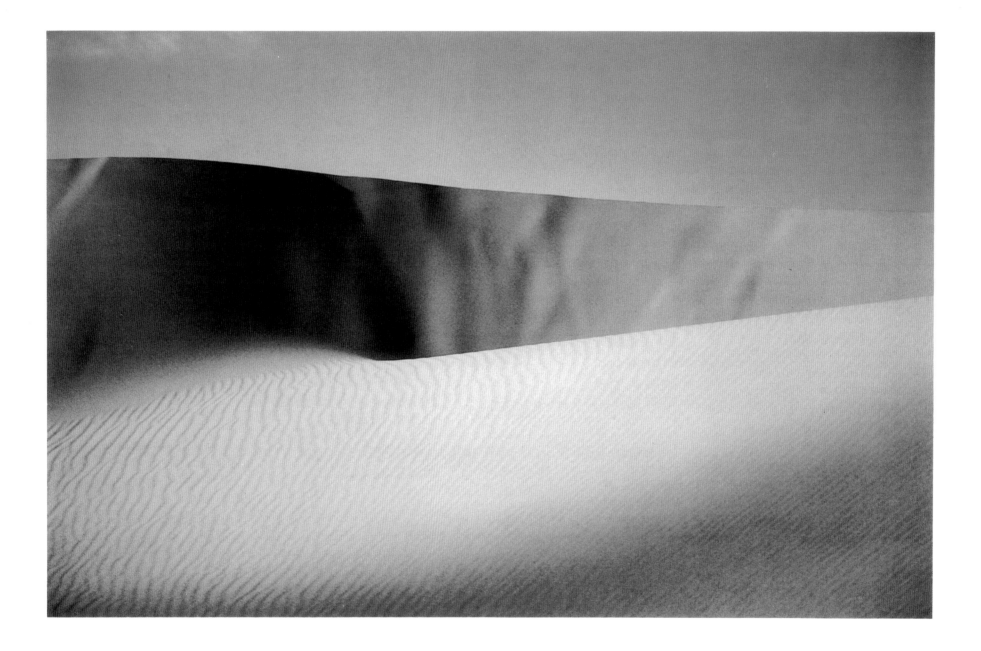

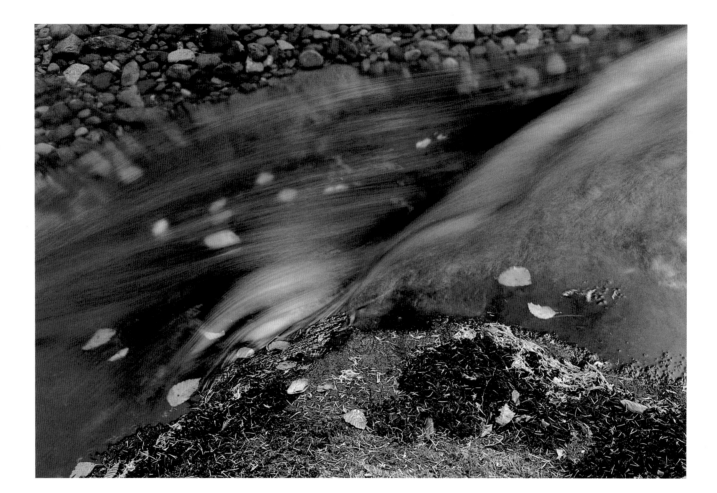

Page 49 AFTERNOON, EARLY SPRING, ELWA RIVER, WA.

I photographed this from the edge of the winding dirt road along the river. It was running high and fast from the spring runoff of the Olympic Mountains. The immediate visual attraction was the contrast and interplay of hues in the emerging leaves, the river, and the tree trunks. I moved back and forth along the road looking for the right combination of the three elements. I chose this place because the non-vertical positioning of the trees creates movement in the composition, keeping the image from being static. I used a Pentax 67 with a 135mm macro lens stopped all the way down to f/32 for maximum depth of field. Exposure of 1 second was calculated from the treetrunks in the right foreground. Velvia

Page 50 EARLY AUTUMN MORNING, MT. RAINIER, WA.

This image and the one following are of the same pond, taken on the same day in October in succeeding years. They demonstrate very clearly how light, color, and weather conditions can render the expression of subject matter so differently. This image was shot in shadow on a clear morning. By not using a warming filter, the uv rays in the shaded area appear as blue on film. I used that situation as a compositional element as the visual tension between the blue grass and colors in the pond give the image visual impact. 80-200mm zoom lens, f/16, 1/4th sec. (metered from blue ice) Velvia

Page 51 EARLY AUTUMN MORNING, MT. RAINIER, WA.

This pond is one I return to every year, and these images clearly show the photographic value of returning to a familiar location. In this image, it had snowed lightly the night before and it is beginning to melt as the clouds are giving way to sunshine (refer to related picture on page). The light is indirect, showing great detail, presenting different hues, and hence possessing very different emotional and expressive content. The clear reflections in the water and the curving shoreline provide the main compositional design, and in leading the eye around through the picture, make the viewer more aware of the intricate detail and subtle colors present.

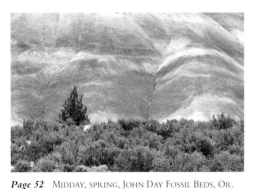

Page 52 MIDDAY, SPRING, JOHN DAY FOSSIL BEDS, OR.

I hope this picture clearly refutes the notion that midday is a poor time to take pictures. It is not the time of day that matters, it is the quality and nature of light that counts. This image and the following one are both taken in the John Day Fossil Beds. I have selected and abstracted a section of the area where the coarsely textured, mineral rich hills meet the scrubby sagebrush of the flat land. The visual contrast of the colors and textures create the tension that makes it come alive. The lone tree provides a center of interest that helps unify the composition, and a visual resting place for the eye as it wanders through the image.

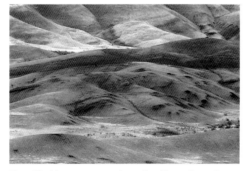

Page 53 MIDDAY, SPRING, JOHN DAY FOSSIL BEDS, OR.

I shot this from the top of the fossil beds and combined with the previous image gives one a greater sense of the very expressive quality of this unique landscape. In a thematic way, the rolling folds and brushes of color in the hills made me see them as waves. The mostly indirect light brings out the variations of hues and textures. The spotlight of sun in the distance is a compositional element as it has become a rather subdued, understated center of interest by slowly drawing the viewer to itself. 80-200mm zoom lens, f/16, 1/4 sec. (metered from gray hills) K25

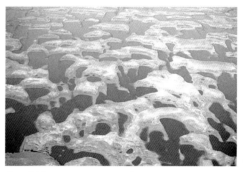

Page 54 SUMMER AFTERNOON, POTHOLES RESERVOIR, WA.

When is an animal the landscape and when the landscape an animal? I chartered a plane and flew over this man-made phenomenon of water and little desert islands to experience this landscape from a dramatically different perspective. Part of the fun of abstracting subject matter and composing the image is letting our imagination take over and run free. I felt most fortunate indeed to witness a rare sighting of a shy and elusive herd of yellow-green flecks gliding silently through a beautiful, cobalt colored sky, looking for a place to light. 80-200mm zoom lens, f/8, 125th/sec. (general metering) Velvia pushed to 100 ASA

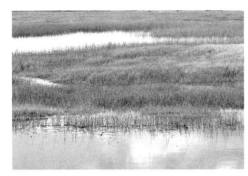

Page 55 SPRING AFTERNOON, ARID WETLAND, EASTERN WA.

Textures are often created in an image by the use of side and backlighting. The appearance of texture in an image can also be created by working with subject matter with great complexity and detail. This wetland is intermittently lit by direct and indirect light. I waited for the sun to go behind a cloud to remove the strong light and resulting shadows. This not only brings out the detail, but also changes the tonal variations of the colors which are the main visual design element. In this instance, like so many, the careful use of transient light is the one element that fundamentally determines the nature and use of all others in the image. 80-200mm zoom lens, f/16, 1/30th sec. (metering from brown grass) Velvia

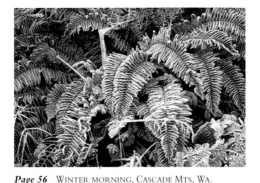

Page 56 WINTER MORNING, CASCADE MTS, WA.

Oftentimes getting a good image requires nothing more than paying attention, seeing the details of the things near us, and simply letting the subject speak for itself. I noticed this patch of ice-etched swordferns along a mountain road as I went speeding by. The cold fog shrouding the forest sprinkled small ice crystals on all the low-lying vegetation it touched. The soft, even light renders the exquisite detail and rich color most effectively. Composing the image required nothing more than giving the overall design room to breath. Pentax 67, 135mm macro lens, f/32, 1sec. (general metering) Velvia

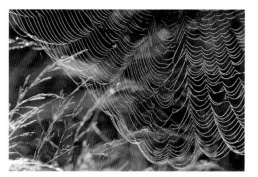

Page 57 AUTUMN MORNING, CASCADE MTS., WA.

The one aspect of nature that strikes me most is the unity and integration of all living systems. Behaviors and adaptive strategies, though they seem to most benefit a particular species, when viewed from a larger perspective, reveal the symbiotic relationship to the whole. It seems that living systems exist in a state of grace, operating quite naturally in a way that benefits the web of life. This image of the spiderweb made me think how a spider creates an indescribable elegance and beauty just in the process of living. As humans, what do we create in the course of our lives? 80-200mm zoom lens with extension tube, f/8, 1/30 sec. (general metering) Velvia

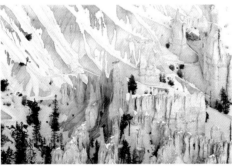

Page 58 WINTER MORNING, BRYCE CANYON, UT.

I shot this image in the shadows of the canyon just after sunrise on a clear morning. The next picture was also shot in the canyon just after sunrise, although in direct light. In this picture, the layer of snow draping the canyon wall is a main design element. In composing the image I abstracted a section of the wall that included the form of vertical, bare spires as a counterbalance to the downward push of oblique lines created by the snow and ridges. 80-200mm zoom lens, f/11, 1/15th sec. (general metering) Velvia

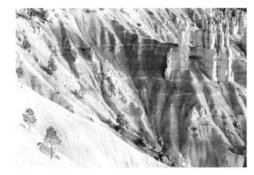

Page 59 WINTER MORNING, BRYCE CANYON, UT.

This image shot in direct light expresses another mood and character of the canyon. The patterns of oblique lines formed by the ridges and folds of the canyon walls and accentuated by the few caps of snow, are the active elements of design here. Unlike the other image, however, the variations of tones and hues in combination are another expressive force at work here. The emotional response to color varies between people, I respond very strongly to earthtones which is why I took this picture. 80-200mm zoom lens, f/22, 1/2 sec. (general metering) Velvia

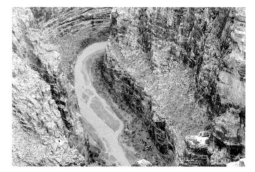

Page 60 WINTER MIDDAY, LITTLE COLORADO RIVER, AZ.

This picture and the one following have the same theme, the geologic force and process of water. I shot this perched on the edge of a rock outcropping which gives it its dramatic perspective. The expressive content in this image works in several ways. First and most obvious is the sweeping curve of the river cutting through the steep canyon. The curve and hue of the river contrast with the solid vertical cliffs, creating visual tension. Thematic tension is also present from the opposing geologic forces represented by the transmuting power of water and the ageless nature of the terrestrial landscape. Pentax 67, 135mm macro lens, f/22, 1/4th sec. (general metering) Velvia

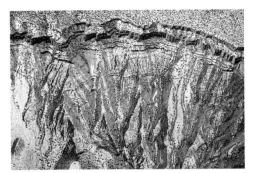

Page 61 WINTER MIDDAY, GRAND CANYON, AZ.

This picture portrays another facet of the role of water in our planet. Seen from an aerial perspective, the eroding powers of water are depicted in an abstract manner. The essential visual design is contained in the patterns of lines formed by the snow and bare earth. I placed the rim of canyon at the top of the image, giving maximum length to the lines in an effort to reinforce the thematic visual depiction of erosion. 24-50mm lens, f/5.6, 125/th sec. (general metering) K25

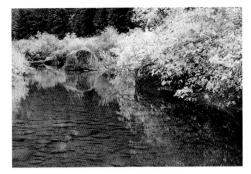

Page 62 AUTUMN MORNING, CASCADE MTS., WA.

Exploring this backwash of the Wenatchee River, I came upon this calm pocket of water reflecting the fall colors. The pattern of rocks under the water were a nice contrast to the texture of the bushes and trees. To get the angle I wanted, I waded out into the water and set up my tripod. The shorelines converging in the distance represent implied oblique lines which create depth by moving our eyes back into the picture, while the rocks in the water provide a counterbalance to this movement. The even light brings out the richness of the colors and makes the submerged rocks visible. 80-200mm zoom lens, f/16, 1/4th sec. (metered from submerged rocks) Velvia

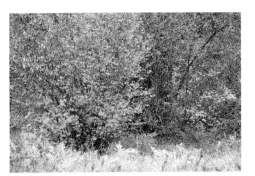

Page 63 AUTUMN AFTERNOON, CASCADE MTS., WA.

In photographs we can accentuate the textural nature of subject matter by side or backlighting. We can also create a type of overall image texture as well. This image of autumn grass and bushes presents an appearance of texture from the complexity and visual interaction of detail, shapes and color variations. I have used a telephoto lens at f/32 (putting everything in sharp focus) not only to abstract the composition from the larger scene, but also to reduce perspective, which compresses the various shapes, colors and lines together, enhancing the sense of texture. Once again, even light makes all the above possible. Pentax 67, 135mm lens, 1 sec. (general metering) Velvia

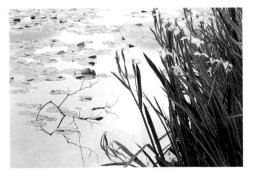

Page 64 SPRING AFTERNOON, SEATTLE, WA.

There is an urban lake near my home whose shoreline is rimmed with lily pads and yellow irises. Every spring I wander around the lake to witness their new bloom. I always stop at a particular spot to photograph because invariably the new growth comes in to form entirely new patterns, shapes, and colors. It is the same place but I see a very different scene. I used an 80-200mm zoom lens to compose this. For some reason I can't explain this composition other than it simply felt right. As we develop our compositional skills, visual design becomes more a natural part of our seeing and feeling, and less of an analytical process. F/11, 1/4th sec. (general metering) Velvia

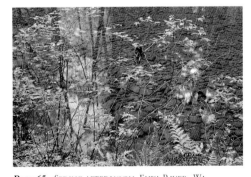

Page 65 SPRING AFTERNOON, ELWA RIVER, WA.

I was walking the bank of this backwash section of the river, marveling at the patterns and shapes of the river rocks, when this foliage interrupted my line of sight. I started to leave because I was looking to find a large boulder sticking out of the water to photograph. I stopped myself in time to notice the nice interplay between the elements in the water (the rocks and reflections of the trees and sky) and shore (the stems and leaves). Sometimes looking for something to shoot can reduce our capacity to really see. Landscape photography should not be an assignment, but a relaxed and open experience of seeing. 24-50mm zoom lens, f/11, 1/8th sec. (metered from rocks) Velvia

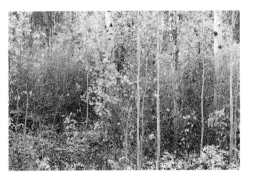

Page 66 AUTUMN AFTERNOON, CASCADE MTS., WA.

The theme of my photographic experience is finding the beauty and art of nature that is close at hand. I shot this image while standing in the middle of the Steven's Pass Highway, dodging the cars barreling down road. This was part of a section the highway that was awash with a brilliant display of colors. I shot this with a Pentax 67 and 135mm lens. To best convey the richness of detail and saturated colors, I stopped down to f/32. The vertical emphasis of the composition is balanced by the curved lines of the branches and the overall expressive quality of the color. 1/2 sec. (general metering) Velvia

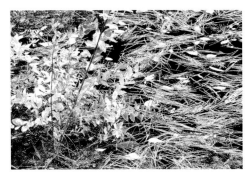

Page 67 AUTUMN MORNING, CASCADE MTS. WA.

 I shot this image in a pond at the bottom of the embankment of the highway not far from the previous image. The dark water was like a black canvas on which the strokes of these pine needles were brushed. I used the single bush as a visual comparison to the design of the needles and leaves on the water. This small pond was a delight to see because it seemed to vibrate with energy. I metered from the bush because the black space in the water would fool the light meter and cause it to overexpose (black absorbs light and the meter compensates by a longer exposure.) 80-200mm zoom lens, f/16, 1/2 sec. Velvia

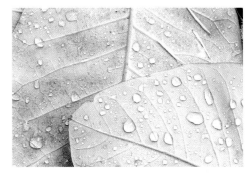

Page 68 AUTUMN AFTERNOON, SEATTLE, WA.

 Sometimes working with visual design to compose an image means less is more. These two leaves, holding water droplets from an autumn rain, possessed an intricate but well ordered design on there own. I simply zoomed in a little with an extension tube on my 80-200mm lens to crop the shot a little and help emphasize the color contrast of the leaves. Visual design and technique should be harmonious with the subject matter. F/16, 1/4th sec. (general metering) Velvia

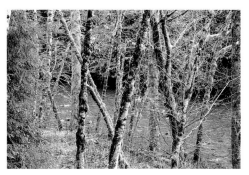

Page 69 AUTUMN AFTERNOON, STILLAGUAMISH RIVER, WA.

 If one believes that nature has a grand design, than perhaps it is for us to find the order in her chaos. Good visual design and abstracting are essential to unifying and bringing structure to apparent disunity. From my vantage point along the road, a thick and tangled network of trees and bushes partially obscured the river and forest behind in the distance. Each of these features in this landscape were beautiful in themselves, but I wanted to create a relative unity of these elements that expressed the unique character of this place. Using an 80-200mm lens at f/22 for the greatest depth of field, I zoomed in, compressing the distance and visually bringing all the elements together in one plane. 1/2 sec. (general metering) Velvia

Page 70 AUTUMN AFTERNOON, SEATTLE, WA.

 I began this outing under the threat of rain although the landscape was completely dry. The autumn colors in this indirect light were rich and saturated and I was happy with the images I was getting. The inevitable happened as the clouds burst and the rain poured, bathing everything in the landscape including me. I hadn't photographed in a while and I was determined to make the most of this trip. My desire was rewarded as the rain not only enriched the colors but studded the ground with the sparkle of water droplets. In photography, as in any endeavor in life, desire and effort are the wings that lift us to the summits of success. Pentax 67, 135 macro lens, f/22, 1 sec. (general metering) Velvia

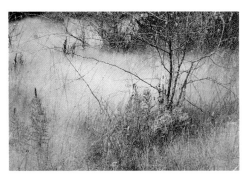

Page 71 ARID WETLAND, EASTERN WA.

 I found this oasis of color on a Summer afternoon in the eastern Washington desert just a few feet from the edge of the road. There is a great amount of detail in this scene so I decided to simplify and bring order to the composition by utilizing this one blooming bush and tree as the main focal point or center of interest. This works here because the multitude of grasses and variations of hues surrounding them help isolate and set the main subject off. Here again the even light is crucial to showing subtle color and all of the detail inherent in the scene. Pentax 67, 135 macro lens, f/22, 1/4th sec. (general metering) Velvia

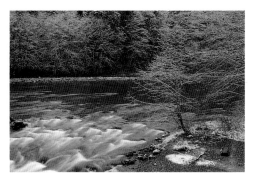

Page 72 WINTER MORNING, SAUK RIVER, WA.

 I shot this from the road in the first morning light after an overnight snowfall. The bare branches of the winter trees came alive with movement and detail from the dusting of snow. The three basic components of design I had to work with were the position and detail of the trees, the shape and color of the river, and the color and form of the waterfall. Composing this became a matter of positioning myself along the road and zooming in a little with my 80-200mm lens to crop out unwanted details. F/16, 1 sec. (metered from gravel bank) Velvia

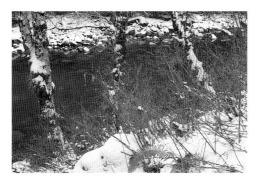

Page 73 WINTER AFTERNOON, STILLAGUAMISH RIVER, WA.

The common perception of winter is often that of a bleak and colorless landscape. My experience is that winter possesses a palette of colors that is entirely unique among the seasons. There tend to be fewer primary colors, and the hues are more subtle by nature, but in fact, are often very lively and expressive. There are not many colors in this scene but the ones present create a dynamic design with detail and strong contrast. With so much snow in the scene, it is easy to underexpose because the reflected light fools your light meter. I accordingly metered from brown stalks. 80-200mm zoom lens, f/22, 1 sec. Velvia

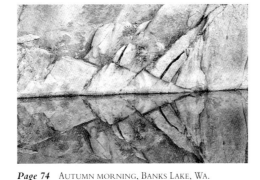

Page 74 AUTUMN MORNING, BANKS LAKE, WA.

This image and the next one were taken from the same area of the lake. I used my 80-200mm zoom lens to "visually wander" around the shoreline looking for designs in the rocks and their reflection. I chose this portion of the rocks because of the colors and the movement of oblique lines in the cracks. I was careful to select an area along the shore that contained variation in color as well as some patches of flowers. The shape and softness of the living plants clinging to the crevices provide a visual and thematic balance to this design of strong lines etched in stone. F/11, 1/4th sec. (metering from rocks) Velvia

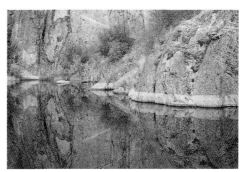

Page 75 AUTUMN MORNING, BANKS LAKE, WA.

This image was taken standing in the same place as the previous picture by simply swiveling the camera on the tripod and following the shoreline to the right about two hundred feet. What interested me was how the design and configuration of the rock walls had changed so much in such a short distance. In this image the lines and surfaces of the rocks are long, sweeping curves and the vegetation nestled in the folds show signs of the emerging autumn. Pentax 67, 135mm macro, f/22, 1/2th sec. (metered from rocks) Velvia

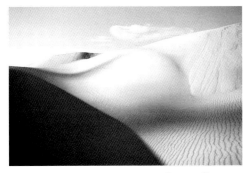

Page 76 LATE SUMMER AFTERNOON, OREGON DUNES.

This picture and the one that follows were taken from the same place about a minute apart. I was standing at the bottom of the dune and the low angle of the afternoon sun was casting dramatic shadows, highlighting the various textures of the drifting sand. I remember marveling how the natural forces of wind, sun, and rain had sculpted these dunes into masterpieces of sensual elegance. It seemed appropriate that I simply render this subject matter true to form. I used a 24-50mm zoom lens for this image and metered my exposure from the upper part of the dune in sunlight. F/22, 1/8th sec. Velvia

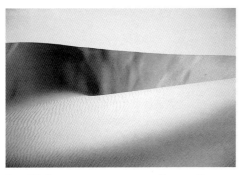

Page 77 LATE SUMMER AFTERNOON, OREGON DUNES.

The strong sidelighting was doing some very interesting things to the texture of the dunes in this shot. I decided to switch to an 80-200mm zoom lens and work with the design a little bit more by zooming in closer and reducing perspective. The absence of clouds and the reduced perspective render this dune an abstract study of of form, color, and texture. Exposure was important to the composition because shadow detail is part of the overall design and as such needed to be maintained. I calculated exposure by metering from the top portion of the dune with the folds in it. This was a good balance between the shadow detail and the highlights of the dune in the bright sun. F/11 1/8th sec. Velvia

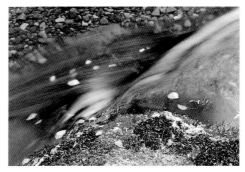

Page 78 AUTUMN AFTERNOON, OHANAPACOOSH RIVER, WA.

As I moved up and down the bank of this section of the river, I was fascinated by the many perturbations of the water flow created by the rocky shoreline. I set up my 24-50mm zoom lens on my tripod and observed this eddy for a while. The rock was causing the water to flow at different speeds in the scene and I wondered what type of designs the frozen movement of the water would create. I exposed this at 1/15th second at f/16. I took the meter reading from the large rock. Velvia

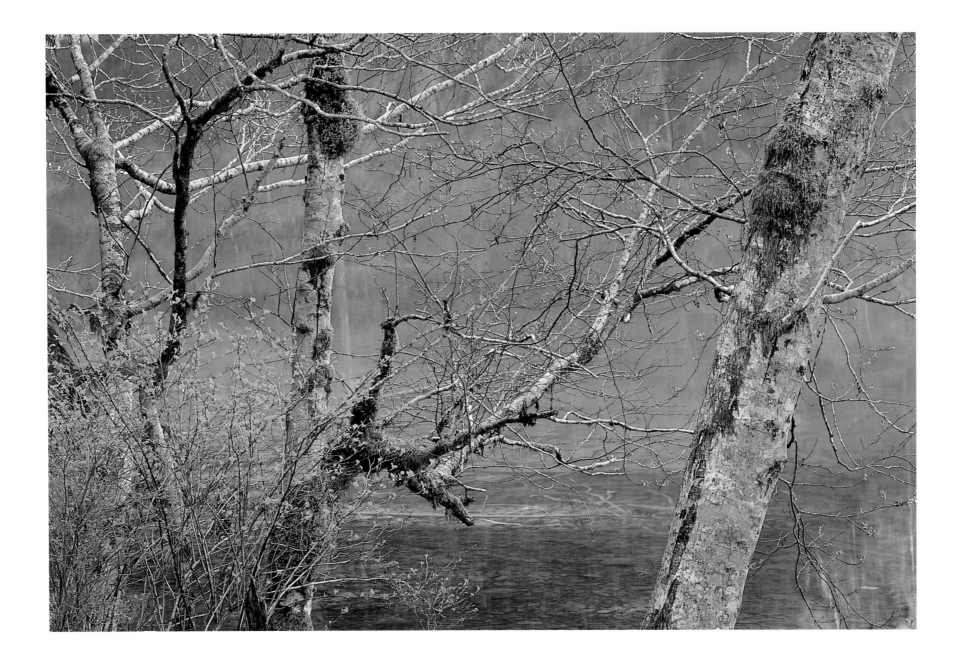

W hen considering the components of light, shape, pattern, texture, line, and color, it would be difficult to quantify their relative importance to one another because they work in consort to create visual expression. Nevertheless, I believe that the component of color merits special consideration because colors can profoundly affect our emotions in different ways that are difficult or impossible to describe or measure. We are probably aware of our response to bright, saturated hues, as they are all around us in our everyday lives. We are less likely to be aware of, much less understand, our response to the more subtle and infinite muted colors that we find in nature. It is largely from those things immeasurable and undefinable, I think, that color derives its unique potential for visual expression.

THE EXPRESSIVE POTENTIAL OF COLOR

The essential properties of color are hue, brightness and saturation (the purity of the color). Working with color in visual design is most successful when we are aware of the relative content of these properties in our subject matter. A scene containing mostly the primary colors (blue, red, yellow) appears relatively stable. Subject matter with mostly secondary hues (green, brown, purple, etc.) tends to be more unstable, or moving toward the primaries. Visual tension and movement are created when colors are drawn away from their fundamental character (reddish, bluish, etc.) Colors can also convey expression by the shapes and designs they create. In a landscape, subjects with warm colors tend to move forward, while areas of cooler colors recede into the distance.

When planning a photo outing, I first consider what colors will be present. Determining factors are the time of year and anticipated weather conditions, as these strongly affect the appearance of color in the landscape. I am not deciding where to go based on physical features nearly as much as on what colors those features will likely display at the time. I find that summer and winter generally remain constant in their color presentations. However, spring and fall are times of transition and as such seem to offer a very dynamic visual display. They not only possess the brilliant colors that we often associate with them, but also, because they are in continuous transition, they generate tremendous variations and subtleties of hue which are very expressive.

In a photographic setting, the appearance of colors is affected by many factors, including the range of other hues in the scene, the time of day and year, depth of field, length of exposure, selective focus, and quality of the ambient light. We can control color to a fair extent in our images by how we manipulate these factors. For instance, we can change the appearance of hues in the scene by waiting for the sun to be obscured by a passing cloud, or by making a long time exposure which may cause the colors to become warmer. Another important element of color control is the type of

film you use. Knowing the film's tonal range and contrast characteristics is critical to accurately assessing how the hues in the scene are going to appear on film. Generally, color film performs better in conditions where contrast is less extreme.

Improving your ability to utilize color for greater expression begins as with the study of light, by observing and studying color on a regular and consistent basis. Seeing how color is used in such things as advertising, interior design, and other forms of art can help you become more aware in a conscious and intuitive way of your perceptual range of color, and how you can use the element of color for visual expression.

UTILIZING TECHNIQUE FOR GREATER VISUAL EXPRESSION

The purpose of gaining more technical skills in photography should be for one purpose only: to improve visual expression. Improving your technique best serves your photography when it is consciously understood from experience and intuitively applied as an integral part of your creative process. Learning technique well should allow you to think less about those skills, and to think more about seeing. The topics to follow do not cover everything there is to know about nature photography. I am presenting those essential technical considerations that have served me well. At times, the application of technique seems to confuse, frustrate and intimidate many photographers. Good photographic technique is not difficult to learn and apply; it simply requires the desire to learn and a consistent effort of practice.

Exposure

Exposure is one of the most important areas of technique and one that often fails the photographer. Getting good exposures results from understanding how your light meter works, that is, how it reads the light. For purposes of simplicity, I will discuss this using a typical center-weighted, through-the-lens light meter system. Center-weighted means that the meter takes an average reading from the circle in the viewfinder. It is based on an average light reflectivity of 18% gray, which means that it assumes everything in the scene has the same 18% reflectivity. When an improper exposure is made, it often results because the photographer wasn't fully aware of what the light meter was actually reading, and in many cases, it is reading only the brightest lit area in the viewfinder. In the photo explanations throughout the book, I have indicated how I took a light meter reading in each case. You will notice that I rarely take a reading from the center of the scene. I do this to calculate the exposure of the area of lowest illumination that I want details in. The photographer assumes that because he can see the details in the low light, so can the film. Part of getting accurate exposures is knowing the tonal range of your film and part is properly exposing for the low light areas that you want rendered with some detail. When I indicated a general metering it meant that the exposure values were equal throughout the scene (you will note that this was invariably in indirect light situations)

The light meter in your camera, knowledgeably used, is the only meter you will probably need.

Learning to get good exposures consistently is greatly enhanced by learning how to determine exposure values by reading the tones in your subject. By identifying the tones in the scene that are 18% gray, you can then determine stops of under or overexposure simply by the darker or lighter tonal gradations. Being sensitive to the ambient light and what range of tones are present in the scene will improve your exposures more than all the rules and formulas in the world.

Bracketing exposures is a procedure where you exposure for the reading you think is correct and then overexpose and underexpose several other frames in the hope that one of them will be properly exposed. This should be saved for those instances where for whatever reason it is difficult to get an accurate or certain reading. Relying on bracketing as a normal procedure not only wastes film, but it retards the photographer's development of a subtle and refined awareness of light and the critical ability to assess the tonal range of the

scene. It is difficult to effectively compose an image without an awareness and careful consideration of tones and how to use them in the visual design of the image. This is part of the process of calculating the appropriate exposure.

Time exposures can be utilized to alter the appearance of both color and movement of subject matter. Time exposures of more than a second tend to shift the color of the scene towards the magenta or red on most films. Also, longer exposures at sunrise or sunset will cause the red to accumulate or build up in the subject matter, often with dramatic results. In the case of colors reflecting in moving water, a longer exposure can intensify the colors, and the movement of water during the exposure can effectively mix the colors with unpredictable but often pleasing results.

How to depict the movement of water in an image should be determined by the subject matter. If the subject expresses the drama and excitement of fast moving water through a landscape, then it is perhaps best photographed by stopping the motion of the water with a faster shutter speed

such as 125th/second. If the theme of the image is characterized by a more subtle mood or emotion, then softening the appearance of the water with a slower shutter speed such as 1/2 second may be more appropriate. There are no rules or formulas for technical application in these situations. These technical skills are acquired only through practice, experimentation, and a careful examination of your images as a feedback source from which to learn.

Depth of field

The use of depth of field and focus can affect both visual design and the portrayal of color. Depth of field is the area in the image that is in clear focus and is determined by the point of focus and the aperture. The larger the aperture(f/4.5, for instance), the smaller the depth of field, and the smaller the aperture(f/16), the greater the depth of field. Using depth of field should be determined by the subject matter and what it expresses. Objects in the scene in clear focus show the greatest intensity of their hues, whereas objects less in

focus are more diffused and hues become less intense and more subdued. The decision of how to use depth of field should be based on what is to be expressed and how you are going to use visual design to achieve it.

Lenses

One of the most important technological advances in photography, in my opinion, has been the development and refinement of the zoom lens. The argument that fixed focal length lenses have discernibly better optical quality has not been supported in my experience. Almost every one of the 35mm images in this book was taken with a zoom lens and I will let their optical quality speak for itself.

The creative advantages of zoom lenses are numerous. You can reduce the amount and weight of equipment you carry around. I have only two lenses, a 24-50mm and a 75-300mm. If your type of photography requires a greater telephoto, a 1.4X or 2.0X tele-extender can give you more telephoto power with very little extra weight. Also, a zoom lens gives you the ability to compose your picture from where you stand by simply changing the focal length with a push or pull of the lens barrel. This greatly enhances your ability to select and abstract subject matter for the purposes of visual design and composition. By not having to change lenses constantly, you can commit your full attention to seeing and creating.

Film and Filters

Selecting a film that works best for you and your subject is a matter of experience and personal preference. There are many good films to choose from and it may benefit you by trying a number of them. My personal choice is Fuji Velvia because of its fine grain, saturation, and tonal range. Another technical consideration for color and contrast control are filters. A warming filter such as an 81A or B can help compensate for the blue cast of ultraviolet light in shadows and make the subject matter appear more natural. A graduated neutral density filter can be useful when you have extreme exposure differences in subject matter. This filter will equalize the exposure values throughout the image. A polarizing filter can reduce or eliminate glare and light reflection of the surface of objects in the scene and in many cases will enrich and saturate the colors.

THE CONSCIOUS PROCESS OF LEARNING

Learning how to effectively express ourselves and our experience through the photographic image is a never ending process. Each new experience brings a unique opportunity to apply ourselves and our creative technique. Improving our photography means that we must build upon what we learn every time we go out to photograph. In the truest sense, we all learn by self-teaching, and in this creative endeavor it is even more so. Following are some ideas that have proved very useful to me as modes of learning.

Reading books and attending seminars are helpful but the real key to learning photography is practice, experience and the careful evaluation of your results. Taking the time to study your images

is essential to understand whether your technique worked or not. Whether you take notes or rely on memory doesn't matter as long as you make the conscious connection between your intentions and your results.

Returning to the same location many times during the year is one of the best teaching strategies I can suggest. From the reference point of the same location, you can witness how light, weather conditions, time of day and season, the colors in the scene, etc., combine to influence the subject matter. When you compile and review your images of that location over time, you can get a very good sense of how all the different elements interact to create the landscape. This is exactly the type of knowledge that you can build upon and incorporate in your photography. Returning Means Learning.

I strongly believe in making the art of seeing and being, visual design, and the study of light a daily experience without the camera. Using those things with skill and creativity in our photography is most effective when they become a natural part of our living. Putting away our camera doesn't mean that we stop noticing how reflections of water dance on the side of a building, or that we stop composing an image of the subtle design of hues in a field while driving on our way to work. Seeing and photographing without your camera is not only a very effective way to learn and develop your skills, but it is a wonderful way to make every day an experience of living fully.

Broadening our visual experiences and influences can enliven and stimulate our creativity and imagination. A number of years ago, I became friends with a very fine painter. We had many long discussions about visual art and I learned a great deal by understanding her unique concept of the subject matter, color, and visual design represented in her work. I consider that association an important formative aspect of my landscape photography. By observing and studying other visual art forms (movies, paintings, sculpture, etc.) and how these artists create by using color and visual design, we expand our own concept of experience and expression.

I hope that I have presented some ideas in this book that will benefit your photographic endeavors. Creating images of substance, expression, and style is not learned like following an instruction manual on how to build something. Expression in art demands much more from us. The concepts in this book, or any book on photography, must be internalized through experience and feedback so that they may provide a meaningful, relevant, and ultimately a useful application for you.

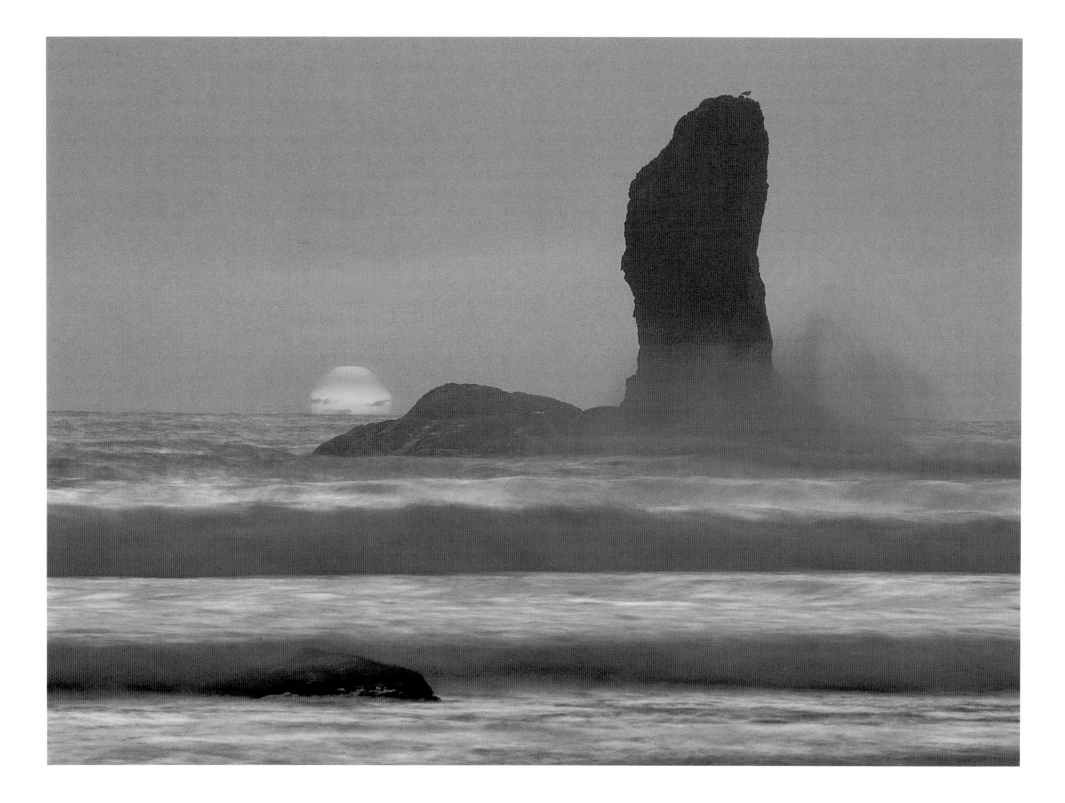

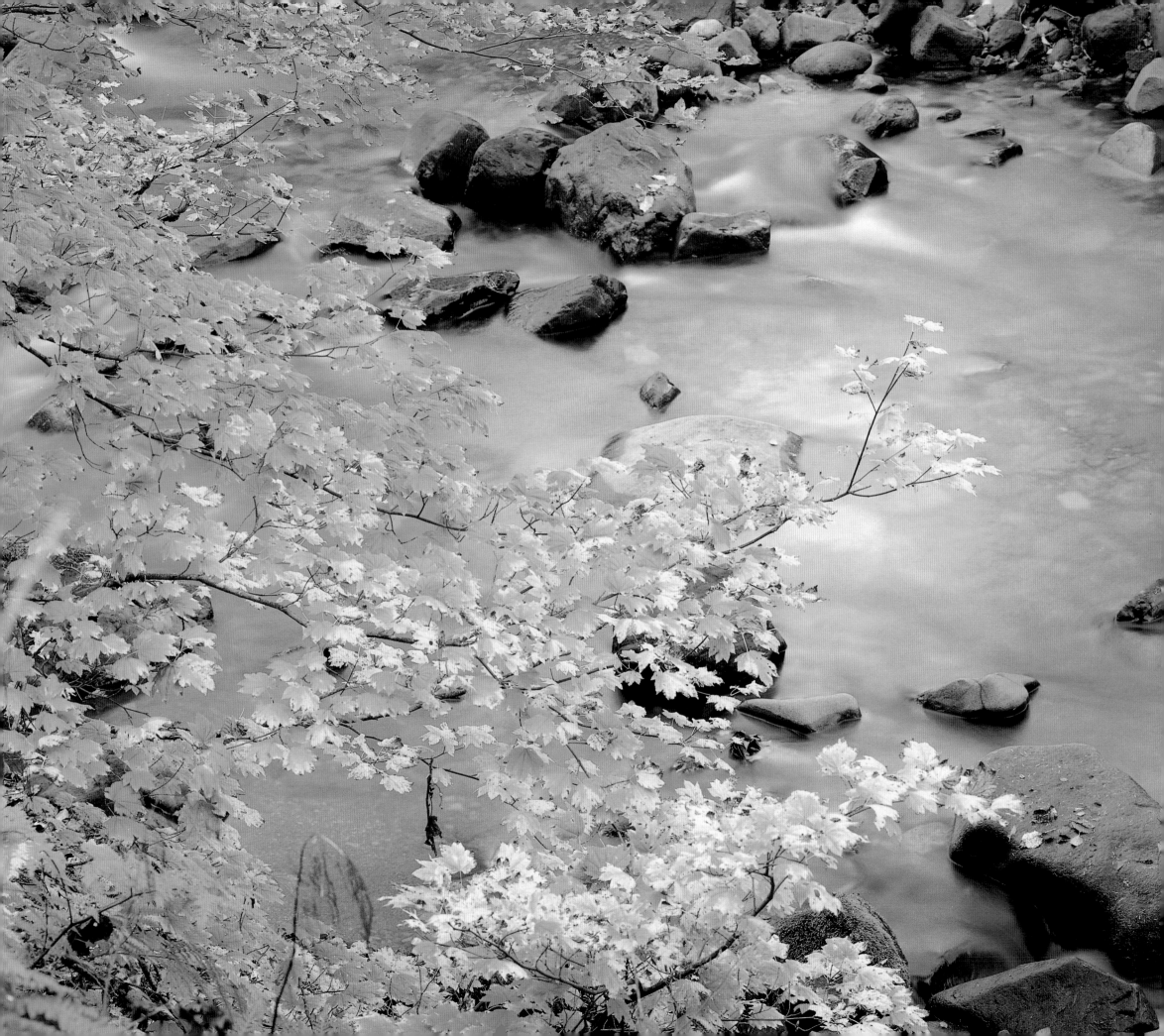

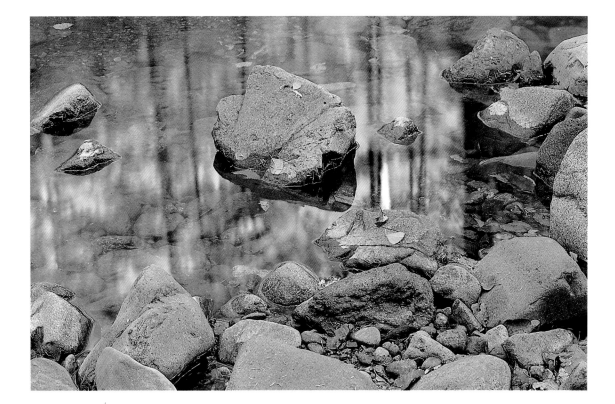

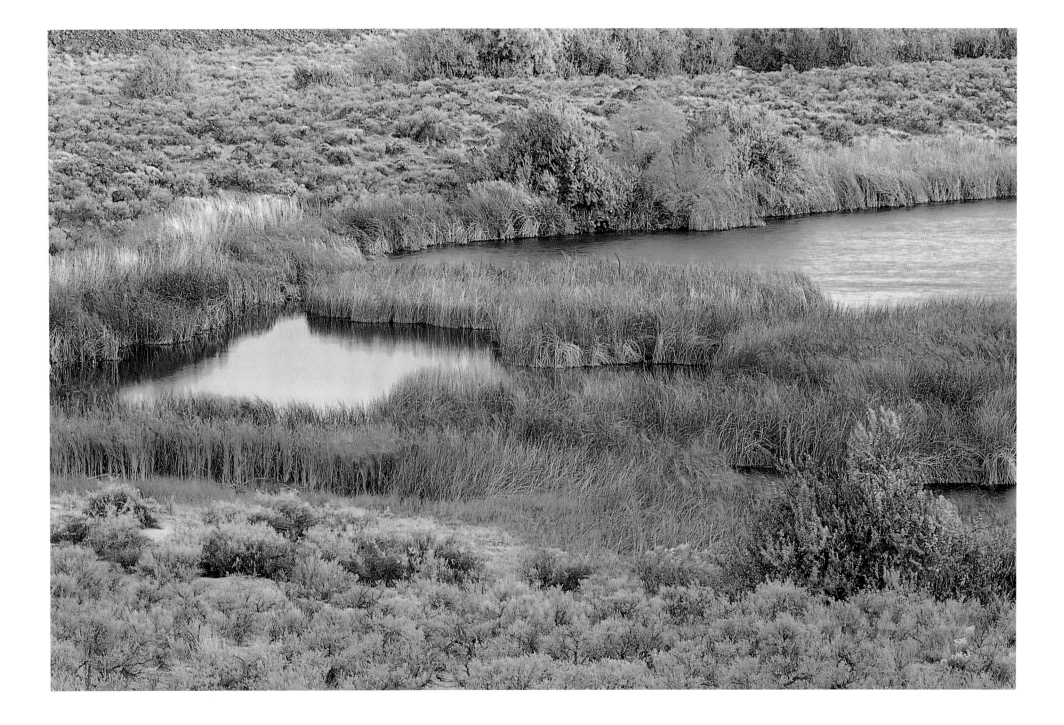

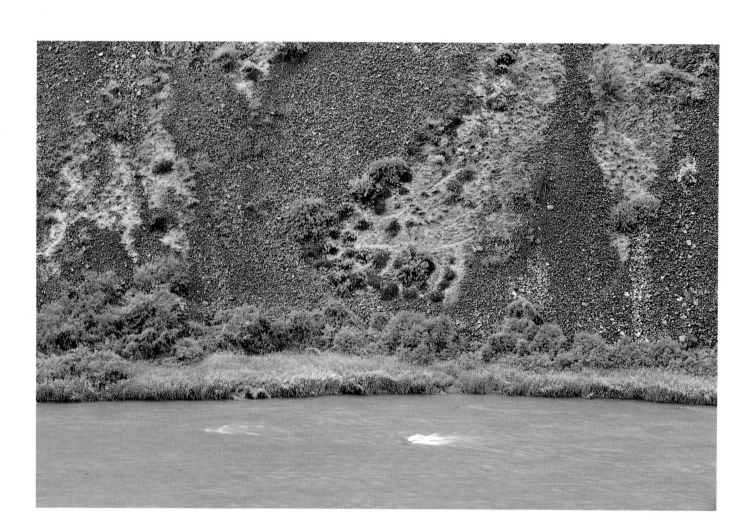

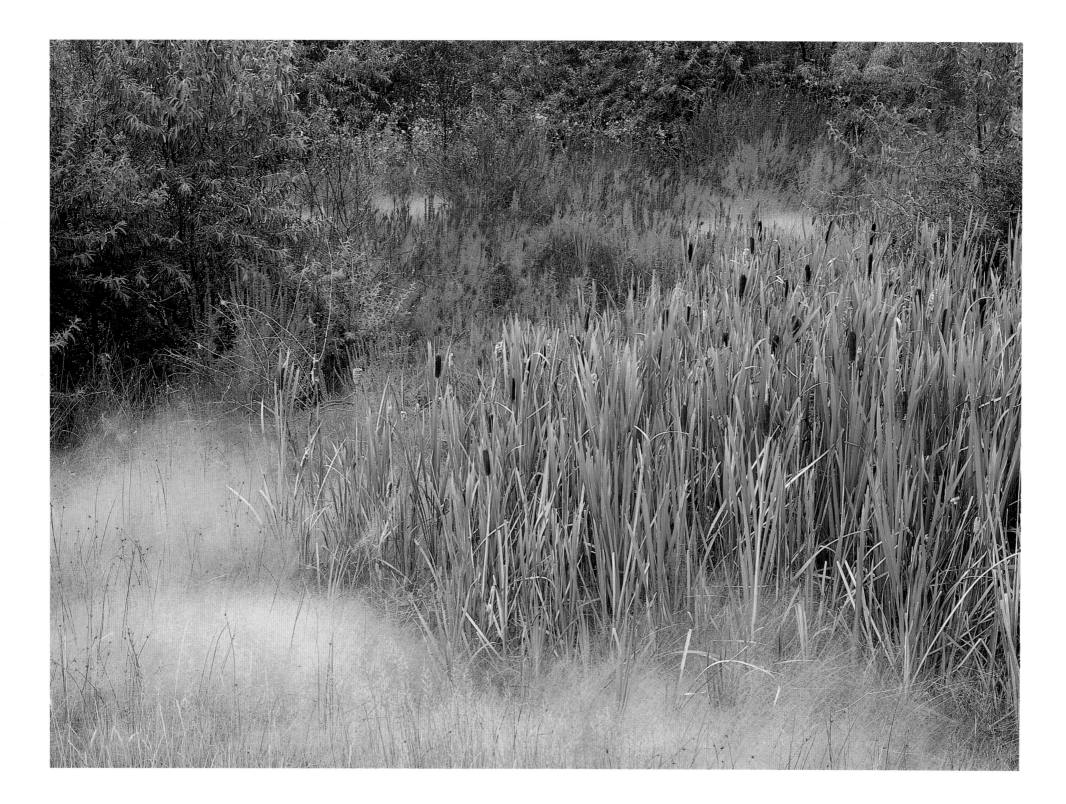

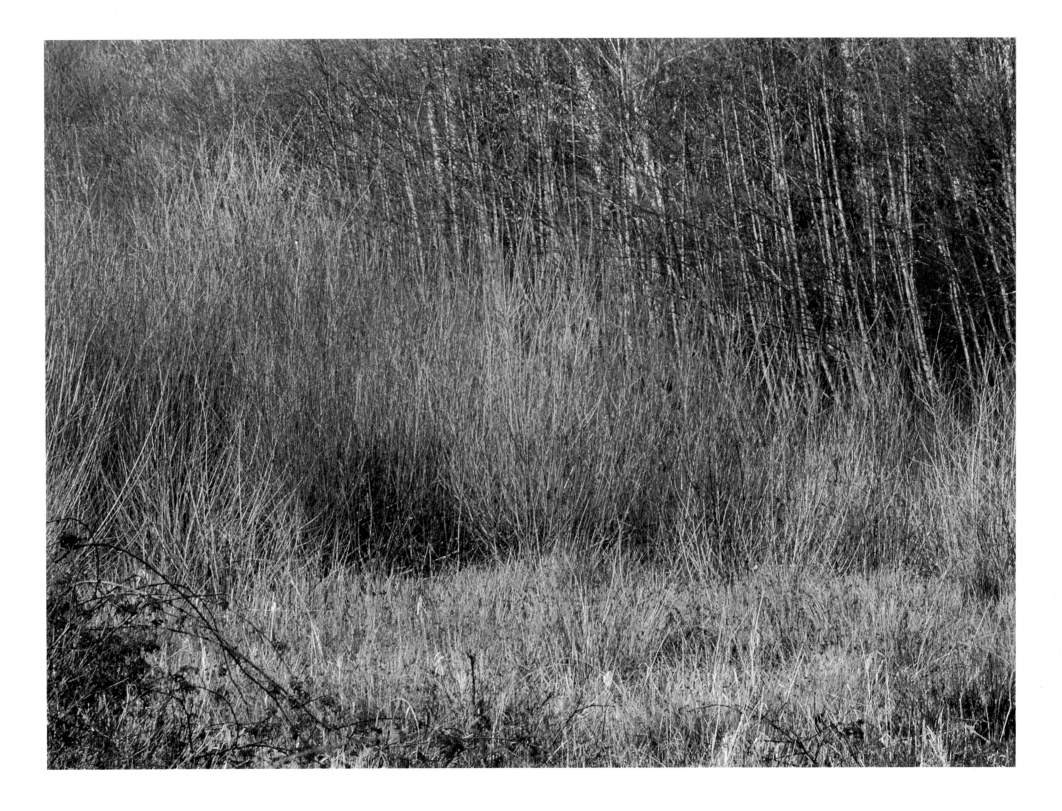

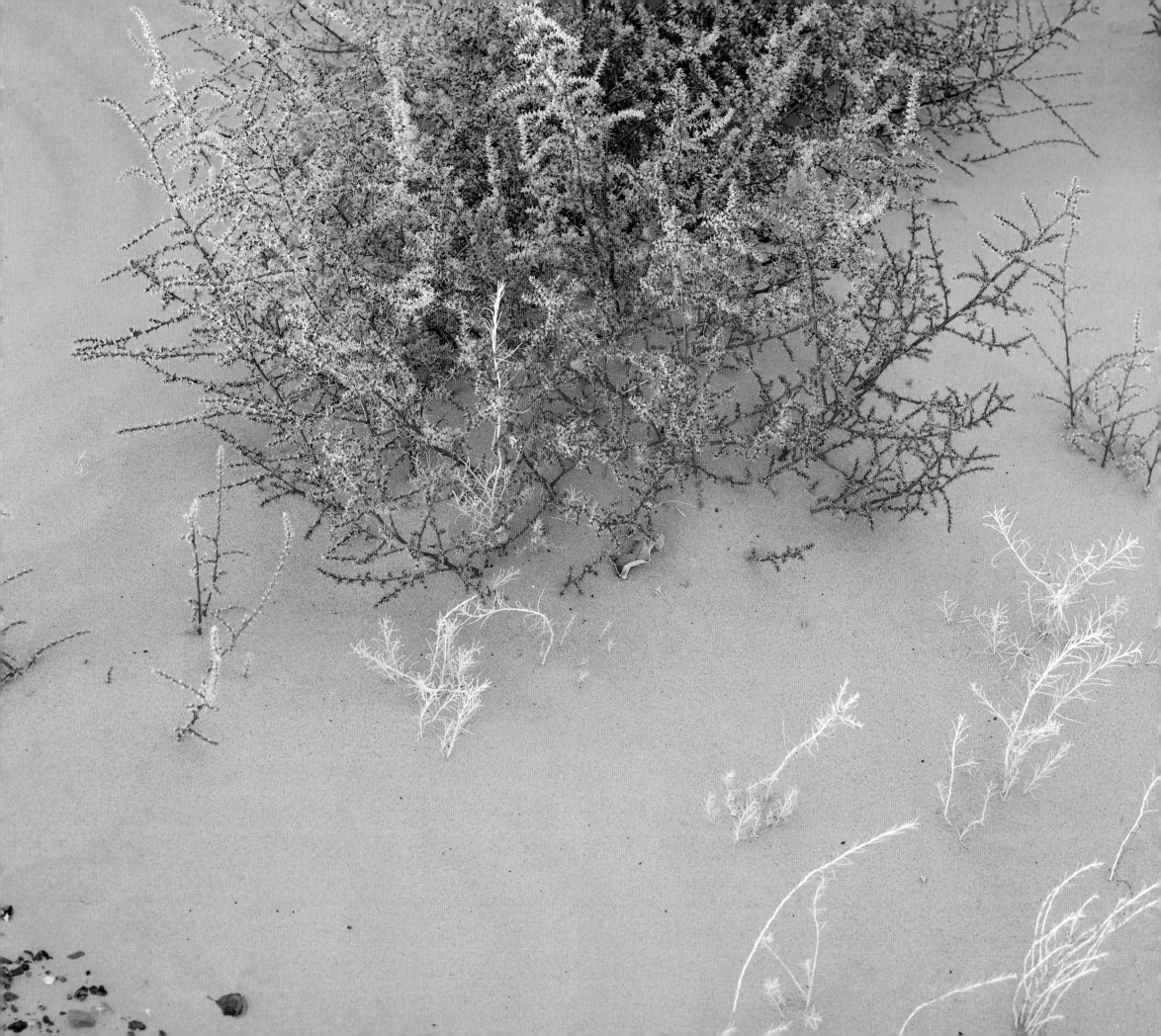

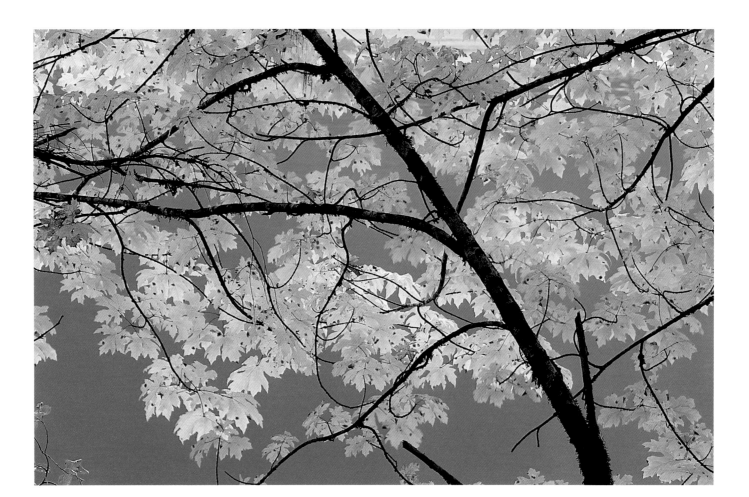

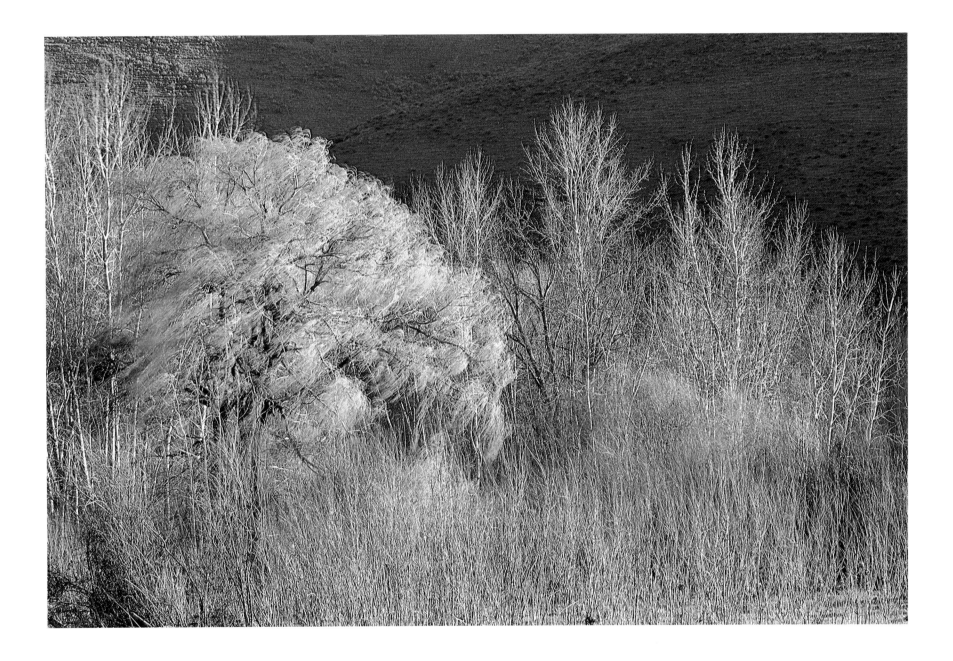

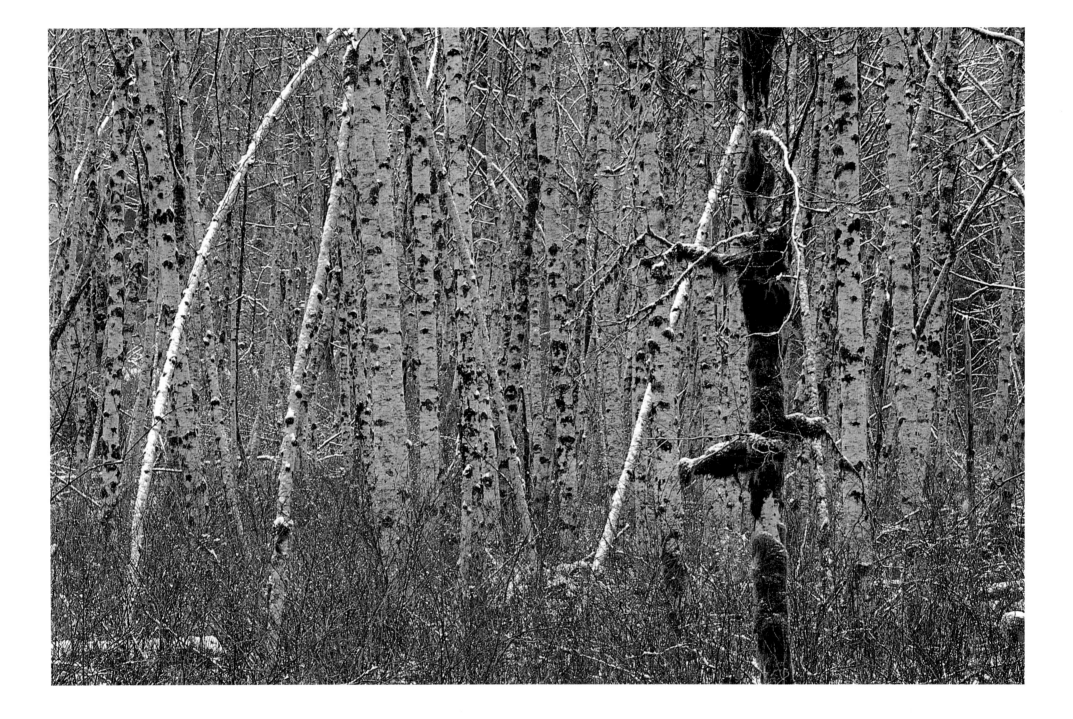

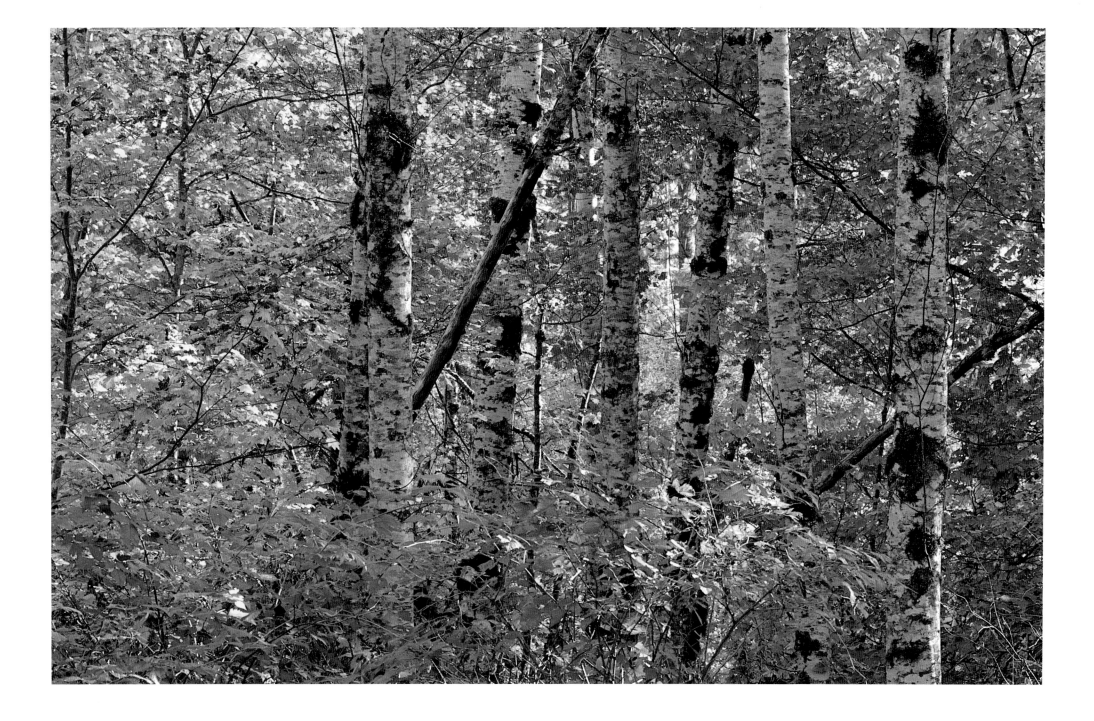

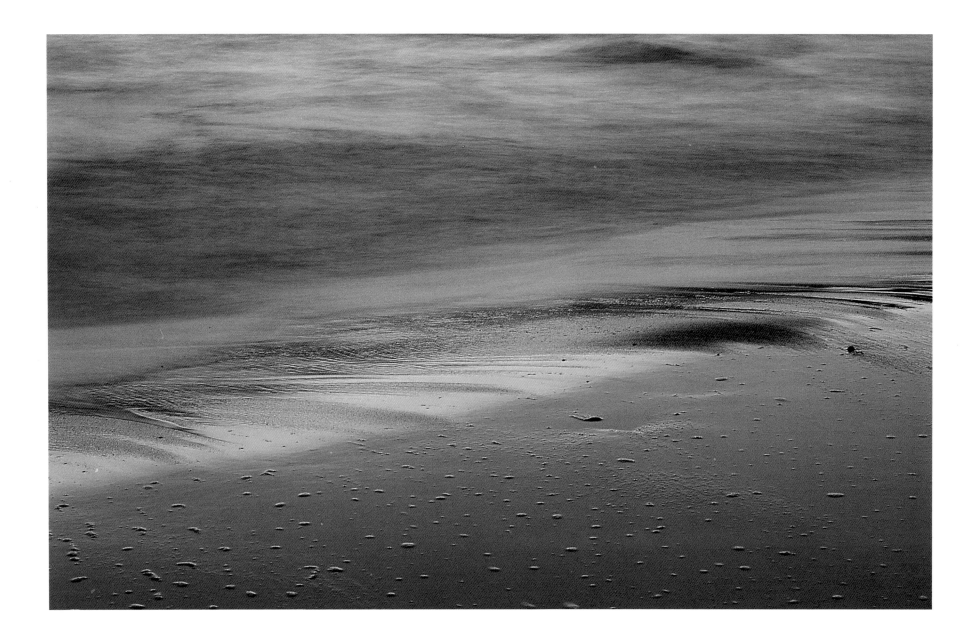

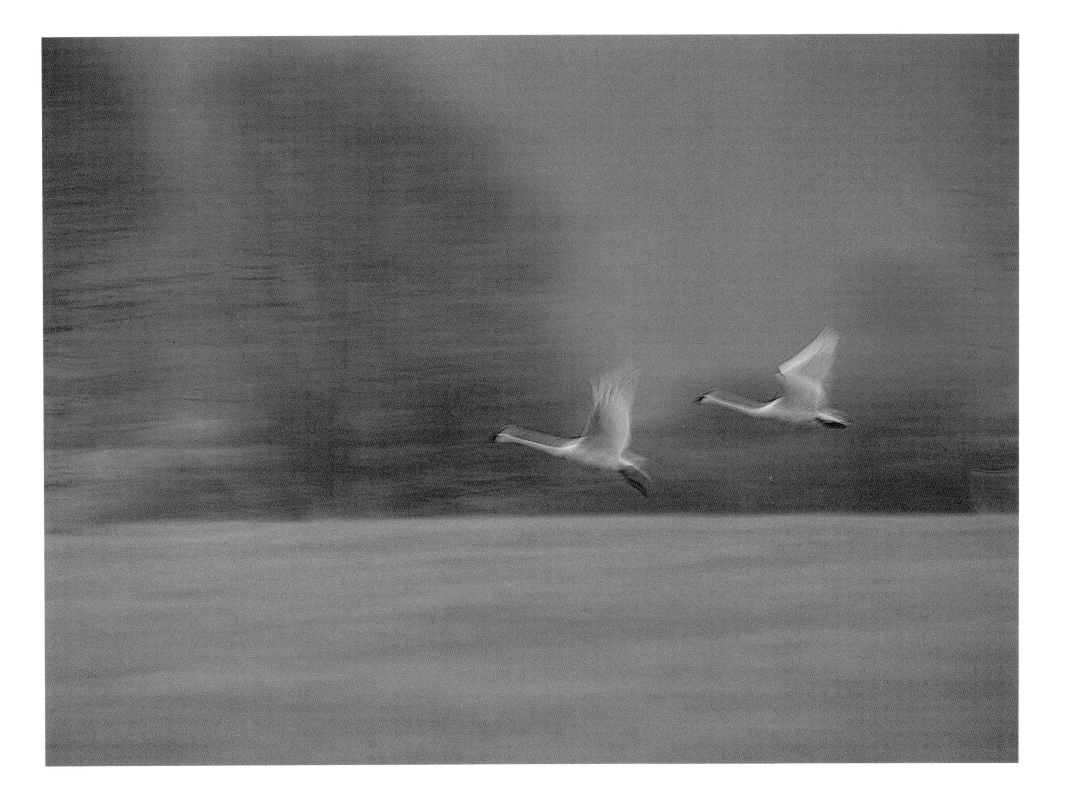

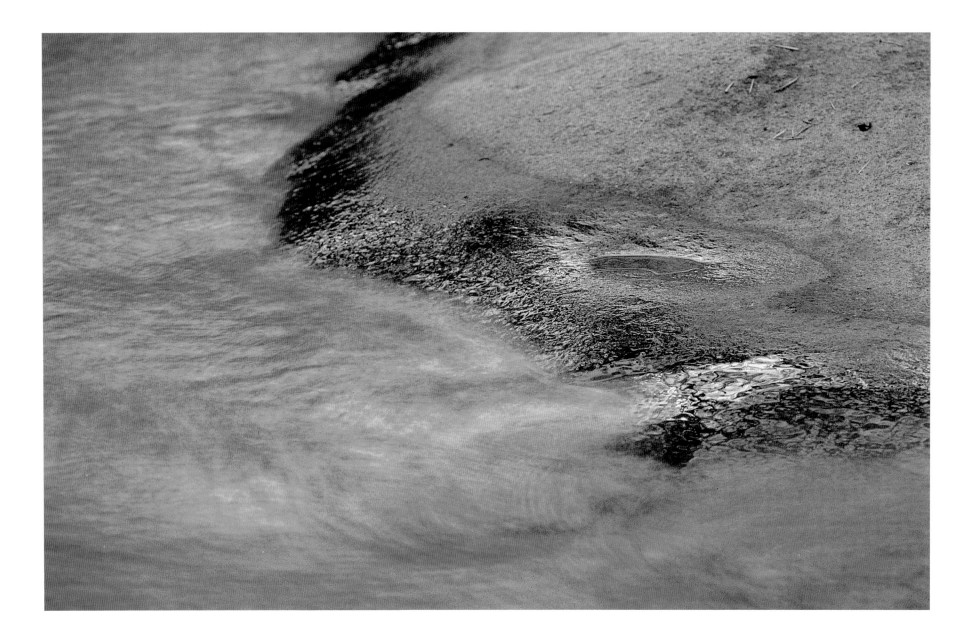

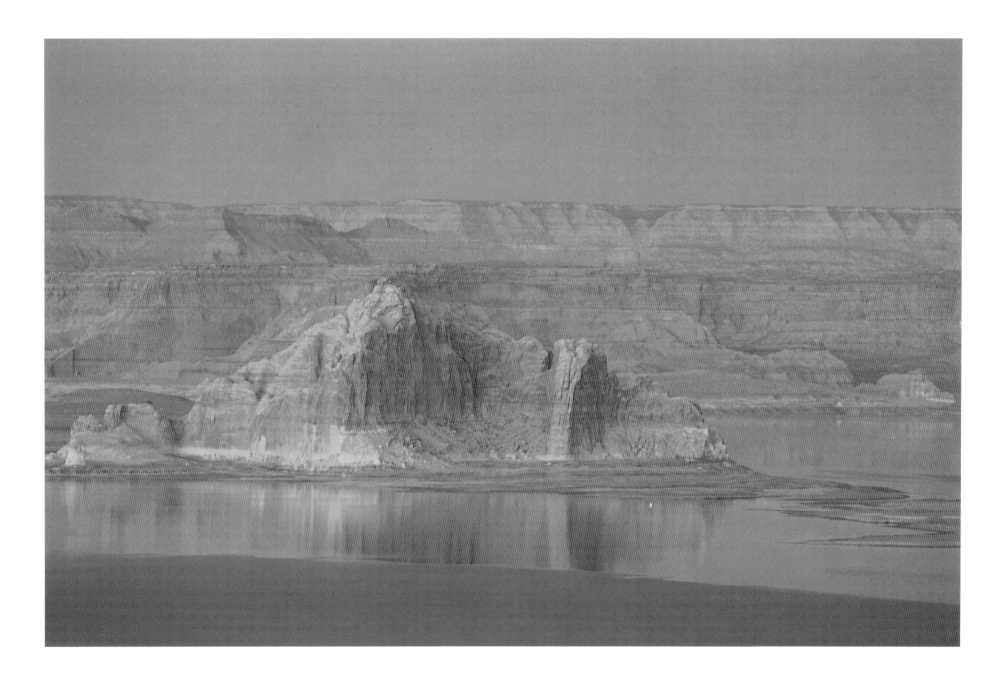

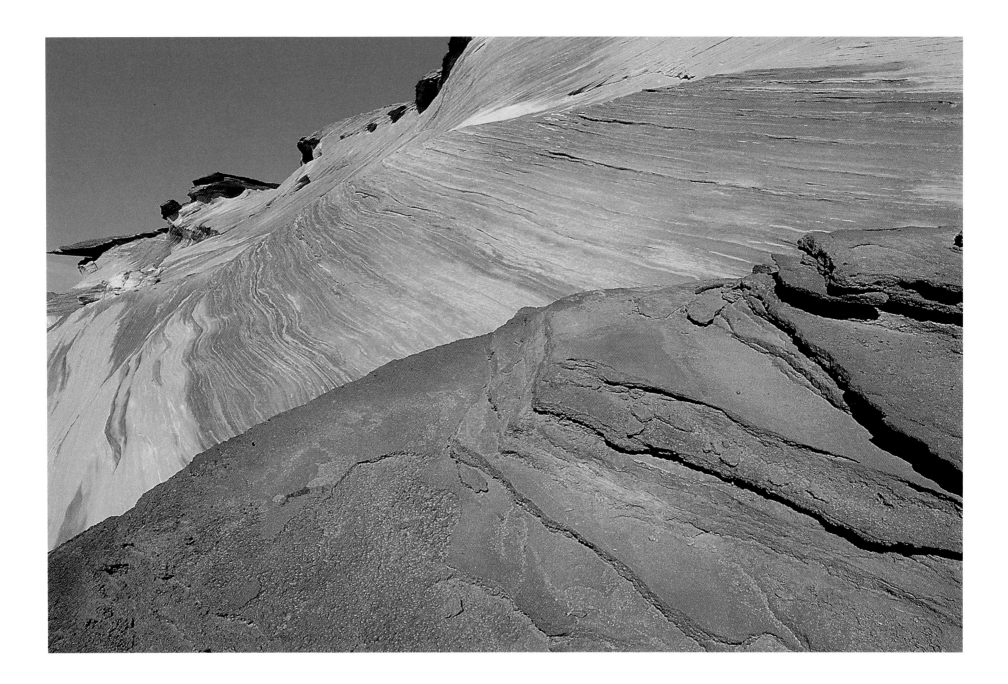

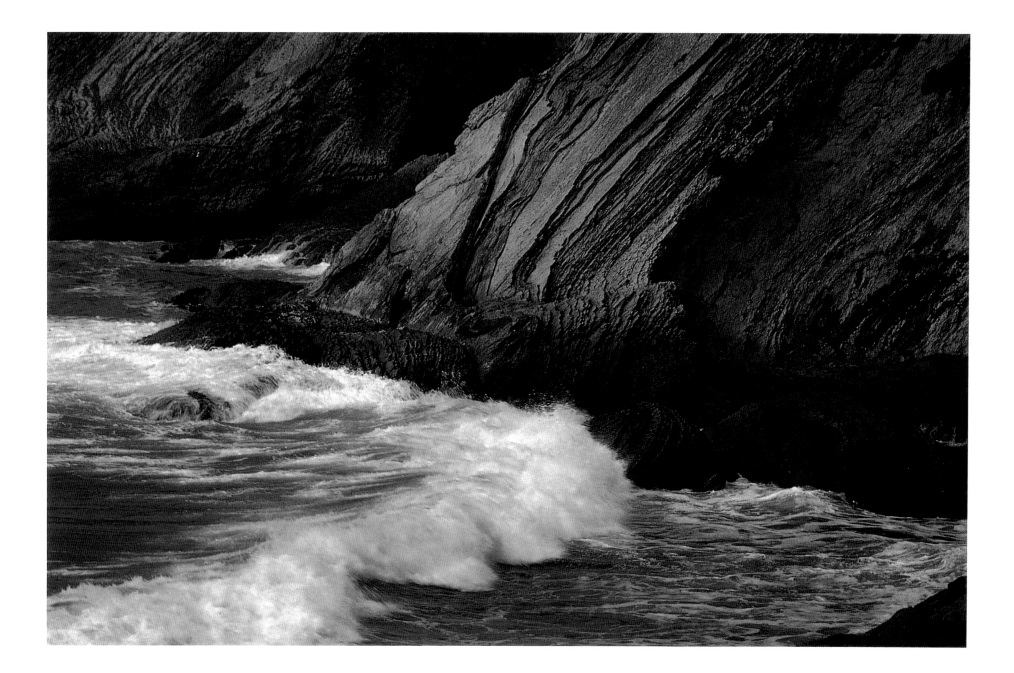

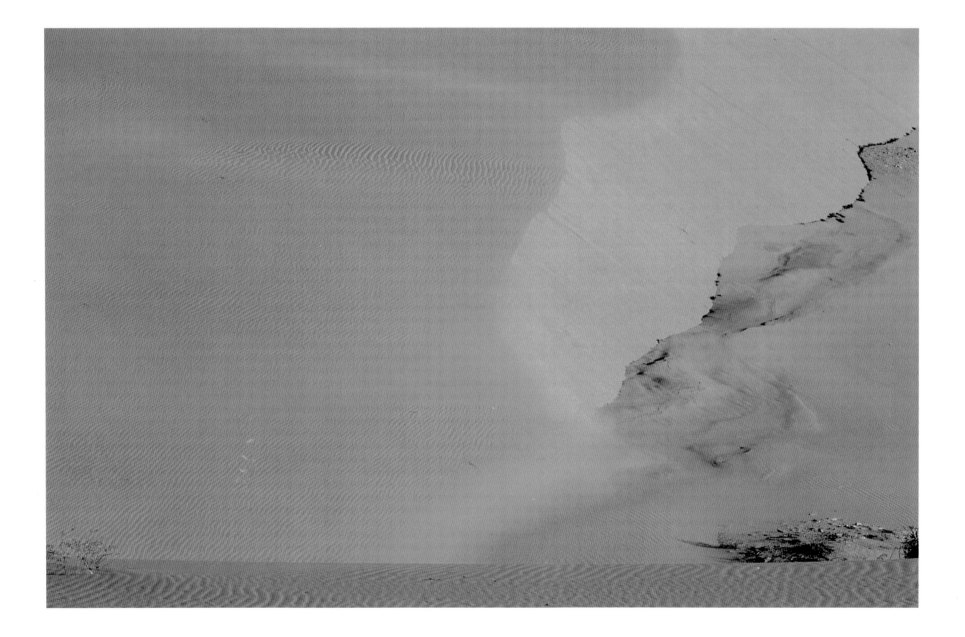

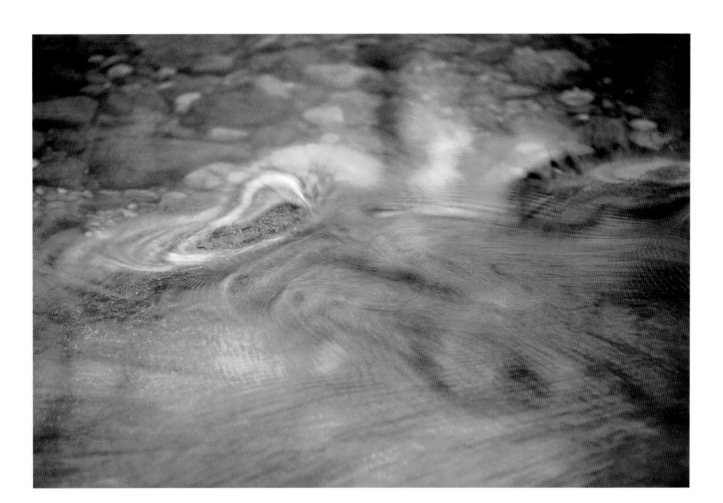

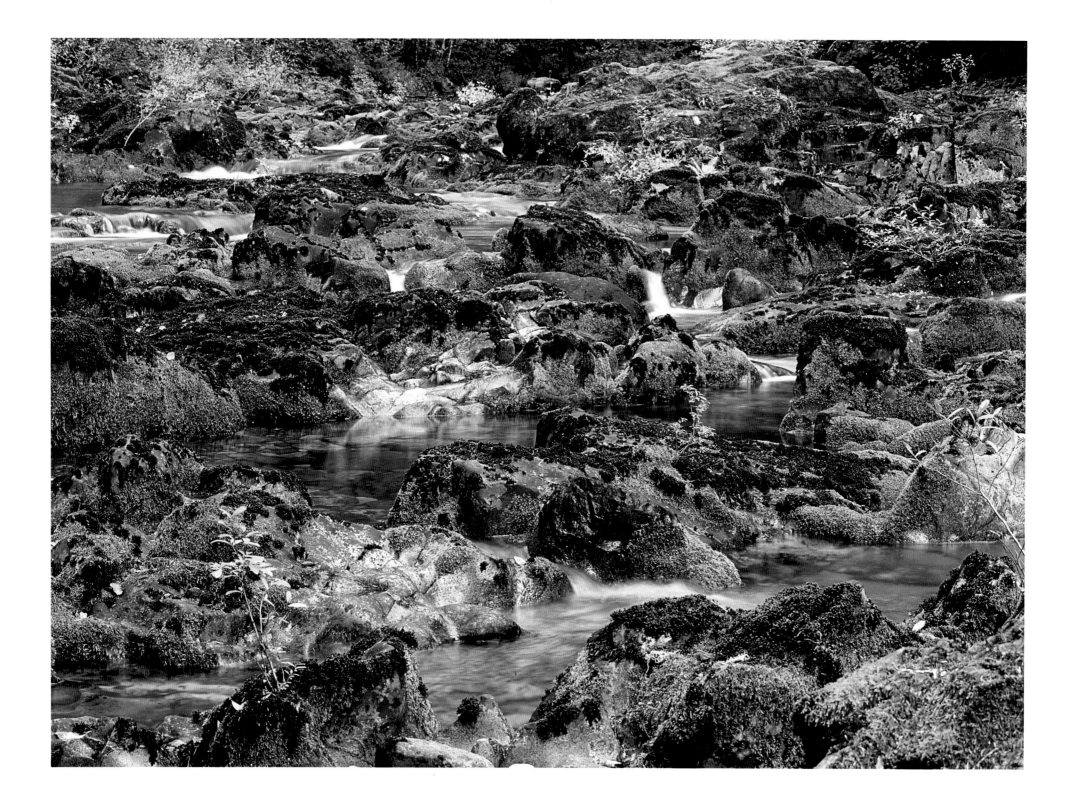

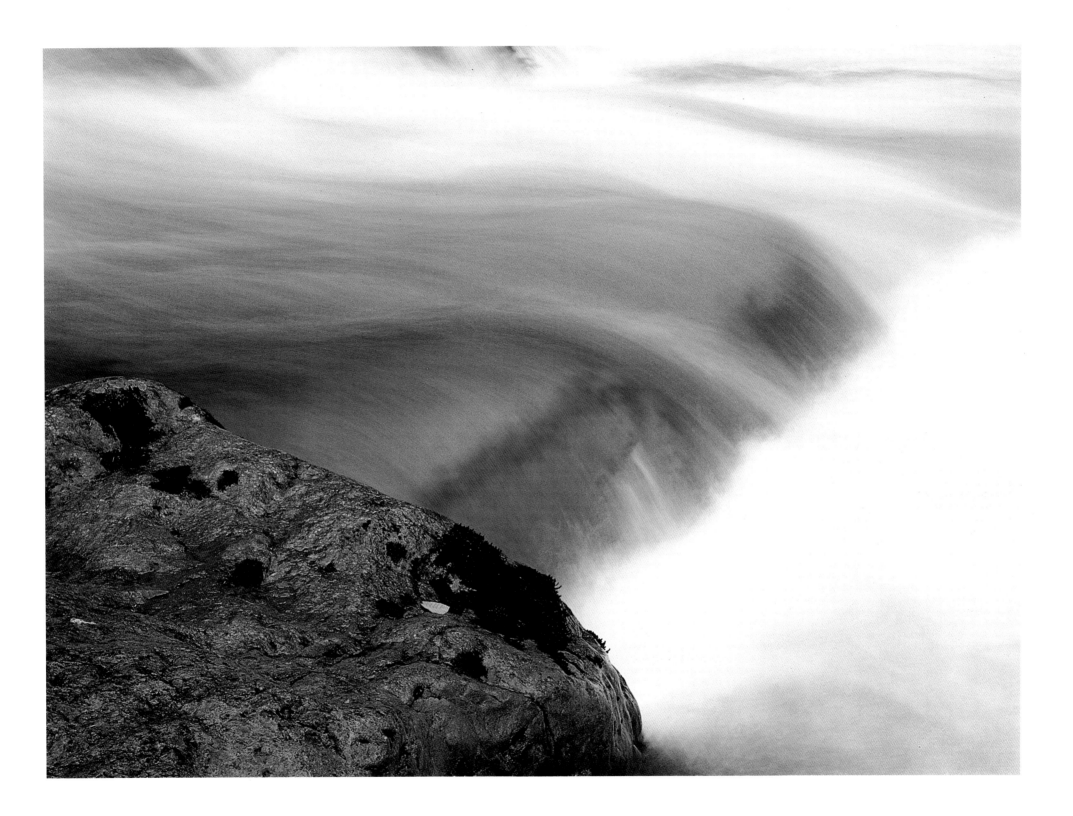

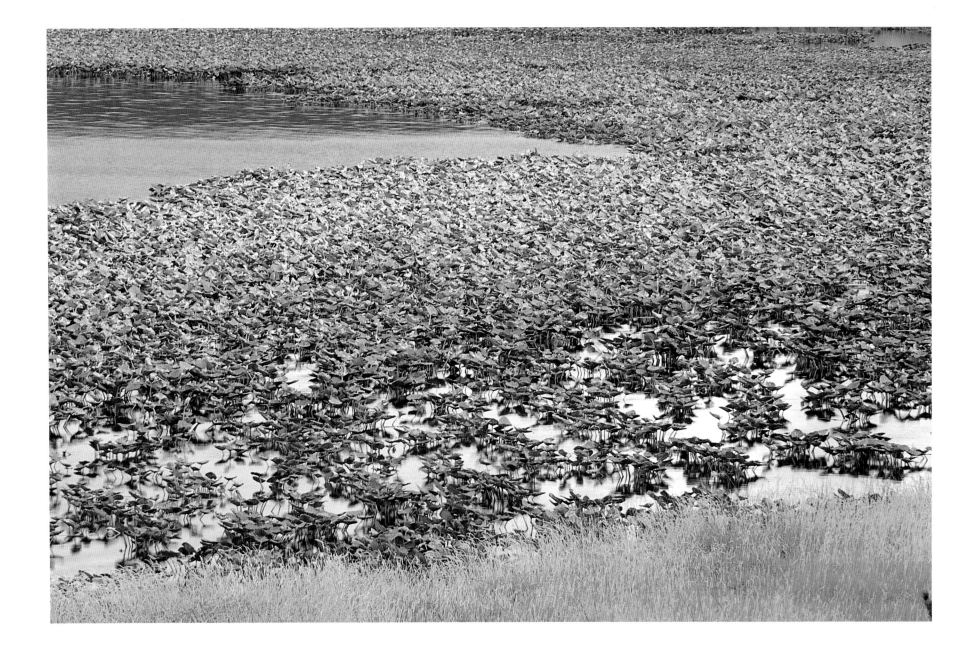

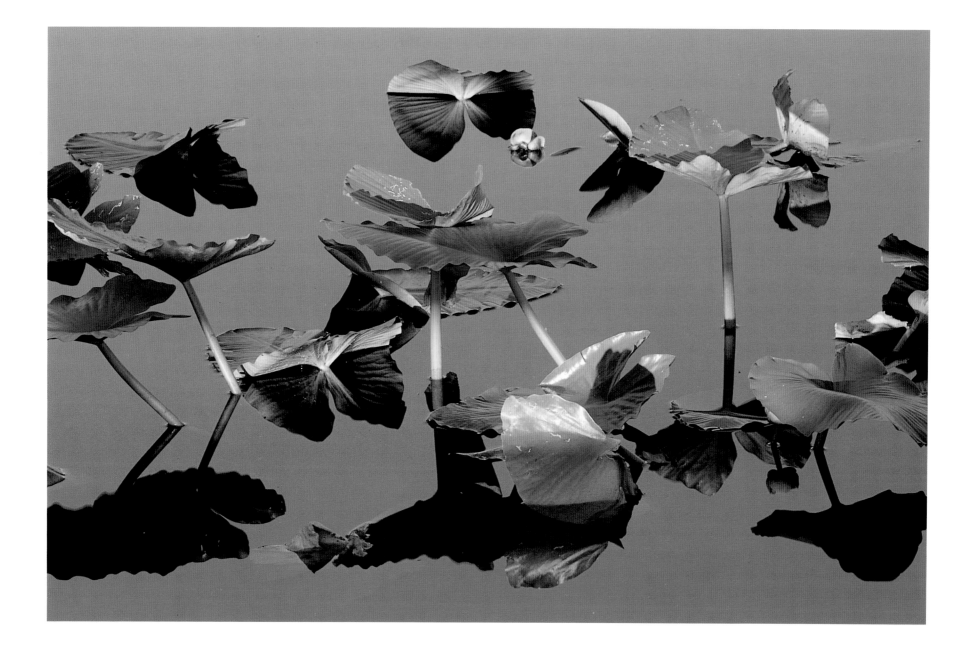

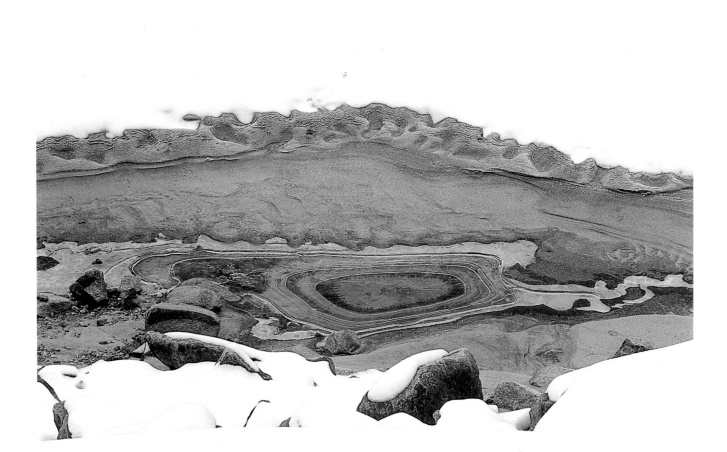

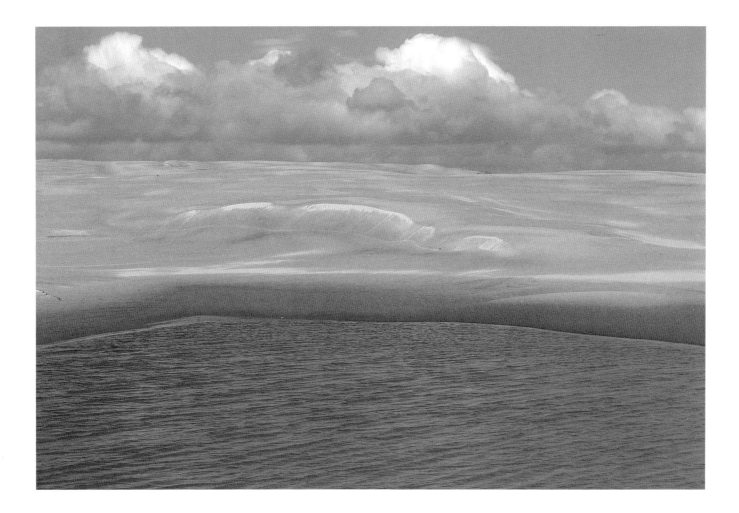

Page 84 MORNING, EARLY SPRING, CRESCENT LAKE, WA.

The transitional seasons of autumn and spring are a time of dynamic color presentation. Whereas summer and winter seem to settle into their own stable color patterns, the hues of spring and fall change day by day. As I was driving around the lake I noticed the light lime green hue of the emerging leaves beginning to fill out the tree branches. I found this spot along the road where the aqua hues of the lake provided a striking color contrast to the trees and leaves. I shot this with my 75-300mm zoom lens. I wanted to keep the detail of the rocks in the water so I stopped down to f/16 for greater depth of field. I metered from the tree trunks. 1/8th second. Velvia

Page 90 SPRING SUNSET, LA PUSH BEACH TWO, WA.

Sun, water, and clouds are elements of the landscape that can interact in dramatic and expressive ways. I was leaving the beach thinking the sun would set behind the clouds when suddenly it appeared as it began sinking below the horizon. I quickly set up my 75-300mm lens and metered on the water to prepare for my shot. I stopped down to f/16 to make a longer exposure of 1/2 second hoping to catch some of the hues from the sky in the water and soften the movement of the waves on the shore and the one crashing on the rock. Velvia

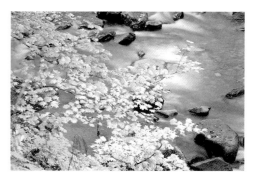

Page 91 AUTUMN AFTERNOON, SKATE CREEK, WA.

The movement and color of the water in this image are a function of an eight second exposure, f/32 aperture, and the unfiltered uv rays. This river is at the bottom of a steep canyon and the autumn colors in direct sunlight are reflecting into the creek. The longer the exposure of moving water the more smooth and unrippled it becomes, often revealing some detail below the surface. It is a clear day and this scene is in indirect light and as such has a lot of uv rays, invisible to the eyes, but which show up as blue on film. I chose not to use a warming filter like an 81A or B because I wanted the water and rocks to absorb some blue color as a part of the color design with the golds and greens of the image. Pentax 67 135mm macro. Velvia

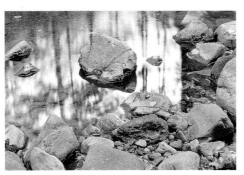

Page 92 AUTUMN AFTERNOON, SKATE CREEK, WA.

This image and the one on page 89 were both taken at about the same time and place on Skate Creek. In this image, however, I chose to use an 81A warming filter. The predominant colors in the water are reds and oranges. In this case rocks with a blue cast would not be as harmonious as the various gray hues that are present, so using the warming filter would keep the rocks their natural color. The reflections of the tree trunk shadows are a nice counterbalance to the mostly round shapes of the rocks. I positioned them in the picture simply by changing my placement on the shore. In this image all technical considerations are intended to support the theme of a vibrant but serene mood of autumn.24-50mm zoom lens, f/22, 1/8th sec. (metered from rocks) Velvia

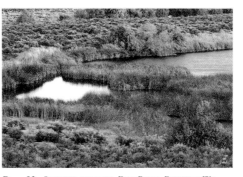

Page 93 SUMMER SUNRISE, DRY FALLS, EASTERN WA.

I shot this arid wetland as the first rays of sunlight warmed the soaring basalt cliffs just out of the picture. Changing camera positions by walking up and down the road I found a place where the gold colors of the cliffs reflected in one pond and the blue sky in the other. Reducing the perspective in the composition by zooming in with my 80-200mm lens helped emphasize the main design elements of the shapes and hues of the ponds. The texture and hues of the grass and sagebrush provide the visual contrast that make the design work. The telephoto zoom lens was indispensable here as it allowed me to shoot from the position where the ponds reflected the colors and zoom in to compose the image. F/22 was used to maintain focus throughout the image. 1/2 sec. (metered from foreground sagebrush) Velvia

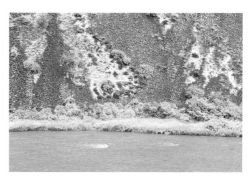

Page 94 SPRING AFTERNOON, YAKIMA RIVER, WA.

This photograph taken in the semi-arid region of Eastern Washington is a study of color as form. In fact, the entire composition is created by the contrast of colors. I photographed this from the highway above the river using my 80-200mm zoom lens. Zooming in to almost 200mm, I was able to eliminate the distracting surrounding details, and compose an image that highlights the tonal contrasts. If I would have returned to this spot in the summer when the nourishing spring rains were long gone, this scene would have looked much different. I shall do that next summer. F/16, 1/4th sec. (general metering) Velvia

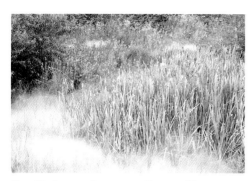

Page 95 SUMMER AFTERNOON, EASTERN WA.

I was attracted to this blooming arid wetland alongside the road by the range of hues and textures. The various grasses, plants, and trees formed a simple, pleasing composition of their own so it was up to me to render them as faithfully as possible. I stopped down my aperture to f/32 to keep everything is sharp focus. The sun was burning through the thin cirrus clouds, casting shadows through the scene so I had to be patient and wait for a build-up of enough cloud cover to diffuse the light and eliminate the shadows. Pentax 67,135mm macro lens, 1/4th sec. (general metering) Velvia

Page 96 WINTER MORNING, CASCADE MTS., WA.

I photographed this from a highway one winter morning. I had to set up quickly because the sun was beginning to break through the overcast and it would change the scene completely. My interest in this roadside field was the color and the delicate vertically etched lines of the trees and grasses. I used my 80-200mm zoom lens at f/32 to keep everything in the near foreground and the distance in clear focus as they are equally a part of the overall design. Once again, my 75-300mm zoom lens is critical because I can compose the shot from where I stood and maintain the angle that I wanted. 1/2 sec. (general metering) Velvia

Page 97 SUMMER, AFTER SUNSET, EASTERN WA.

I ran from my car across the sand dunes to try to reach the Columbia River before the sun went down. As the sun dipped below the horizon, I stopped running and sat down to catch my breath. Thinking the day was over, I got up to leave when I noticed these tumbleweeds growing in the sand. The light in the sky was a pale yellow turning red. I wondered as I set up my camera how the transmuting colors of the sunset might render the colors of the weeds and sand in a time exposure. I stopped down my Pentax 135mm macro lens to f/32 and exposed for four seconds. The long exposure imparted a soft, warm light that makes me feel like I'm still resting on that dune every time I look at it. Velvia

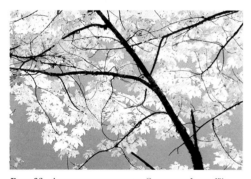

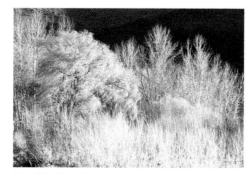

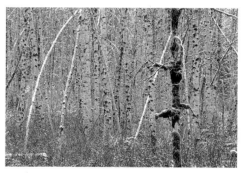

Page 98 AUTUMN AFTERNOON, CRESCENT LAKE, WA.

When I decide to go photograph at Crescent Lake, I'm not thinking of seeing a lake, I'm thinking of seeing color. This lake has what seems like an absolutely infinite palette of blue hues that change minute to minute. My experience of seeing at this place is the often extraordinary interaction of the hues of the lake and the living things around it. This image was taken in late afternoon on a dark overcast day and the nature of the light is represented in the hue of the water. I found this design of maple leaves set off against the lake and shot it with my 80-200mm zoom lens at f/8. 1/8th sec. (metered from leaves) Velvia

Page 99 EARLY SPRING, AFTERNOON, ELLENSBURG, WA.

This is a very rare photograph taken without my using a tripod while I was sitting in my van. The sun was setting and throwing its light at a very low angle across the landscape. As I sat there, I noticed how the light on the hill in the distance was turning into a blue shadow. As it did, the dramatic emerging color contrast completed this composition literally before my eyes. The gusting wind added the final touch by giving the willow a counterbalancing movement to the vertical positioning of the trees. Part of being in the landscape means the patience to sit and observe the light unfolding before us. 80-200mm zoom lens, f/8, 1/60th sec. (metered from trees) Velvia

Page 100 EARLY SPRING, CASCADE MTS. WA.

The anticipation of an early spring snowfall in the foothills of the North Cascade Mountains brought me to this setting. I selected a portion of this forest alongside the road as I was attracted by the lone mossy tree and the sway of the snow covered saplings. I used my 80-200mm zoom lens to compose the shot. I decided to keep the trees in the foreground and middle distance in focus for the detail, letting the scene behind the middle distance trees gradually go out of focus by receding into the far distance. The result is a diffusion and diminishing of the bluish-brown hues in the distance. This subtle color variation helps make the trees in focus more lively. F/11, 14th sec. (general metering) Velvia

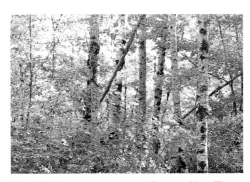

Page 101 AUTUMN AFTERNOON, CASCADE MTS., WA.

This picture and the previous one are a good demonstration of the emotional impact of color. The images are a similar design of red alder trees photographed in approximately the same way. However, the similarities end there because the saturation and the hues in each image bring such a different emotional response. How do you feel when you look at both of them? The picture with snow is more of a subdued, reposed nature, whereas the autumn image is bright, lively, energetic. Look at your images and see if there is a pattern or inclination of certain colors and subject matter. Better understanding what colors you respond to is a first step in working effectively with them. 80-200mm zoom lens, f/8, 1/30th sec. (metered from tree trunks) Velvia

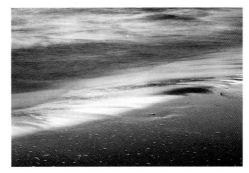

Page 102 SUMMER SUNSET, PUGET SOUND, WA.

As we improve our visual and technical skills we are better able to visualize the final image at the moment we press the shutter. However, there are times when the nature of the subject matter is such that our best effort may be an educated guess. At sunset I usually turn my attention to objects or natural surfaces that are lit by the warm light of the setting sun. In this image, the sky just after sunset is reflecting on the smooth wash of the sea on the sand. I am experimenting to see what kind of abstract design I can create from the colors and movement of the water. I used an 80-200mm zoom lens at f/22 and one second. Although I had an idea how it might turn out, I wouldn't really know until I saw the image. (General metering) Velvia

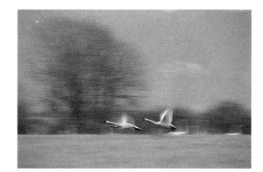

Page 103 WINTER MORNING, SAN JUAN IS., WA.

While driving around the island one cold winter morning, I found some Canada geese feeding in a pasture. They were nervous about my presence so I calmly but quickly set up. I set my camera on the tripod and loosened the grips slightly so I could pan. I set my aperture at f/16 and took a general meter reading of 1/2 second as their restlessness turned to flight. I caught these two as they trailed the flock. I liked the results because it reflects my feelings about the grace and elegance of birds in flight and I used techniques that effectively conveyed that idea. 80-200mm zoom lens. Fuji 50

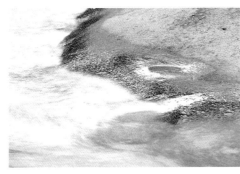

Page 104 AUTUMN AFTERNOON, SKATE CREEK, WA.

This image was taken at about the same location and time as the first two in this last section. Here I have decided to abstract a portion of a river rock and shoot a time exposure of the water swirling around it. I have stopped down my 80-200mm zoom lens to f/16 for a four second exposure. The long exposure has created a mixture and saturation of autumn colors in the water that did not exist to the eye. Part of the excitement of photography is what can be created and learned by experimenting. Metered from the rock. Velvia

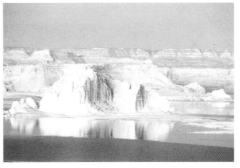

Page 105 WINTER, AFTER SUNSET, LAKE POWELL, AZ.

I arrived at this overlook at Lake Powell just as the sun was setting, but by the time I got set up it had dropped below the horizon. The sunlit island and the plateaus in the distance were quite striking as the sun was setting, however, the scene was losing it brilliance by the minute. I decided to try to recreate that brilliance after the fact. I took a metering from the island and stopped down to f/22 to give me an exposure of thirty seconds. This is a good situation to bracket so I took several shots of different exposure lengths. The long exposure has allowed the diminishing light to accumulate in the sky, rocks, and water, saturating the colors and making the scene look much it actually did at sunset. 80-200mm zoom lens. Velvia

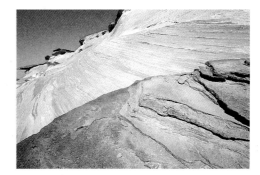

Page 106 WINTER MIDDAY, PARIA RIVER COUNTRY, UT.

Photo-graphing the landscape at midday when the sun's light is strong is not necessarily unflattering to the subject. This type of light can be very good given the appropriate subject matter. The design in this image is clearly enhanced by the direct overhead light. The saturation of the sky at this time of day is an important compositional element that balances the forms of shadows in the right of the image and also produces a strong color contrast. Making the overall design work meant that everything in the image had to be in sharp focus. I metered from the brown foreground rocks and set my 24-50mm zoom lens at f/22. I used my depth of field preview to make sure that the entire image was in sharp focus. 1/30th second. Velvia

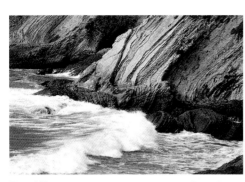

Page 107 AUTUMN AFTERNOON, NORTHERN CALIF. COAST.

Many a good image is lost because the photographer is not carefully considering how the camera's light meter is reading the scene. This is particularly true in compositions where there is a fair amount of white space that is being metered. If I had taken a general light reading, the amount of white water would have caused the meter to read more light than there actually was, causing the rocks to be underexposed. By zooming in and taking my light reading exclusively on the rocks, I have ensured that they will be properly exposed. This is but another example of the benefit and utility of a zoom lens. 80-200mm zoom lens, f/11, 1/8th sec. K25

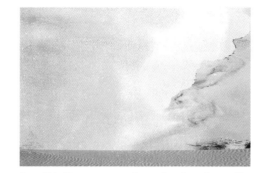

Page 108 WINTER SUNSET, CORAL PINK SAND DUNES, UT.

This is an example of what is called a monochromatic image. It consists of variations of tonal values of one hue. This was taken right at sunset and the extreme low angle of the sun across the dunes is highlighting their textures, patterns, and tonal differences. These were the basic elements of design I had to work with as I used my 80-200mm zoom lens to compose the image. Depth of field is once again crucial as the design that I conceived requires everything to be in sharp focus. I set my aperture at f/16 and checked my depth of field preview to make sure everything was in focus. 1/8th sec. (general metering) Velvia

Page 109 AUTUMN AFTERNOON, SKATE CREEK, WA.

This is another image I took that autumn afternoon at Skate Creek. After shooting the general scene from various wide angles, I switched to my 80-200mm zoom lens and began to look closer at the little pools and eddys that formed along the banks of the creek. I found this small rock stretching the surface of the water and forming this design. The heart shaped form over the rock fluttered like a butterfly from the gentle movement of the water. I did not want this form to diffuse in a long exposure so I opened up my aperture for more speed (and losing some depth of field) to 1/8th of a second. When we know what the subject expresses, we can then employ the appropriate technique. F/8, (general metering) Velvia

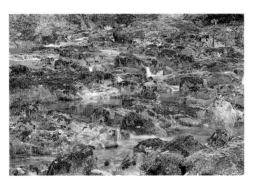

Page 110 AUTUMN AFTERNOON, OPAL CREEK RESERVE, OR.

I spent a day wandering through this magical place of dense old growth forest and the opal-hued waterfalls and pools of its watershed. The vegetation on the rocks indicates a stable watershed and river system. The ecological area adjacent to the reserve is under enormous pressure from clear-cutting and I wondered for how long this special place would remain untouched. To visually convey the beauty and magic of this creek, I used my 75-300mm zoom lens to compress this scene and emphasize the complexity and fragility of the natural elements. It has been the artist's calling for centuries to create in their work a reflection of society and the condition of the human spirit. You do not have to be professional to create images that inspire others to preserve what we still have. F/32, 1 sec. (general metering) Velvia

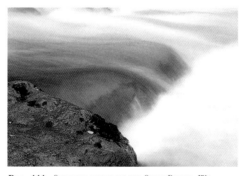

Page 111 SUMMER AFTERNOON, SAUK RIVER, WA.

This river is one of my favorite places to return throughout the year. It is a forested mountain environment that is in a constant state of change. I feel like I know this place as a friend, and every time we meet she seems to lift her shroud of mystery just enough to reveal a little more of her character. The river is fed by massive glaciers carving their way down the mountain sides high above. Every time I return the river is at a different height and running at a different speed. To properly expose this image I zoomed on the rock to take my reading, as metering on the water would have underexposed it. The appearance of moving water during a time exposure depends on the speed of the water and duration of exposure . Experience and practice should be your guide here. 24-50mm zoom lens, f/16, 1/2 sec. Velvia

Page 112 SUMMER AFTERNOON, SEATTLE, WA.

Close-up or macro photography gives us the opportunity to capture those things that exist on a smaller scale that are all around us. With a macro lens or extension tubes we can enter another realm with the mere pull on the barrel of a zoom lens or a twist of the focusing ring. By abstracting, we are free to use our imagination and engage that of the viewer. I walked outside into my backyard just after a summer rain and plunged into the wet grass to see what a shower looks like to an ant. I used my 80-200mm zoom lens with two extensions tubes and explored the tangle of grasses and water drops by simply changing focus and focal lengths. F/8, 1/4th sec. (general metering) K25

Page 113 SPRING MORNING, SEATTLE, WA.

The effects of depth of field on color and design are particularly pronounced in macro photography. In this image of poppies I have isolated these two to be the main design elements. I am using the distant poppy as a secondary form to support and balance the one in focus. I used my 80-200mm zoom lens with an extension tube and focused on the near poppy. Starting with my aperture at f/8 and holding down my depth of field button, I gradually opened the aperture wider, diffusing the color and softening the outline of the rear poppy until it appeared as I wanted it. Previewing the depth of field at the planned f/stop is the only way to know how it will affect the overall design and rendition of hues in the image. F/5.6, 1/60th sec. (general metering) Velvia

Page 114 SUMMER EVENING, LAKE NEWMAN, WA.

When I first came upon this end of the lake, the lily pads stretched out across the water as far as I could see. I hiked up to this vantage point and set up my camera with my 80-200mm zoom lens. Composing the image was a matter working with the design of water, lily pads, and grasses in different combinations by changing focal lengths and angles of view. Because of my inability to move much on this steep hill, I probably could not have gotten this in-camera-cropped-image with a fixed focal length lens. As part of the design, I shot this at f/22 to keep every part of the image in focus. 1/4th sec. (general metering) Velvia

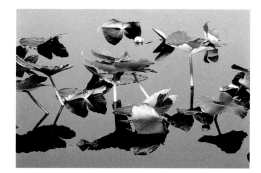

Page 115 SUMMER EVENING, LARSON LAKE, BELLEVUE, WA.

The soft evening light was warming these lily pads near the shore of this small urban lake. The low angle of the side-lighting was creating numerous shadows, abstract in form. Working with this abstract nature of the scene, I utilized my 80-200mm zoom lens to select a portion of the lily pads and shadows that presented the most interesting design. To enhance the abstract design, I eliminated perspective by setting my aperture at f/16 to keep everything in sharp focus. They appeared not so much to rest on water as to float across the sky. 1/8th sec. (metered from sunlit reflections) Velvia

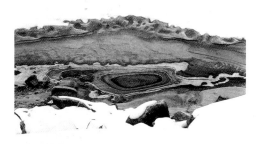

Page 116 WINTER MORNING, WENATCHEE RIVER, WA.

Looking down from the highway, I found this design of a frozen puddle in the dried up backwash of the Wenatchee River. This is an easy type of image to underexpose. The snow in the scene commands the greatest area in the viewfinder and the light meter will mostly read the bright light of the snow, underexposing the sand and puddle which are about two stops darker. Once again, using my 80-200mm zoom lens as a spot meter, I am reading the light from the sand and puddle to ensure their proper exposure. Calculating exposure is not difficult, one simply must be fully aware of how the meter will read the light, and take your reading accordingly. F/16, 1/4th second, Velvia

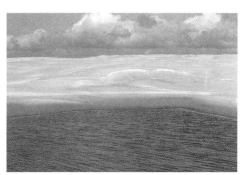

Page 117 SPRING AFTERNOON, OREGON DUNES.

I hiked out about a mile into the dunes under pleasant sunny skies. Before long I was too absorbed in shooting patterns in the sand to notice a rain squall approaching. There was no place to take refuge so I put my gear away and sat, waiting for the squall to pass. The sun came out shortly and to my delight, the rain-darkened dunes were streaked by lighter areas of drying sand, creating textures and forming designs across the dunes. Zooming slightly with my 80-200mm lens, I created this composition as a visual comparison between the water, dunes and cloudy sky. I shot this at 1/125th second to maintain the rippled effect in the water, as it is visually important in the comparison between the elements. F11, metered from dark sand, K25

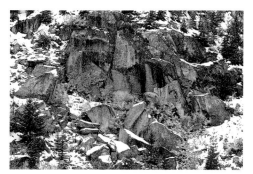

Page 118 AUTUMN AFTERNOON, CASCADE MTS., WA.

I pulled off the highway when I spotted these patches of autumn foliage perched among the rocks. I began this trip anticipating a light snowfall in the mountains and I was rewarded with this dusting of white on an autumn mountain side. Using my 80-200mm zoom lens I zoomed in to form this composition. In this situation a correct exposure could be taken by simply reading the meter. The center-weighted meter will in this case read the center of the image containing the approximate 18% gray tones of the rock, allowing everything else to expose properly as well. F/16, 1/2 second, Velvia

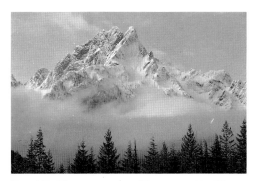

Page 119 WINTER MORNING, WHITEHORSE MT., WA.

The mysterious beauty of mountain light, I think, emanates from its elusive and transient nature. Capturing a fleeting moment of magical light is one of my greatest joys of photographing. I woke up in my camper parked along the Sauk River to discover that the overnight storm had blanketed the Cascade Mountains with over four feet of snow. When I came to this place, the mountain was beginning to appear through the clouds. I photographed for an hour as the sunlight danced across the mountain in the powdery snow. I used my 75-300mm zoom lens to crop in on the shot. I took an average metering of the entire mountain not in sunlight. F/16, 1/8th second, Velvia

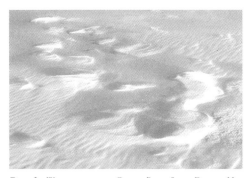

Page 2 WINTER SUNSET, CORAL PINK SAND DUNES, UT.

I was immediately attracted to this area by the way the setting sun was highlighting and exposing patterns and textures in the dune. I used my 80-200mm zoom lens to select this design and crop out the surrounding space. Every part of this scene is important to the overall design, hence everything needs to be in sharp focus. To get the foreground and the most distant shapes in focus, I stopped down to f/22. I used the depth of field preview to make sure that I had accomplished that. If I hadn't, I would need to have changed positions and tried again. 1/4th second, (general metering) Velvia

BIBLIOGRAPHY

Franck, Fredrick, *The Zen of Seeing,* New York: Vintage Books, 1973.

Franck, Fredrick, *The Awakened Eye,* New York: Vintage Books, 1979

Arnheim, Rudolf, *Art and Visual Perception, A Psychology of the Creative Eye,*
 Berkeley: University of California Press, 1974

Patterson, Freeman, *Photography and The Art of Seeing,*
 Toronto: Van Nostrand Reinhold, 1979

SUGGESTED READING

Nachmanovitch, Stephen, *Improvisation in Life and Art,* J.P. Tarcher Inc., 1990

Patterson, Freeman, *Photography For The Joy of It,* Van Nostrand Reinhold, 1977

Patterson, Freeman, *Photography of Natural Things,* Van Nostrand Reinhold, 1982

Shaw, John, *The Nature Photographer's Complete Guide to Professional Field Techniques,*
 Amphoto, Watson Guptill, 1984

Peterson, Bryan F., *Learning to See Creatively,* Amphoto, Watson-Guptill, 1984

Bruce W. Heinemann

Bruce has photographed the landscape for over twenty years. His images have
appeared in Sierra Magazine, Audubon, Outdoor Photographer, Alaska Airlines,
and in the publications of major national and international corporations. Bruce has
also studied and performed the classical trumpet for over thirty years. Combining
his images and music he performs a multimedia concert entitled: The Art of
Nature. He is currently completing his second in a series of three Art of Nature
books in addition to a music video and CD-ROM.

WITH GRATITUDE

I would like to acknowledge and sincerely thank Ted Mader and Associates for
their many contributions to The Art of Nature Series. Without their dedication
and support, this series and this book in particular, would have been difficult if not
impossble to complete. Thanks to editor Barbara Visser for her ideas and sugges-
tions. A big thank you to my wife, Judy for her patience and support, and a very
special thank you to my son, who endlessly inspires me to see like a child.
A special thank you to Gordon and Raoul Goff of Palace Press International for
their outstanding effort on this project.

A Guide to Photographing the Art of Nature, Published by Prior Publishing,

6712 Mary Avenue NW, Seattle, WA 98117 (206) 789-6359

Design by: **TMA** Ted Mader + Associates, Seattle, WA

All Photographs and text of A Guide to Photographing the Art of Nature

©1994 Bruce W. Heinemann

The Art of Nature is a registered trademark of Prior Publishing.

Printed in Hong Kong through Palace Press, San Francisco, CA.

ISBN: 0-930861-08-6